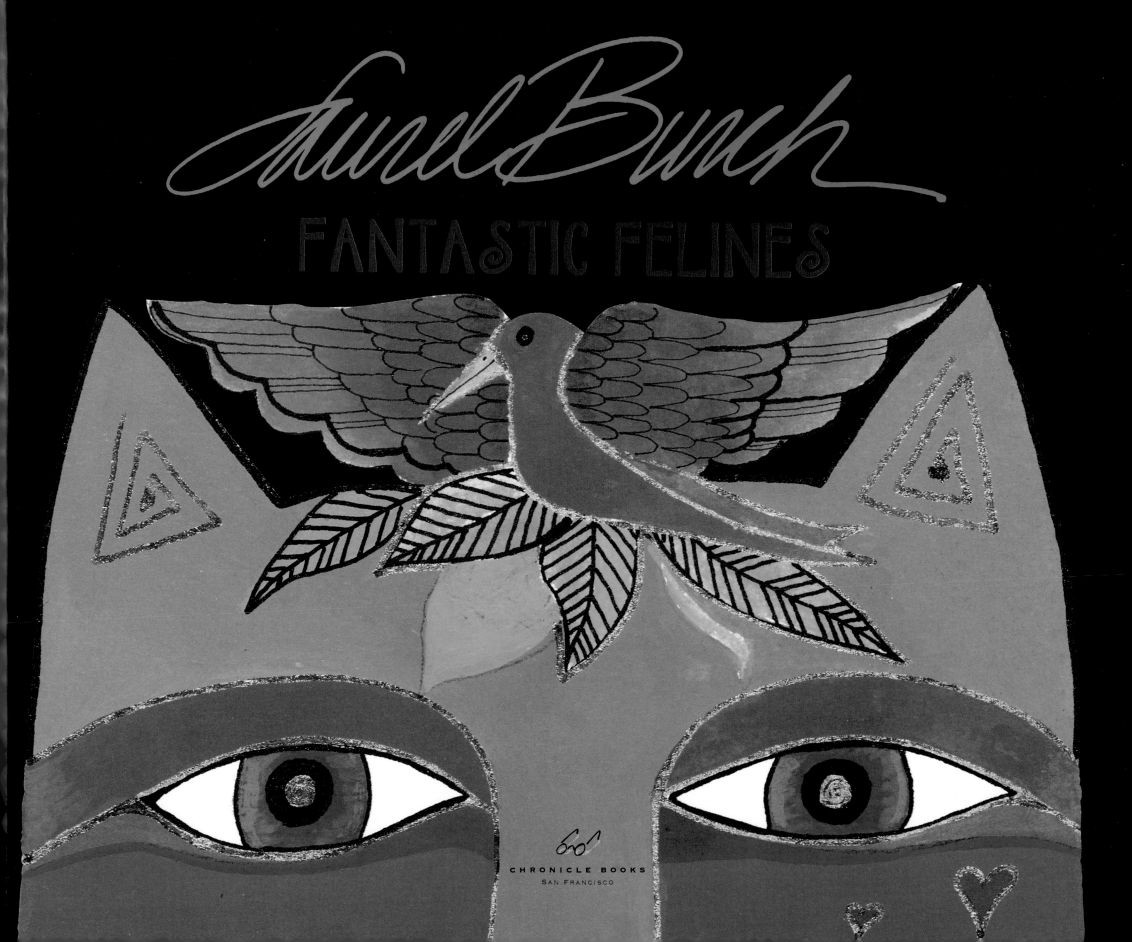

Laurel Burch
FANTASTIC FELINES

CHRONICLE BOOKS
SAN FRANCISCO

ACKNOWLEDGMENTS

FOR ALL MY KINDRED SPIRITS AROUND THE WORLD.
YOU FILL MY HEART WITH THE PASSION THAT INSPIRES
MY ART AND STORIES. MY DEEPEST GRATITUDE TO
MARA MURRAY FOR MAKING THE DREAM OF THIS
BOOK COME TRUE. THANK YOU ANNIE BARROWS
AND CHRONICLE BOOKS FOR GIVING ME THIS
OPPORTUNITY TO SHARE MY LIFE AND ART
IN SUCH AN INTIMATE WAY. TO SARAH PAULI
FOR THE PASSION YOU BROUGHT TO THIS PROJECT,
AND TO STEVE FUKUDA, LENNY LIND AND RICK SARA
FOR YOUR BRILLIANT PHOTOGRAPHY.
TO MY FAMILY, AARIN, JAY, ROBERT, MAGGIE, AND
ELIJAH BURCH. YOUR LOVE HAS SUSTAINED ME.

Printed in Hong Kong.

Library of Congress Cataloging-in-Publication Data:
Burch, Laurel.
Fantastic Felines / by Laurel Burch.
p. cm.
ISBN 0-8118-1644-3
1. Burch, Laurel–Themes, motives. 2. Cats in art. I. Title.
N6537.B859A4 1997
709' .2–dc21 96-45230
 CIP

Book and cover design: Laurel Burch and Mara Murray
Composition: Cameron Imani
Cover illustration: *Fantasticats* by Laurel Burch

Distributed in Canada by Raincoast Books,
8680 Cambie Street
Vancouver, B.C. V6P 6M9

2 4 6 8 10 9 7 5 3 1

Chronicle Books
85 Second Street
San Francisco, CA 94105

Web Site: www.chronbooks.com

CONTENTS

♥

♥

INTRODUCTION

ABOUT THE ARTIST

Laurel Burch and her artistic vision have been enthusiastically embraced by collectors and kindred spirits around the world. Whether on an Australian beach, on New York's Fifth Avenue, or in a Moroccan market place, local residents adorn themselves

with her trademark cloisonné earrings, gather treasures in her silkscreened totebags, or proudly wear shirts emblazoned with the mythical animals that are distinctly and unmistakably Laurel Burch.

Many a kitchen shelf is graced with Laurel's delicately gilded coffee mugs. Friends and families in lands near and far express their love for one another on Laurel's notecards and stationery. Walls in schools, homes, and offices display paintings and prints that communicate in the universal language she speaks fluently—the language of the heart.

The number of moving legends about the giving, receiving, and sharing of Laurel Burch art are a reflection not only of the woman herself, but of all the collectors who are drawn by her spirit as

well as her designs. Many of them know and have been deeply touched by her life story. At the age of 14, Laurel Burch left her tumultuous home life in Southern California with nothing more than a paper bag of clothing and the rare bone disease—osteopetrosis—she was born with. Cooking, cleaning, and babysitting for her room and board, she embarked on a search for some stable ground to support her fragile body, hoping to discover a fragment of self-worth along the way. Homes changed as often as the years, and at the age of 19, she migrated north, with hair straight to her waist, skirts to her ankles, and a baby daughter on her back. With no job, no money, and no dreams, Laurel Burch reached the Golden Gate of San Francisco.

It was 1965, and the Haight-Ashbury district of the city was filled with strange and colorful people. You could be yourself, do your own thing, and wear flowers in your hair. Lost souls found a home, and Laurel was among them.

Part of Laurel's search for connectedness was evidenced in

Opposite page: Laurel Burch, spring 1996.

 the jewelry she began to make for herself and wear— old coins, bones, and beads arranged into earrings and necklaces. Wearing them gave her a sense of belonging, if only to an exotic world of her own making. Fascinated by her otherworldly adornments, people on the street began to ask her where she got them, and this artistic validation gave Laurel the sense of self worth she had long been missing. Her creations became bridges to friendships and patrons.

Whether selling her wares off a table on the street or participating in an occasional art fair, 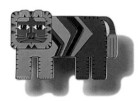 Laurel was inspired by the new acknowledgement and appreciation to work long into the night making jewelry. Somehow, wire hammered out on the back of an old iron frying pan evolved into something with spirit and imagination, and, for a mere $2, one could acquire a pair of earrings and enter the realm of Laurel Burch magic.

Through trading, selling, and giving them away, these fetish like artifacts found their way into the lives of people all across the country, and the phenomenon of collecting Laurel Burch began.

At the age of 23, Laurel gave birth to her second child, a beautiful baby boy. Still challenged by the frequency of broken bones caused by her disease, Laurel's little family of three was forced to seek the aid of welfare services to supplement the income from her jewelry.

Passion and perseverence eventually prevailed, and a small business blossomed in a garage by the 1970s. Hiring friends, neighbors, and people off the street, Laurel created the original pieces of jewelry and taught the others how to duplicate them. She sold her designs to shopkeepers up and down the coast of California and came back home when her boxes and baskets were empty.

In 1971, Laurel made her first trip to the People's Republic of China, as the guest of a Singaporean friend and importer. The purpose of the trip was to take a small collection of her drawings to be made into jewelry using the ancient Chinese art of cloisonné.

"Though this was not an art form I knew myself, I was ecstatic about the possibility of having my paintings hand-crafted 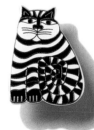 into colorful little pieces of art that could be worn and enjoyed by all my new collectors and friends.

"I will never ever forget the day the first 12 pairs of earrings were unveiled by the cloisonné artisans. Never before had I envisioned something in my mind, drawn it on paper, and seen it come to life in the hands of another craftsman. Of course, this made it possible to share my designs in more forms, and with more friends. The most incredible door opened to my life's work when I realized that, through my art, I could communicate with cultures all over the world, and that within the images, I could express shared values and a love for life that could link us all together, at the heart!"

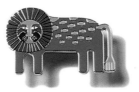

And so Laurel Burch's love affair with the world—and with the artisans who work hand in hand with her to bring her art into all its various forms—began to flourish.

Over the years, Laurel's prolific career has given birth to hundreds of mythical animals, ethereal birds, and figures that capture the soul of humanity—all portrayed in a rainbow of brilliant colors and accented with gold and silver.

Crossing the boundaries of age and race, countries and cultures, and even the physical

and spiritual worlds, every image she dreams up is rooted in her respect and reverence for all living things.

Whole themes emerge from her fertile imagination with powerful and moving results—*The Secret Jungle, The Art of Human Being, The Spirit of Womankind,* and of course, *Fantastic Felines* to name a few. The boundless energy and imagination of this extraordinary artist place her among the most treasured creative spirits of our time.

Laurel continues to live and create in Northern California, and the Laurel Burch Gallerie and design studio are located in a 1914 firehouse in the little town of Sausalito, just north of San Francisco. While still engaged in long periods of healing broken bones, she nevertheless continues to find joy and sustenance in following her passion to create. The outcome is a world made more magical and—for sure—more vibrantly colored.

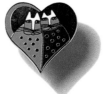

I LIVE WITHIN THE VIVID COLORS OF MY IMAGINATION...

SOARING WITH RAINBOW FEATHERED BIRDS,

RACING THE DESERT WINDS ON HORSEBACK,

WRAPPED IN ANCIENT TRIBAL JEWELS,

DANCING WITH MYTHICAL TIGERS IN STEAMY JUNGLES.

AS I GROW, SO GROWS MY PASSION TO DREAM,

AND AS I DREAM, I PAINT.

MYTHS EMERGE,

BEINGS COME TO LIFE,

KINDRED SPIRITS CONNECT...

STUDIO SANCTUARY

I think of my studio as more of an internal concept than an external physical space. A sanctuary where I can dream and imagine and bring my passion for life out on paper. I carry this "inner sanctum studio" with me everywhere. Under an old oak tree near my home, onto the beach in Mexico, to my kitchen table, to the back of a boat in the Mediterranean Sea. Even hospital beds have served as paint studios when that was where I needed to be. Wherever I am, imagination and inspiration go with me, and so do paint brushes, paper, gold inks, and pens. I have as many art supplies as clothes in my bags when I travel, and if by chance I don't, an art store is the first stop I make.

I am often asked if I travel for inspiration. Actually, for many years, the only travelling I did was in my own mind. With my feet on the ground and my head in the clouds, life itself is inspirational. I'm sure I learned this by spending a great deal of time in bed, healing broken legs throughout my life. I dream up mythical worlds and imagine ways I can share them with others.

Through creative imagination, almost any part of life's journey—whether joyful or challenging—can be shared in positive and meaningful ways.

I am a self-taught artist, and my tools are very simple. I have a passion for papers and brushes, and gather them from all over the world. Often I buy them simply because I think they're beautiful and they make me feel good when I look at them. A lot of times, I don't use brushes at all—I put my hands right into the paints.

Though my mind is afire with ideas that all want to come out at once, I seem to prefer keeping the environment of my studio orderly and under some degree of control. There are always flowers on the table, music fills the room, and Matisse, my black Lab and constant companion, is always at my feet (which are bare—somehow, I can think better in bare feet). The table itself, on the other hand, is a wild frenzy of paints and rags, pens, pencils, and inks and is not at all orderly. My parrot, Rainbow, adds to the air of chaos by hanging upside down from the lamp trying to eat paint brushes and occasionally falling into the paint dishes, hence his name. (He was primarily green when he arrived in my life.)

Home is definitely my favorite studio sanctuary, but you might say I think of the whole world as a place to create and imagine.

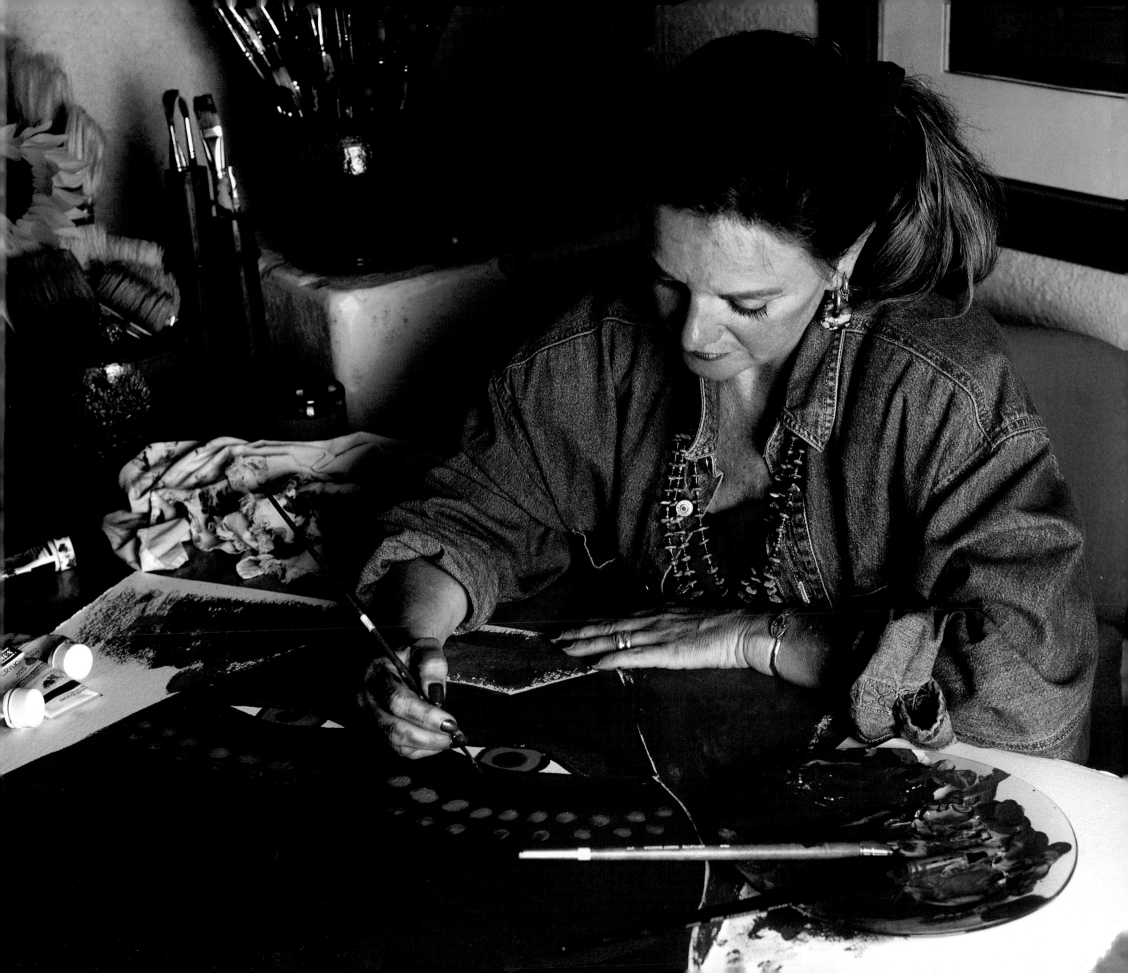

For as long as I can remember, I have wished I could speak in every language known to humanity, thereby being able to connect with people of all kinds, all over the world, and they with me. I try to do this with my art, thinking of it as a universal language. The quality of art to communicate in this way has been an enormous inspiration to me from the very beginning.

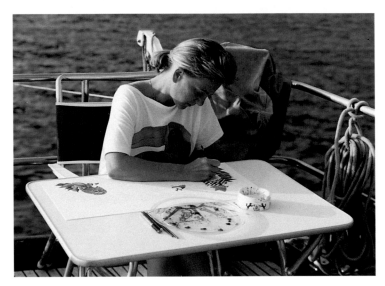

Greek Islands, 1988.

I think I am really a folk artist, telling stories. I simply love to create beauty and color that can brighten the spirit of the world. That seems to be the motivation behind everything I do or touch, no matter where I am.

Home Studio, Sonoma 1996.

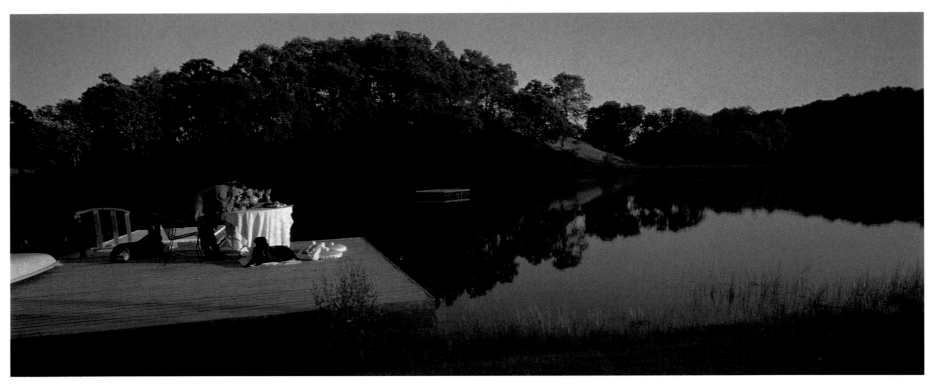

Sonoma, California, 1996.

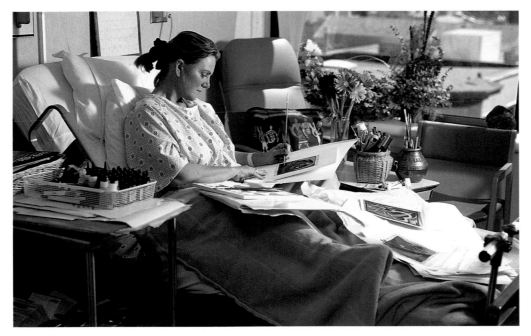

California Pacific Hospital, San Francisco, California, 1996.

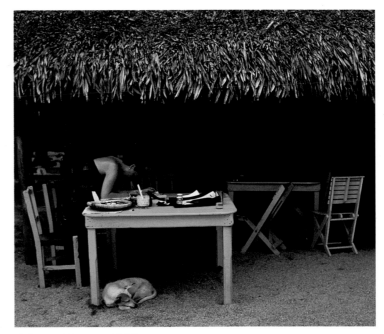

Yelapa, Mexico, 1985.

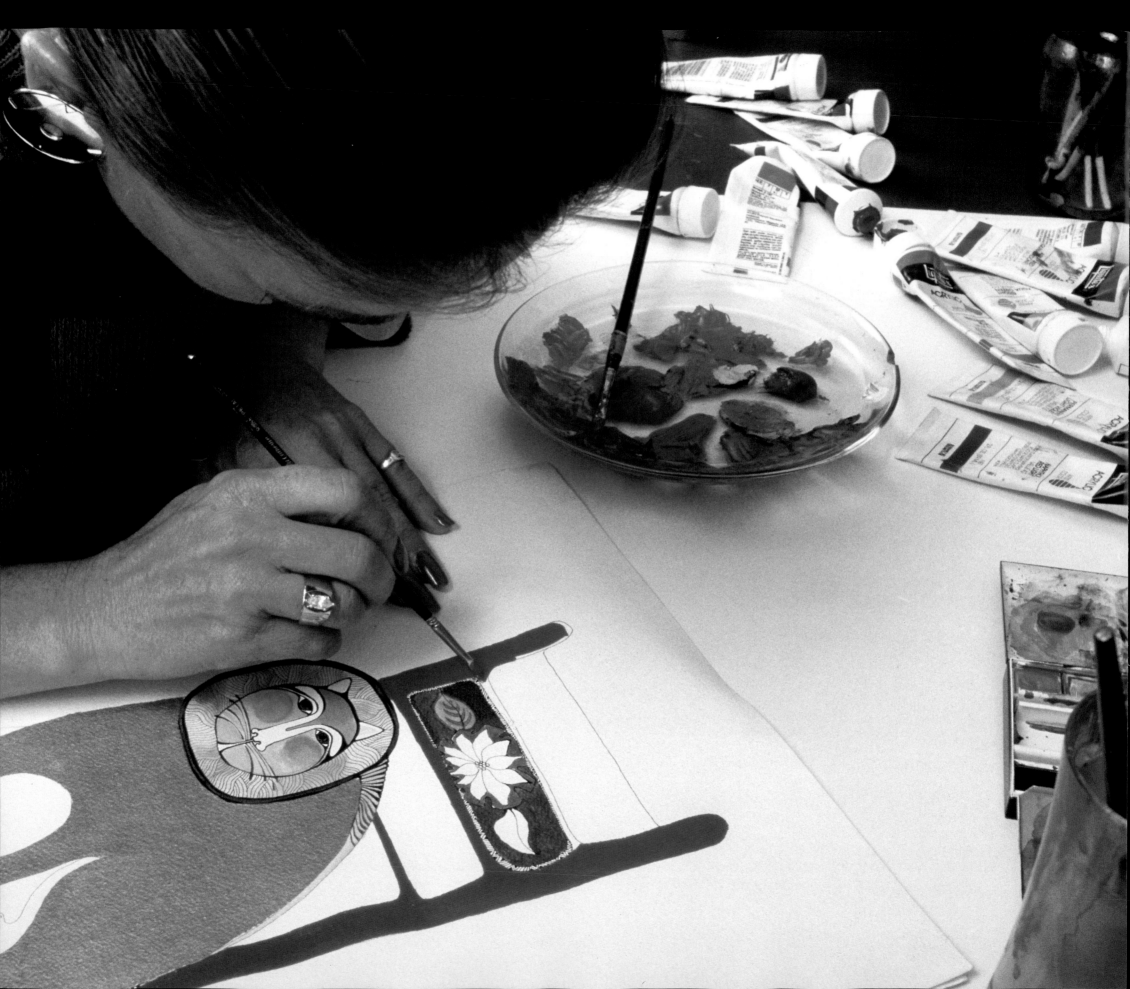

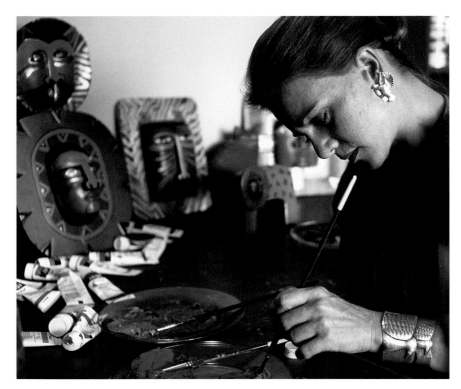

Painting masks in 1990.

Many realizations have come to me during my personal odyssey as an artist. I didn't go to school to learn painting and drawing—I learned to rely on my intuition and passion, believing I could speak from my heart and all else would follow.

Detail from Sunset Spirit *mask 1996.*

Opposite page: Home studio, 1989.

U ntil I create something on paper, I only have a vague sense of what it will look like. So many creatures have emerged by surprise—line by line, color by color, whisker by whisker. An eye becomes a face, a face becomes a feline, and a feline finds friends. There is often an entire family of friends by the time I get up from the drawing table.

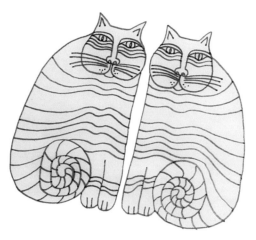

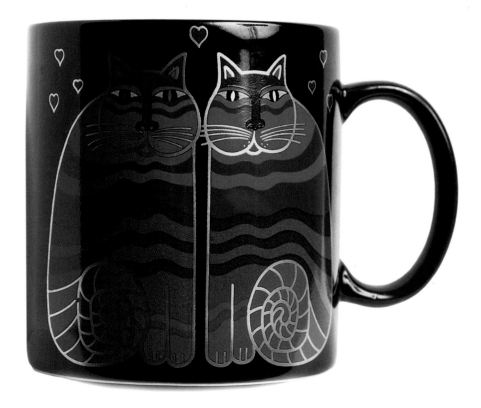

Rainbow Cats *mug, 1986.*

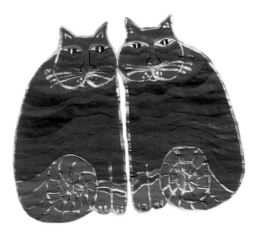

The various stages of design development.

Rainbow Cats *cloisonné necklace, 1986.*

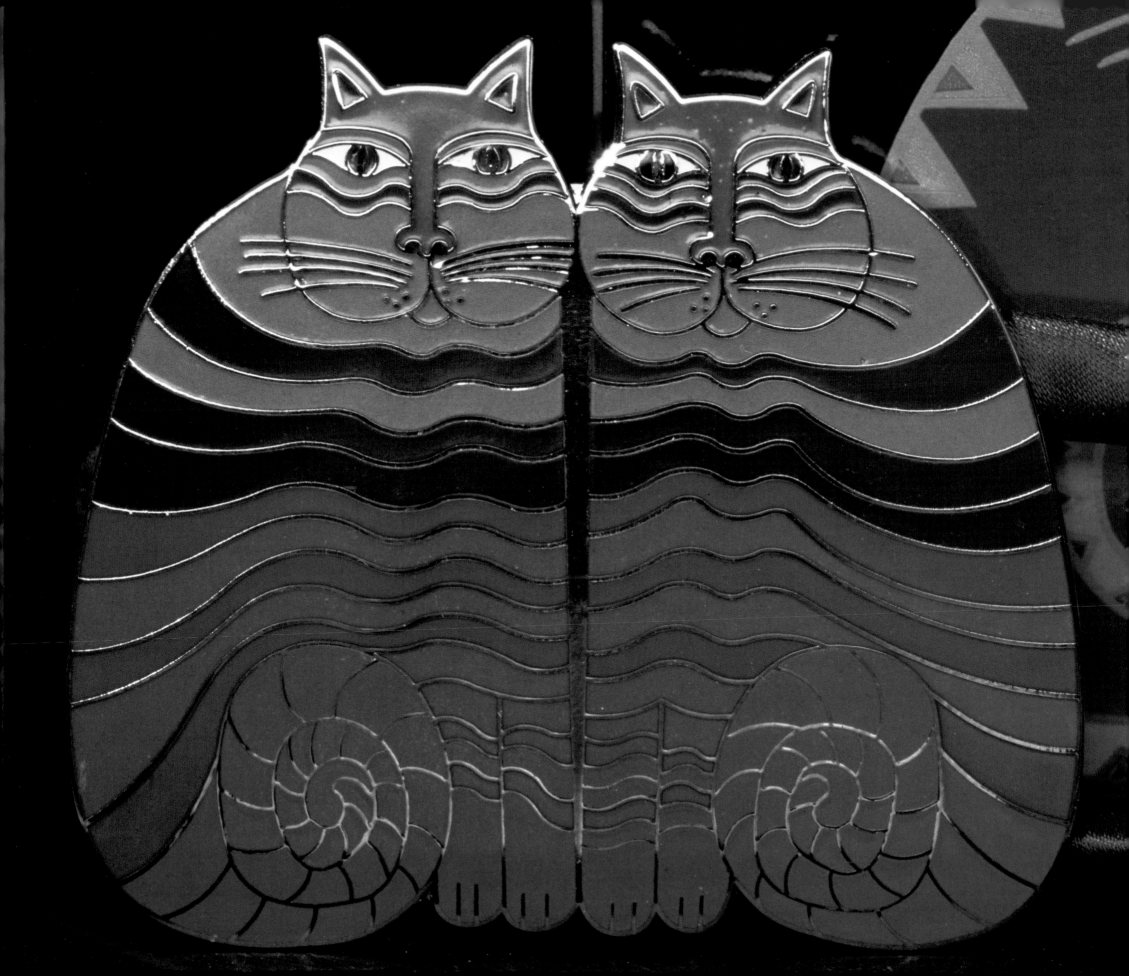

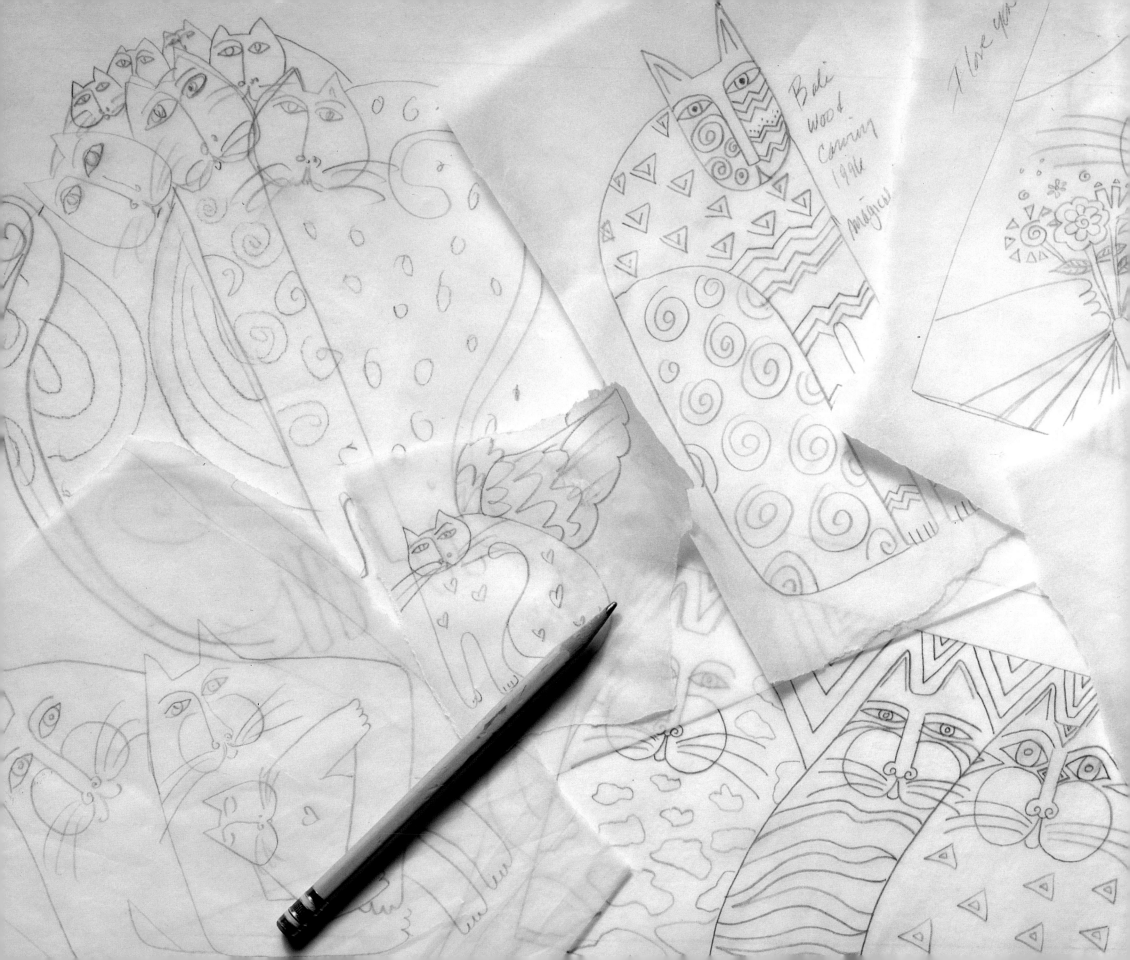

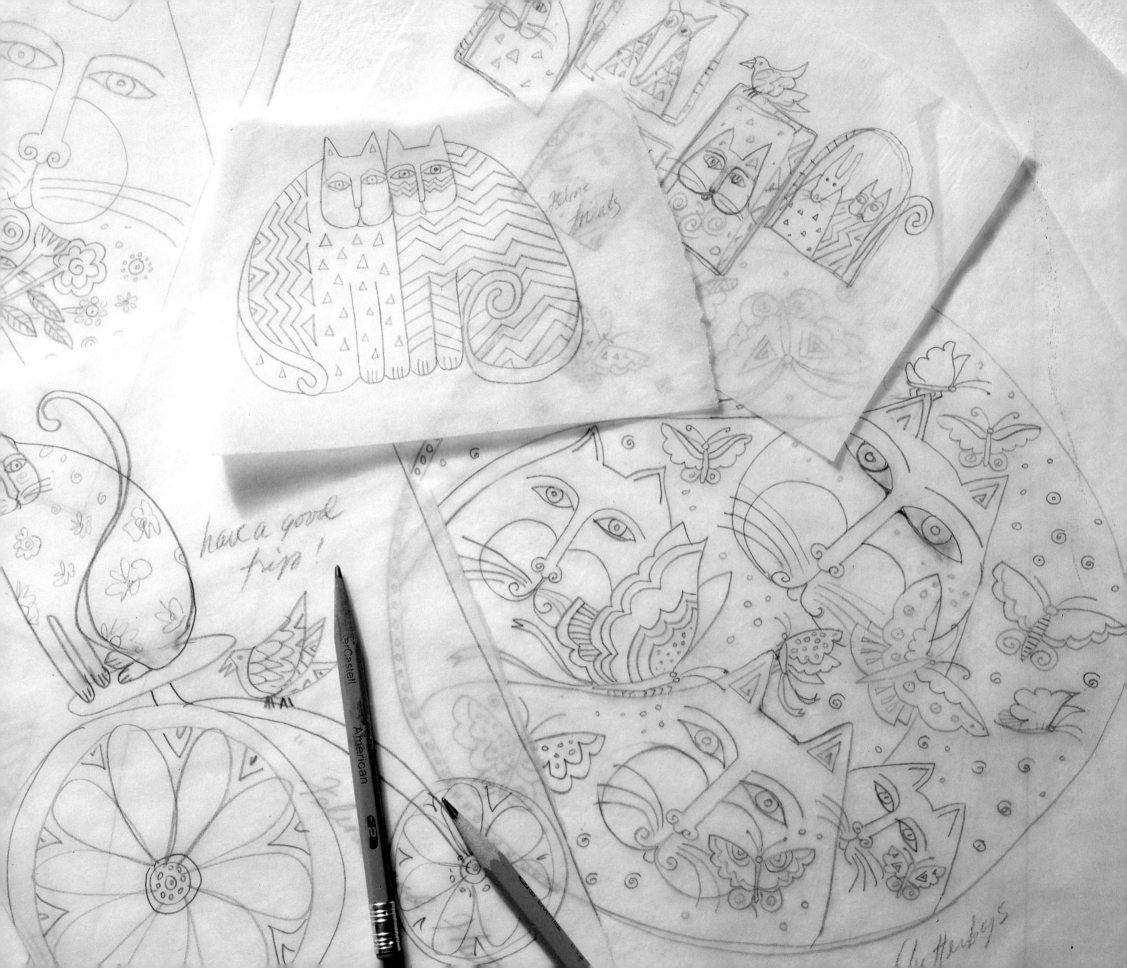

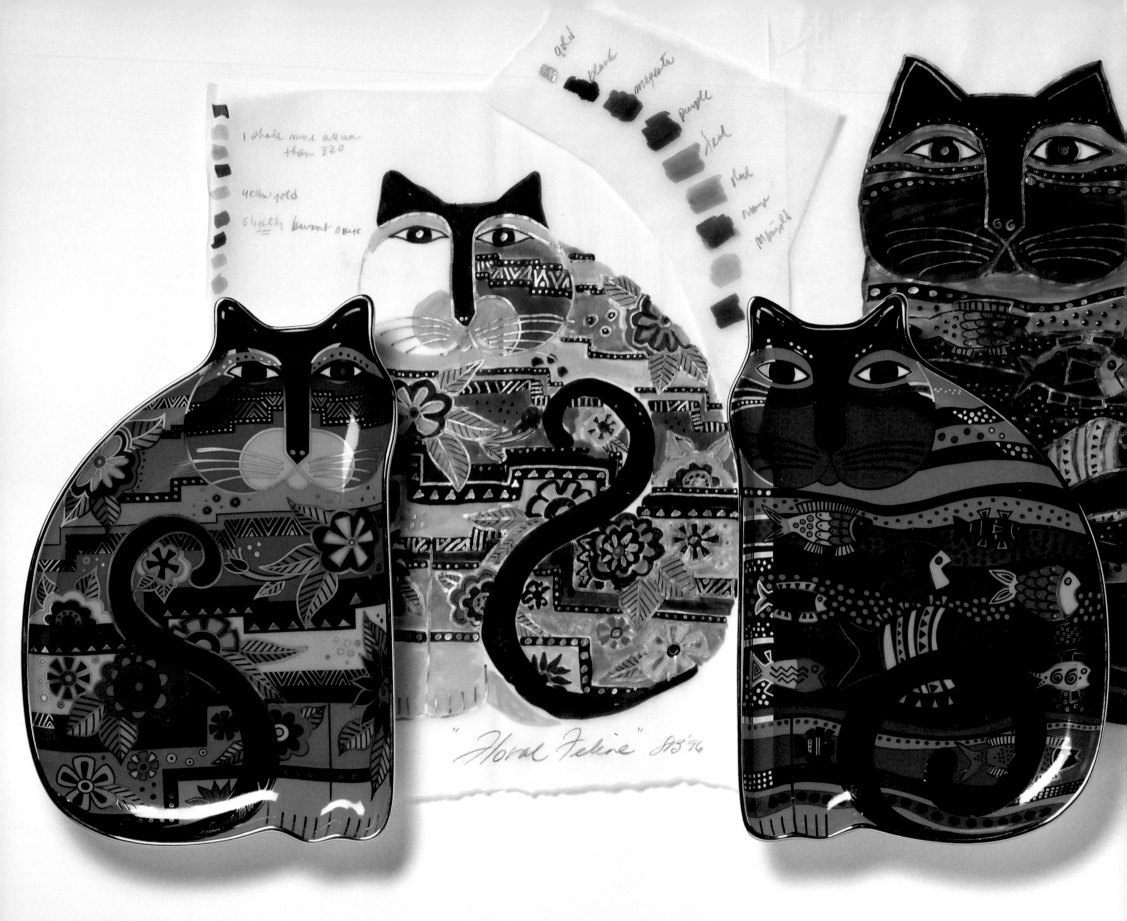

"Floral Feline" SJB '96

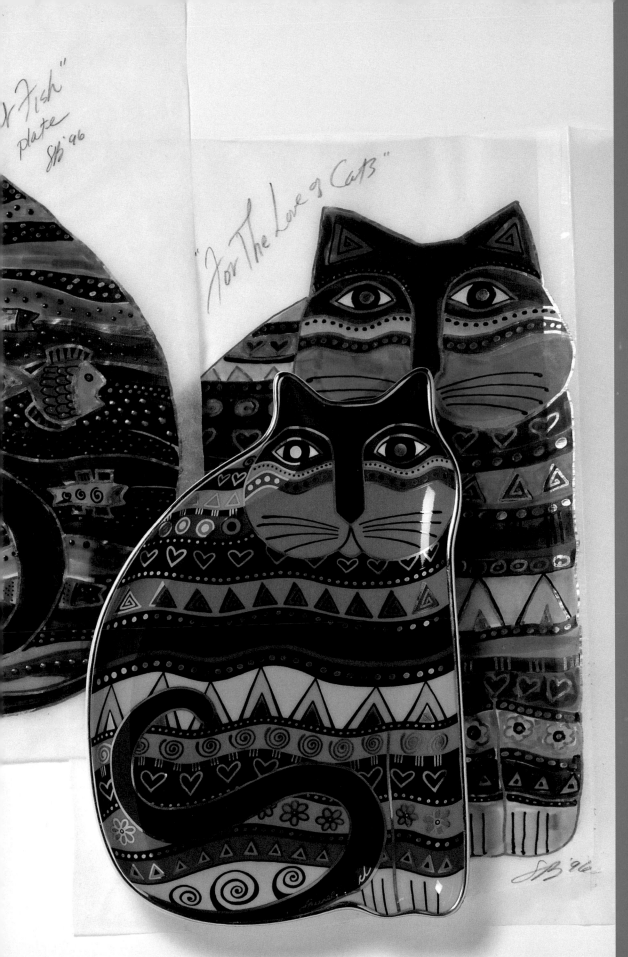

"For The Love of Cats"

Fish"
plate
SB '96

I could never choose one favorite fantasy feline any more than I could choose one color over another. It is the profusion of personalities and the wild explosion of patterns all together that set my artistic imagination afire. At the same time, each and every feline is special in its own way, just as real ones are. This is where I find the continuous joy in creating MORE cats.

Laurel's drawings and samples from the
Laurel Burch Franklin Mint cat-shaped plate series.

Following pages:
New Family *and* Whiskers, *1995.*

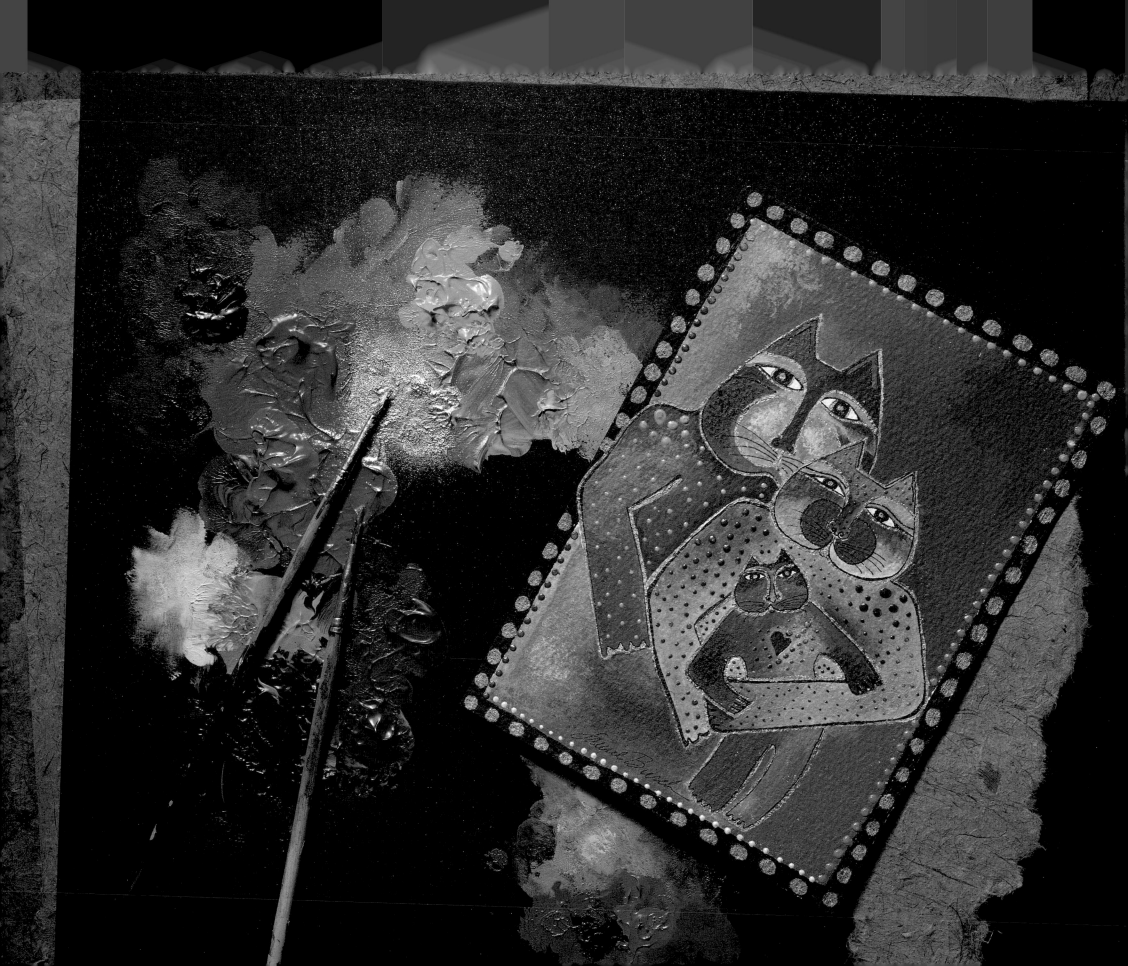

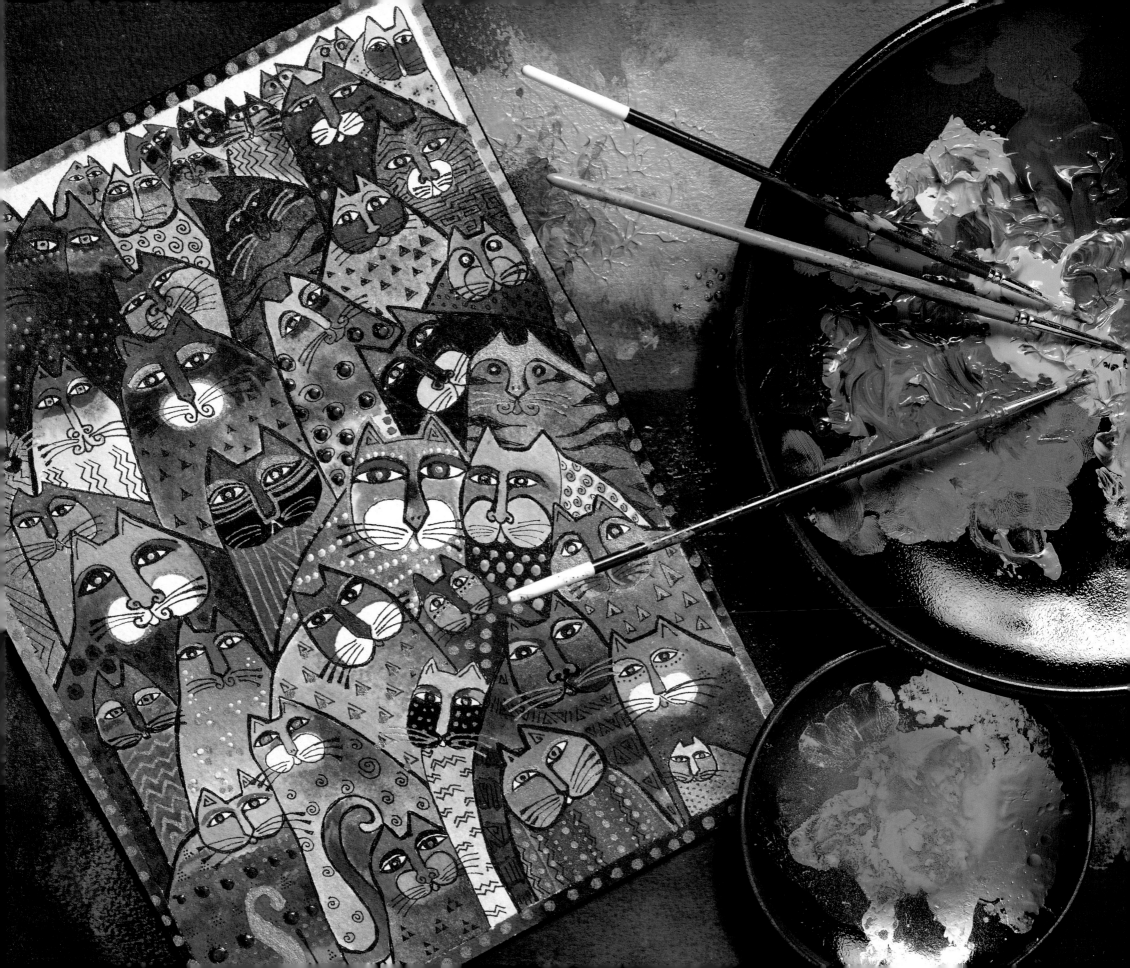

WILDCATS,

ALL GRACE AND SPIRIT...

LOOKING INTO MY SOUL

WITH THEIR ANCIENT EYES.

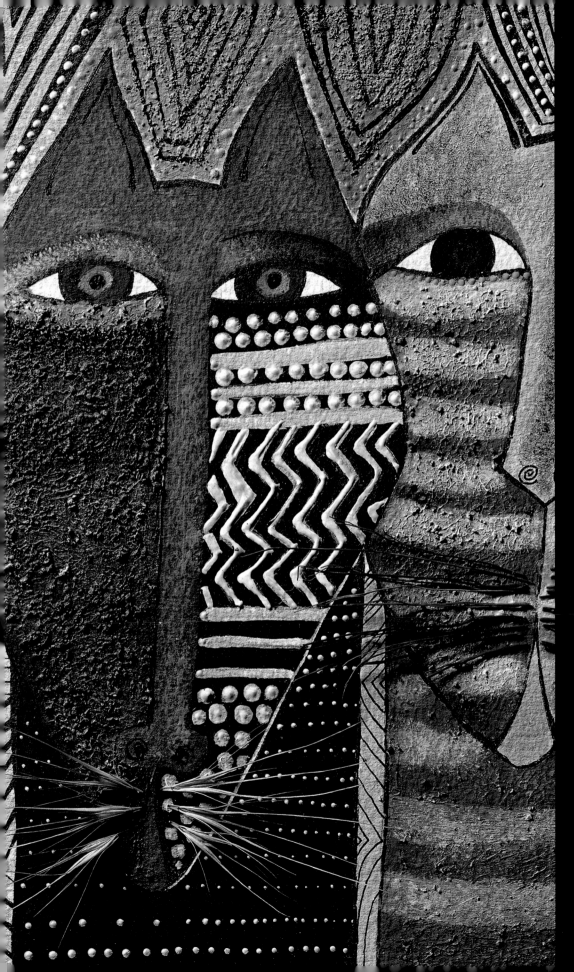

WILD
CATS

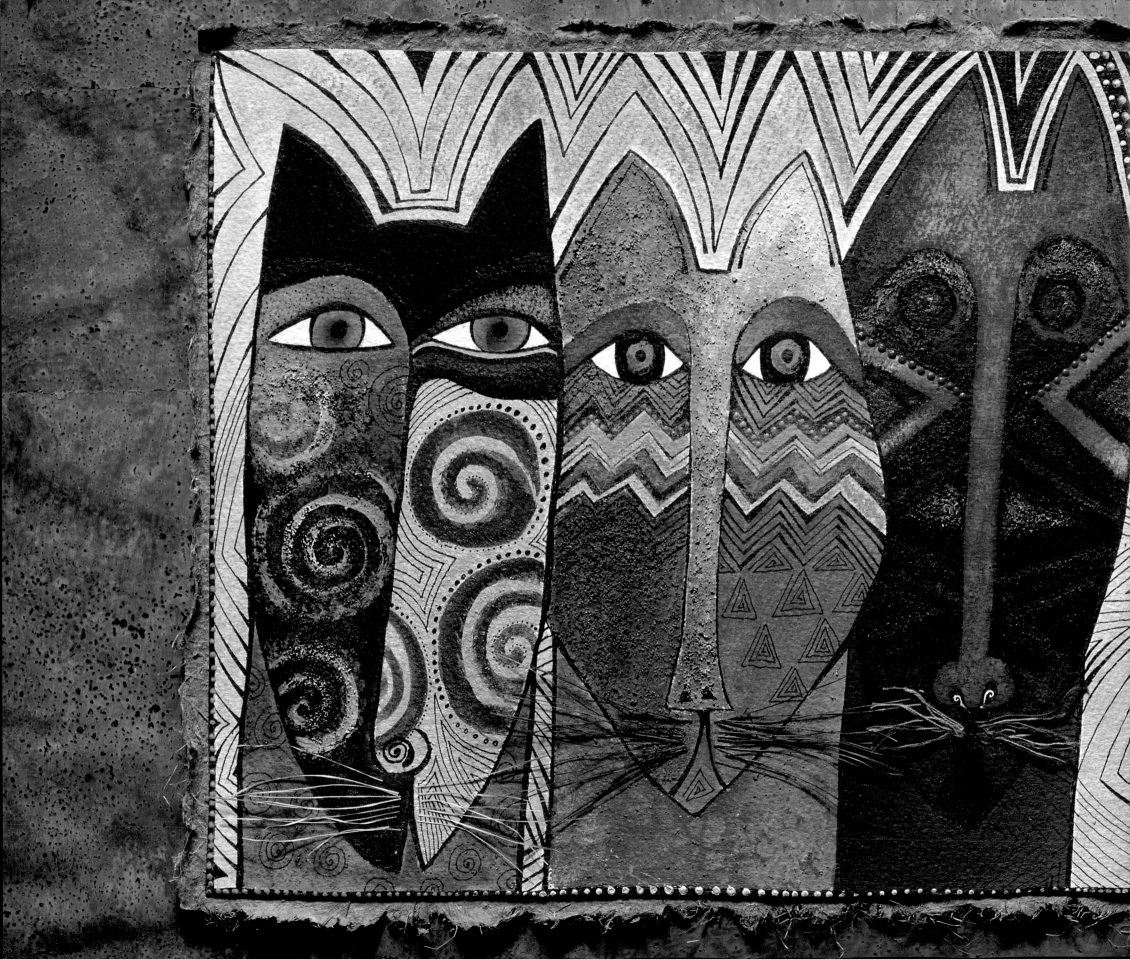

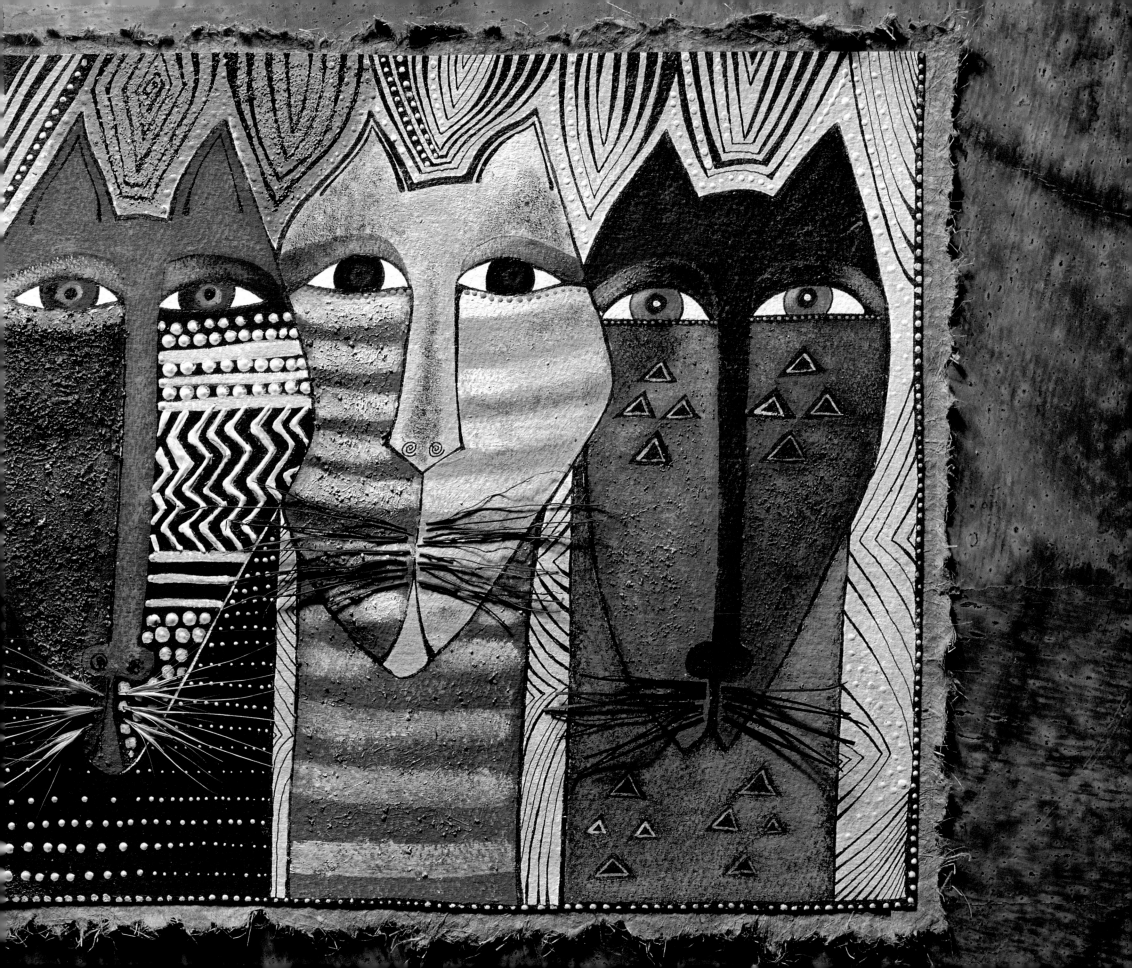

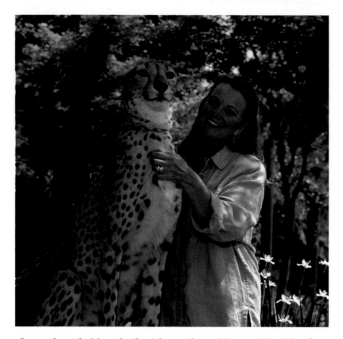

Laurel with Marah the cheetah at Marine World Africa USA, spring 1996.

I am in utter awe of the grace and spirit of the big wild cats, and my supreme love for them has inspired most of my feline art.

My life has been forever altered by being in the presence of such magnificent beings. I have felt the overwhelming power of their strength and been captivated by their astounding elegance and beauty. Long before I had the thrill of wrapping my arms around tigers, leopards, lions, and cheetahs, I was fascinated by them. Now that I've had those experiences, my love affair with these Fantastic Felines is all the more profound.

Laurel and Rocky, a Bengal tiger, at Marine World Africa USA, spring 1996.

Preceding pages: Native Cats *painting mounted on handmade papers, 1996.*

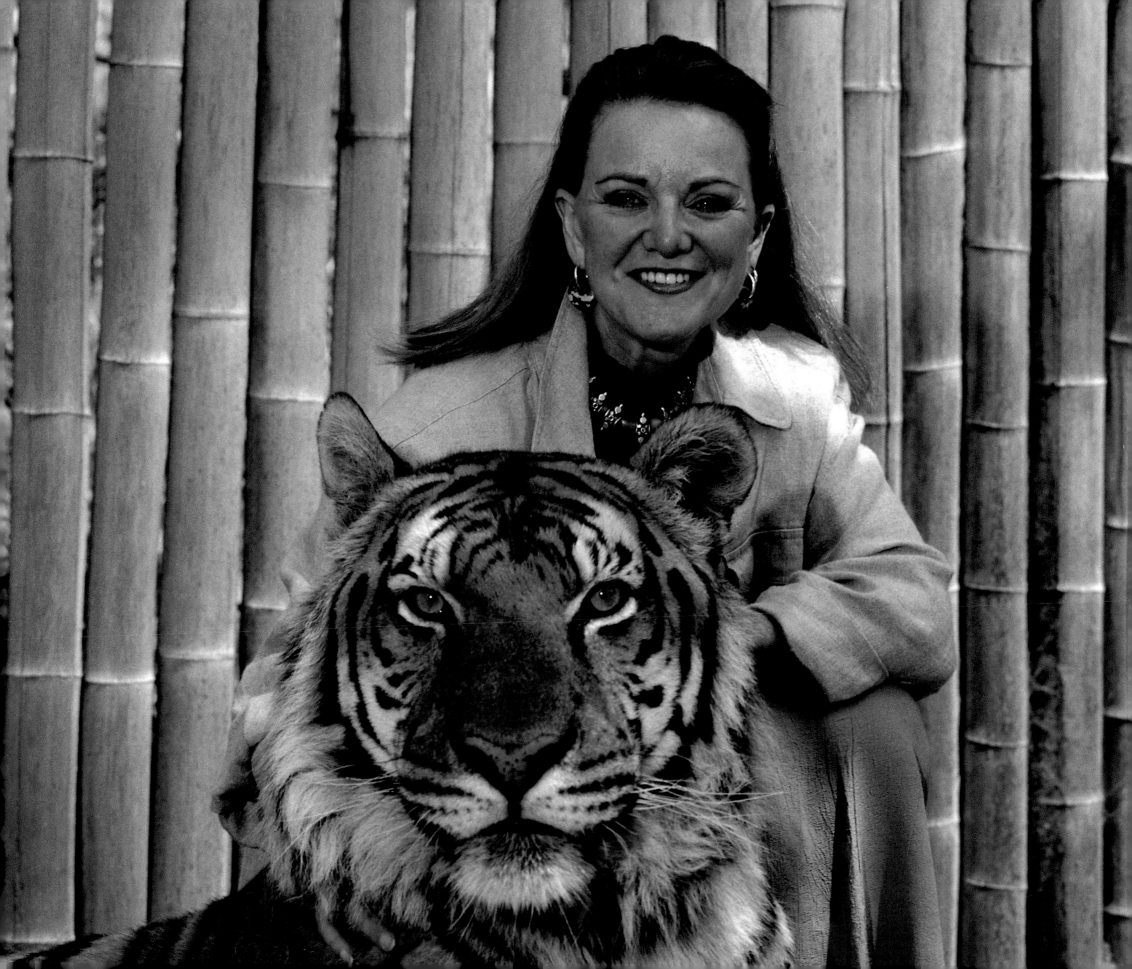

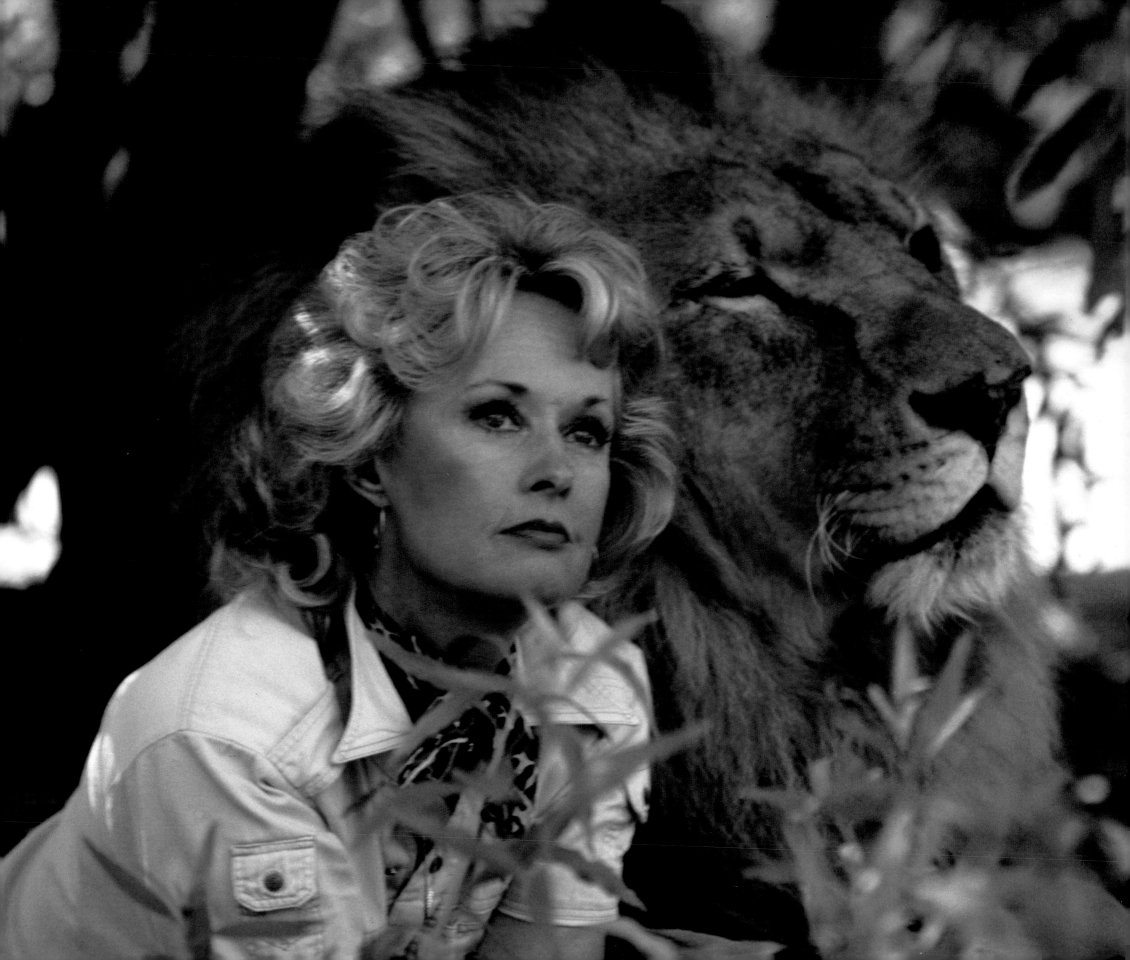

Laurel and Tippi playing with Buster the leopard at Shambala, 1983.

Tippi Hedren with her African lion, Star, 1983.

O ne of my most treasured friends is film actress Tippi Hedren. Her love for exotic big cats—and her commitment to their well-being and protection—inspired Tippi to create a sanctuary in 1972 for those born in captivity throughout the United States.

All of the animals at Shambala Preserve depend upon humans for their needs and protection. None of them have ever been in the wild. Many of these beautiful creatures were orphans, cast-offs from circuses, zoos, and private owners who could not care for them.

My first visit to Shambala (Sanskrit for "a meeting place of peace and harmony for all beings, animal and human") was in 1983—and I fell in love with Buster. Supremely elegant one moment, a giant playful kitten the next, this exquisite leopard opened my heart and soul to the spirit of big cats.

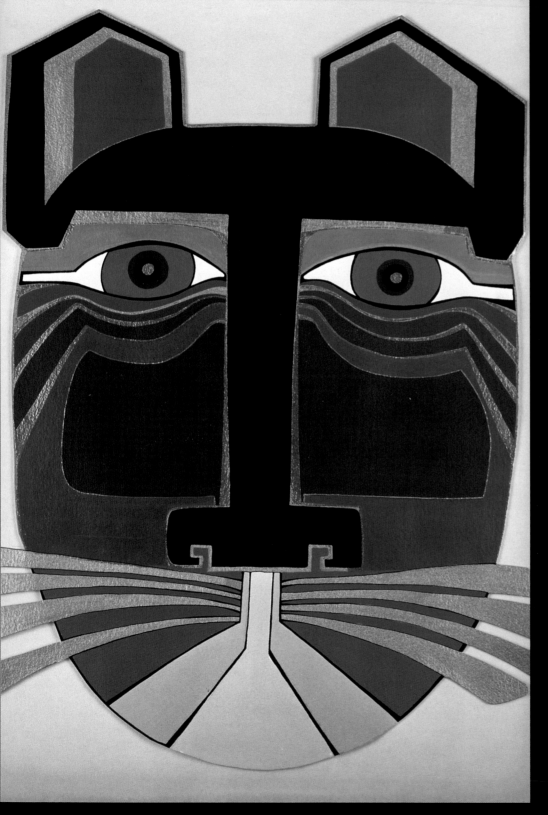

Miikio, *1986.*

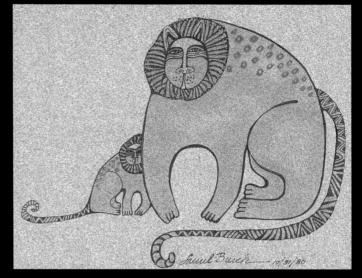

Harlequin Cats, *1980.*

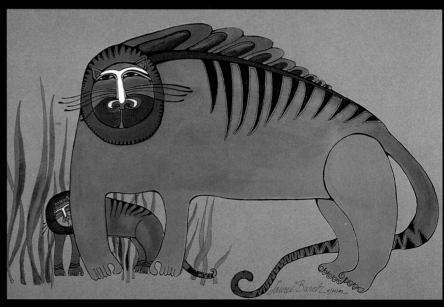

Mythical Tiger and Baby, *1980.*

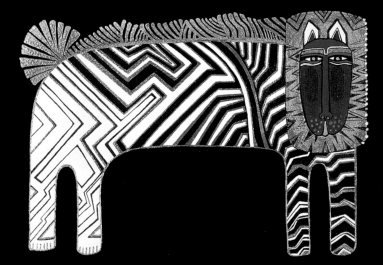

Zebracat, *1986*.

MYSTERIOUS,
MAGICAL,
MYTHICAL
CATS

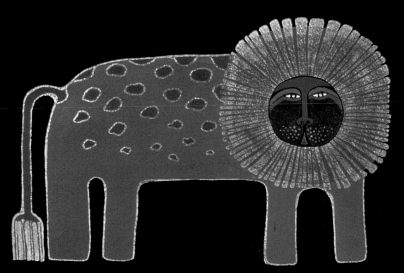

Leonardo, *1986*.

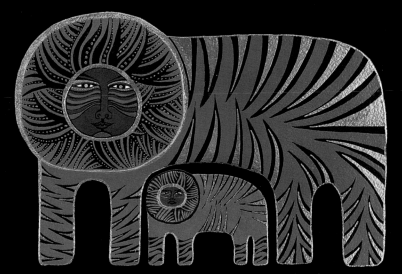

Los Tigres, *1986*.

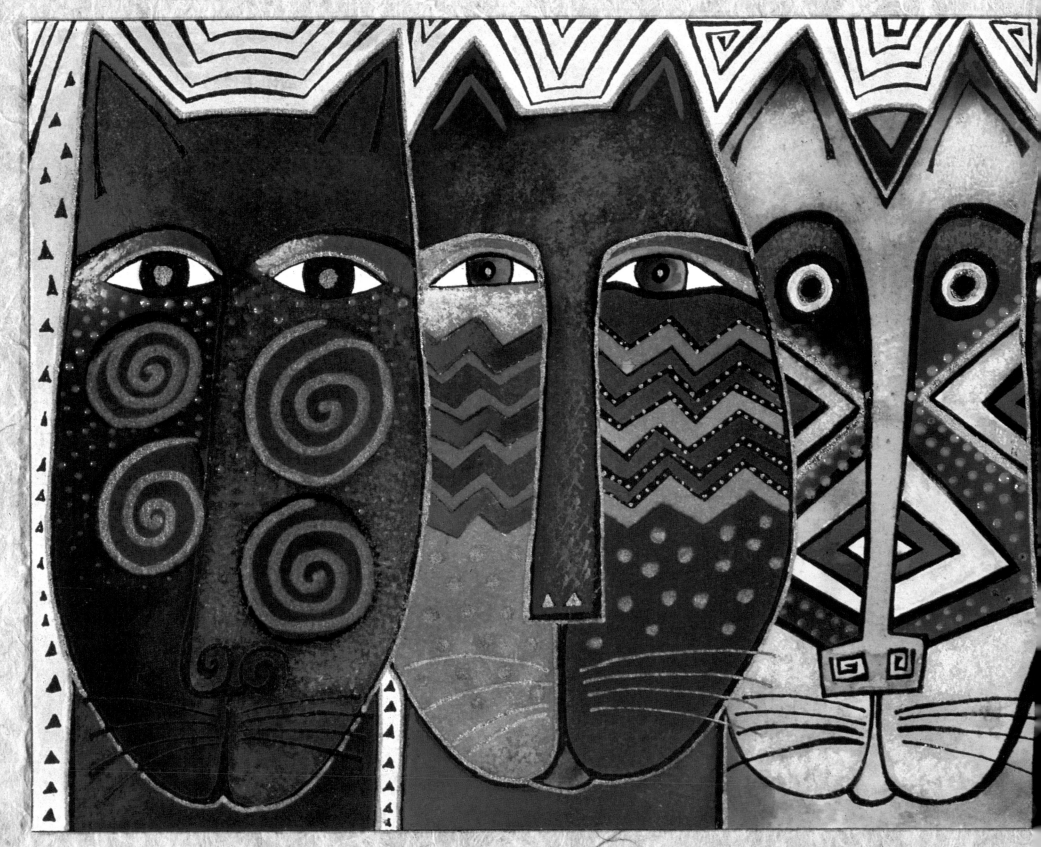

Wildcats, 1996.

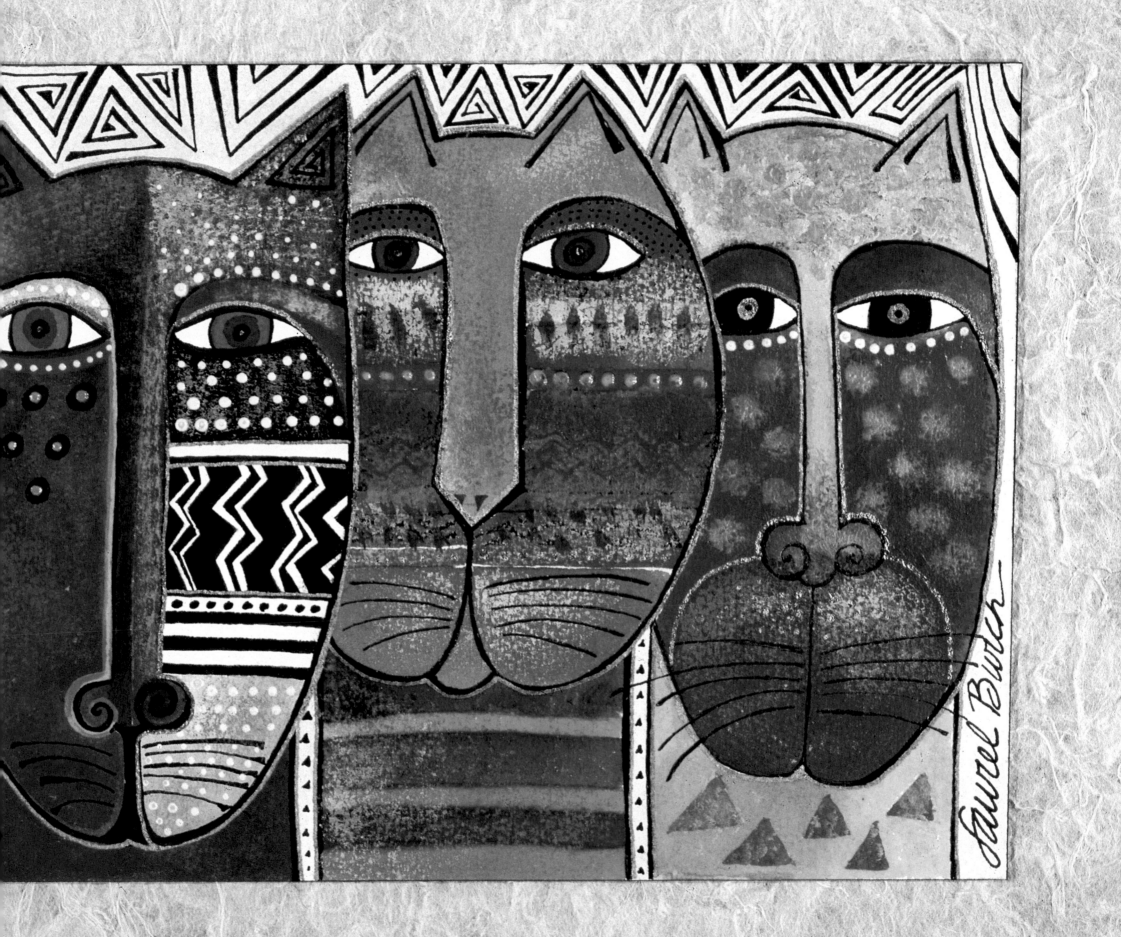

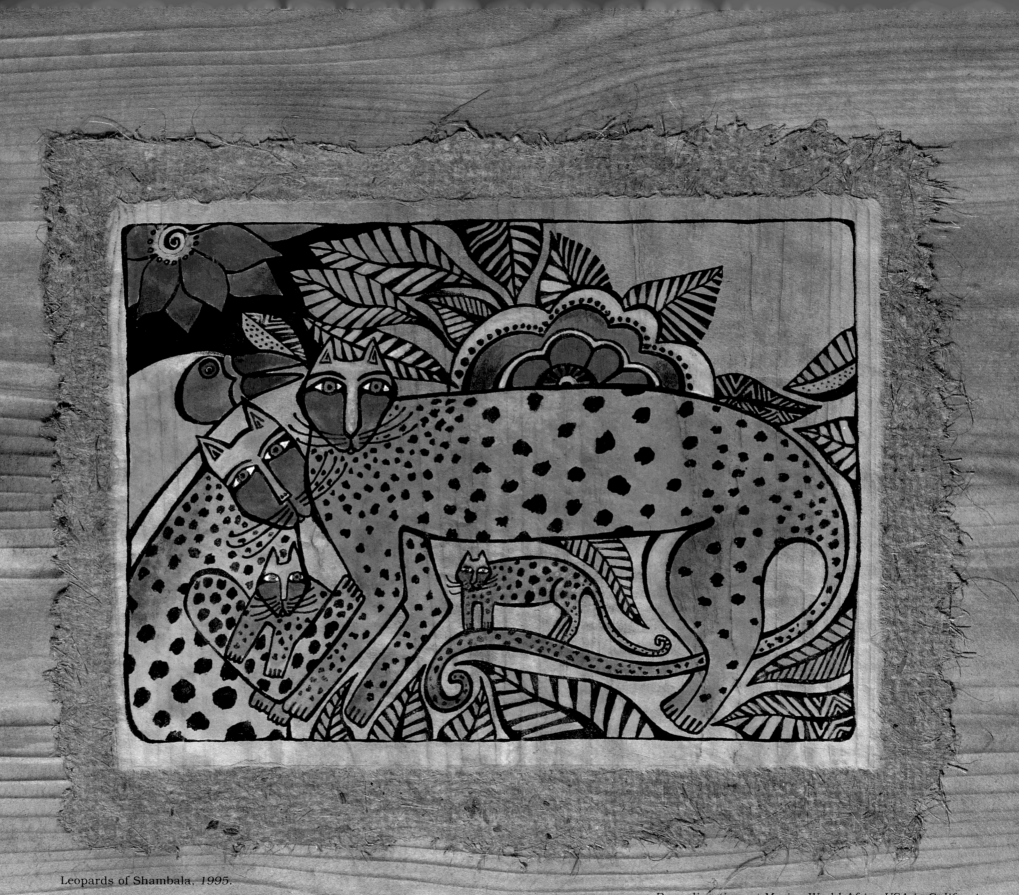

Leopards of Shambala, *1995.*

Bengali, a tiger at Marine World Africa USA in California,
was just eight weeks old when she stole Laurel's heart away, spring 1996.

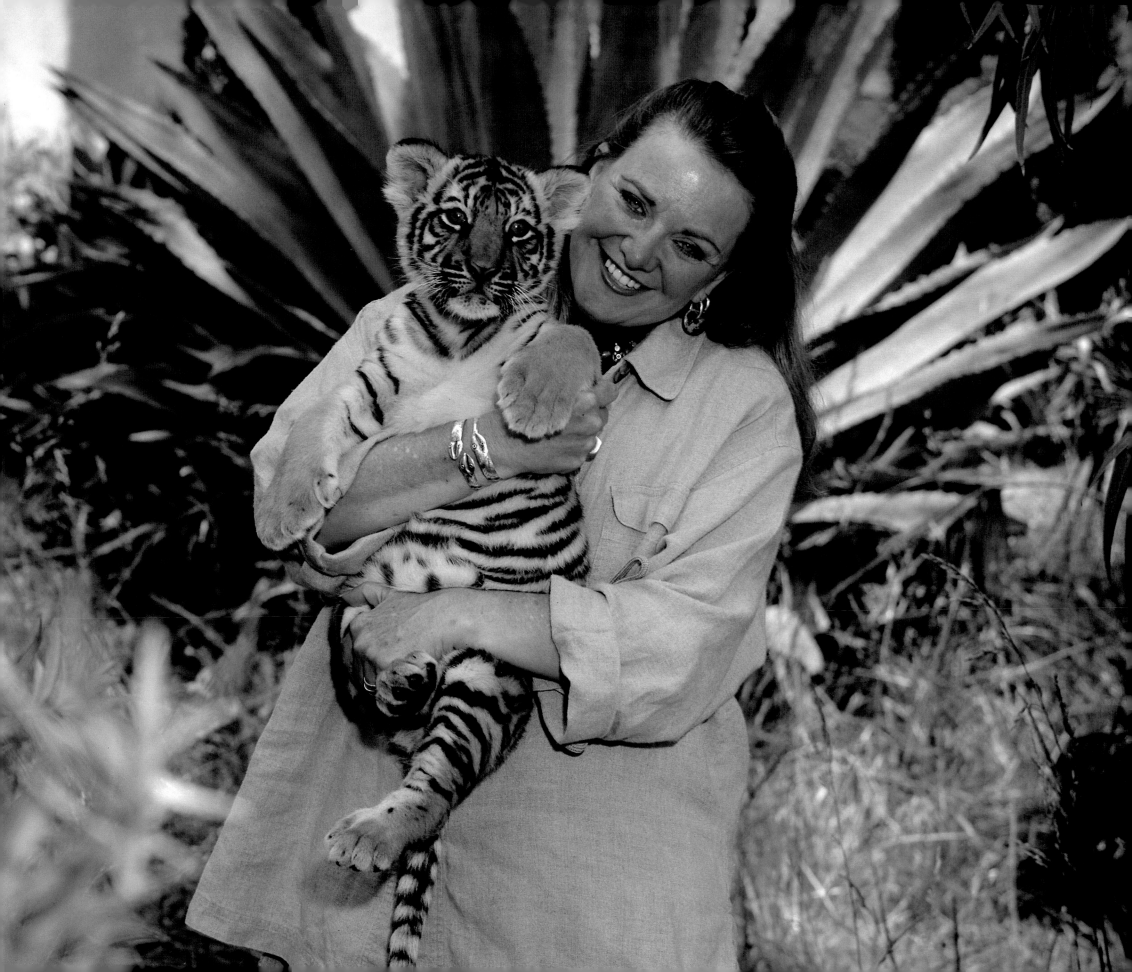

Fantasticats

LOOK AT ME, LOOK AT ME,

WHAT DO YOU SEE?

WHISKERS GOLD AND PATTERNS BOLD

AND EYES THAT DANCE WITH LIGHT.

MYSTIC CREATURE OLD AND NEW,

WHO ARE YOU?

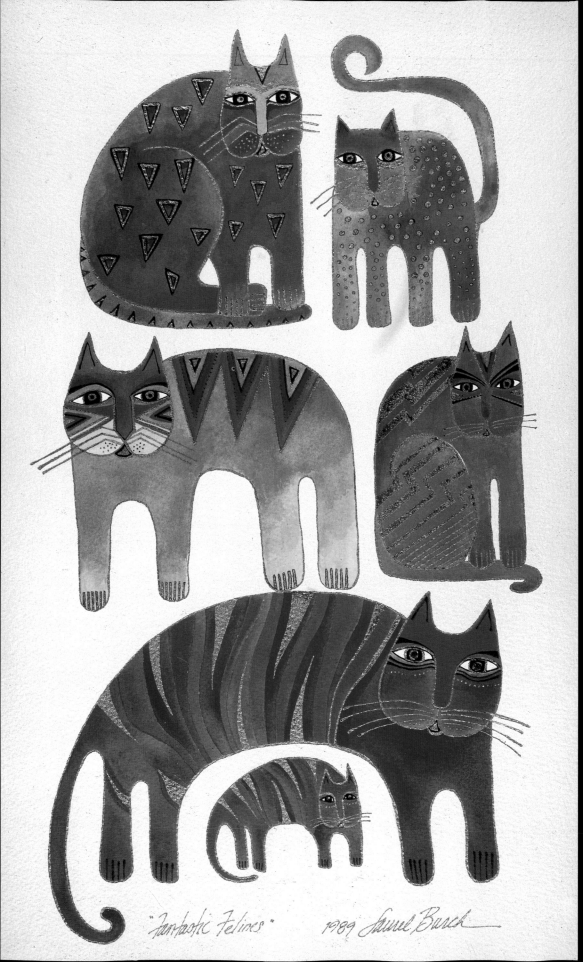

"Fantastic Felines" 1989 *Laurel Burch*

The first time a cat appeared on my drawing paper, I was quite surprised. I did not own a cat, had never owned a cat, and did not even dream of owning a cat. Why, then, did this brightly colored, free-spirited creature creep into my imagination? It took me years to answer that question.

Looking back, I remember the sheer *delight* I felt when, in the midst of creating an array of earthen-colored animals—mysterious birds, and otherworldly people— I reached for a clean white piece of paper and began painting a cat, sitting on a red flowered chair.

"Who are you?" I asked.

"Your friend!" was the answer.

And so he was.

Right when I needed one.

Life had been serious, and I was busy searching my soul. I wanted my art to be profound and meaningful, not silly and insignificant.

"Phooey!" said this sassy cat, perched on the red flowered chair. "It's time to play. Get out some brighter colors, and LIGHTEN UP!"

Well, that was the beginning. As each Fantastic Feline arrived on paper through the tip of my pencil, their wit, whiskers, and whimsy taught me my first lessons about the lighter side of beings.

As a result of their riotous entrance into my otherwise serious life, I realized the joys and values of being reminded to play, to paint a chair red and sit in it to dream.

Most wonderful of all—I realized my new-found friends could be the messengers of bright spirit and joy, as no one else could.

Come and meet some of them . . .

Fantastic Felines, *1984.*

Flamenco Cat, *1988.*

Crimson Cat, *1996.*

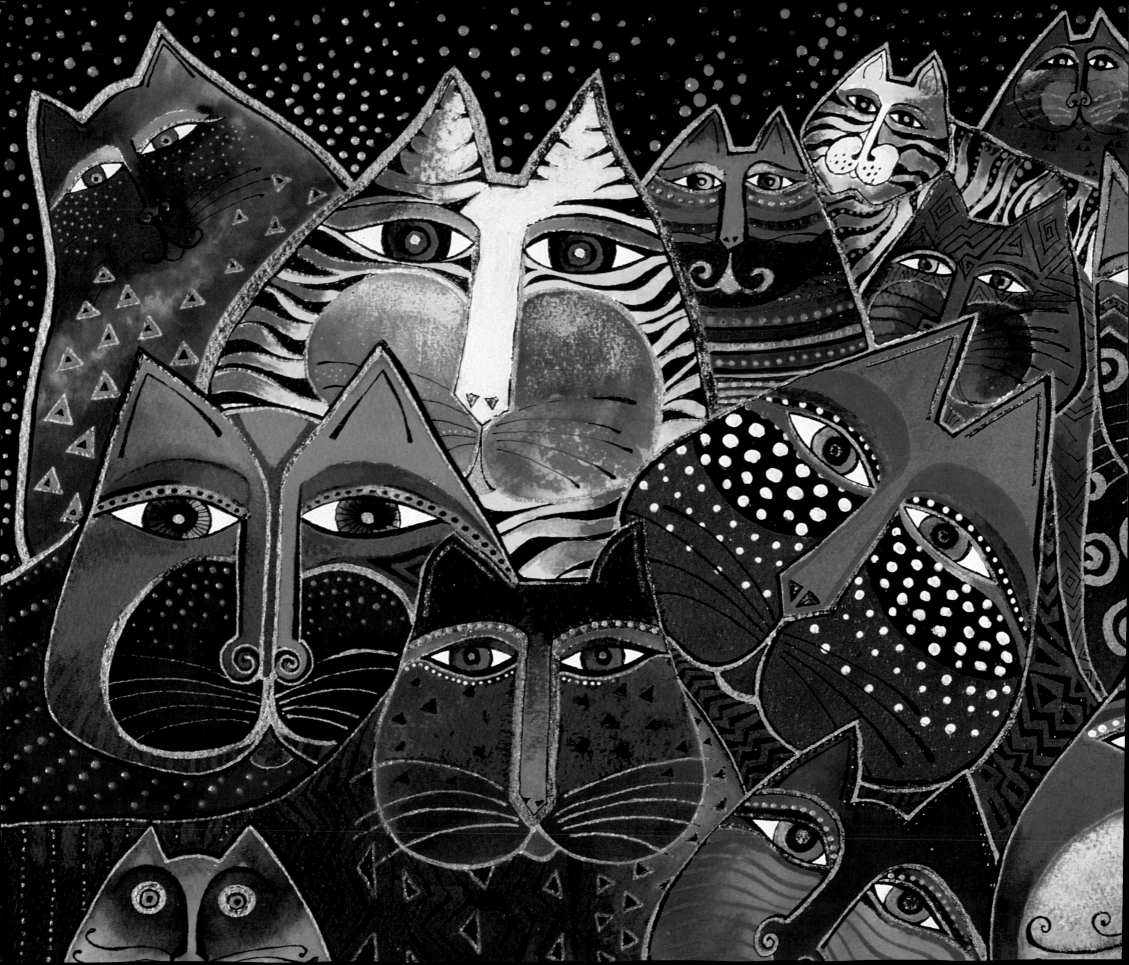

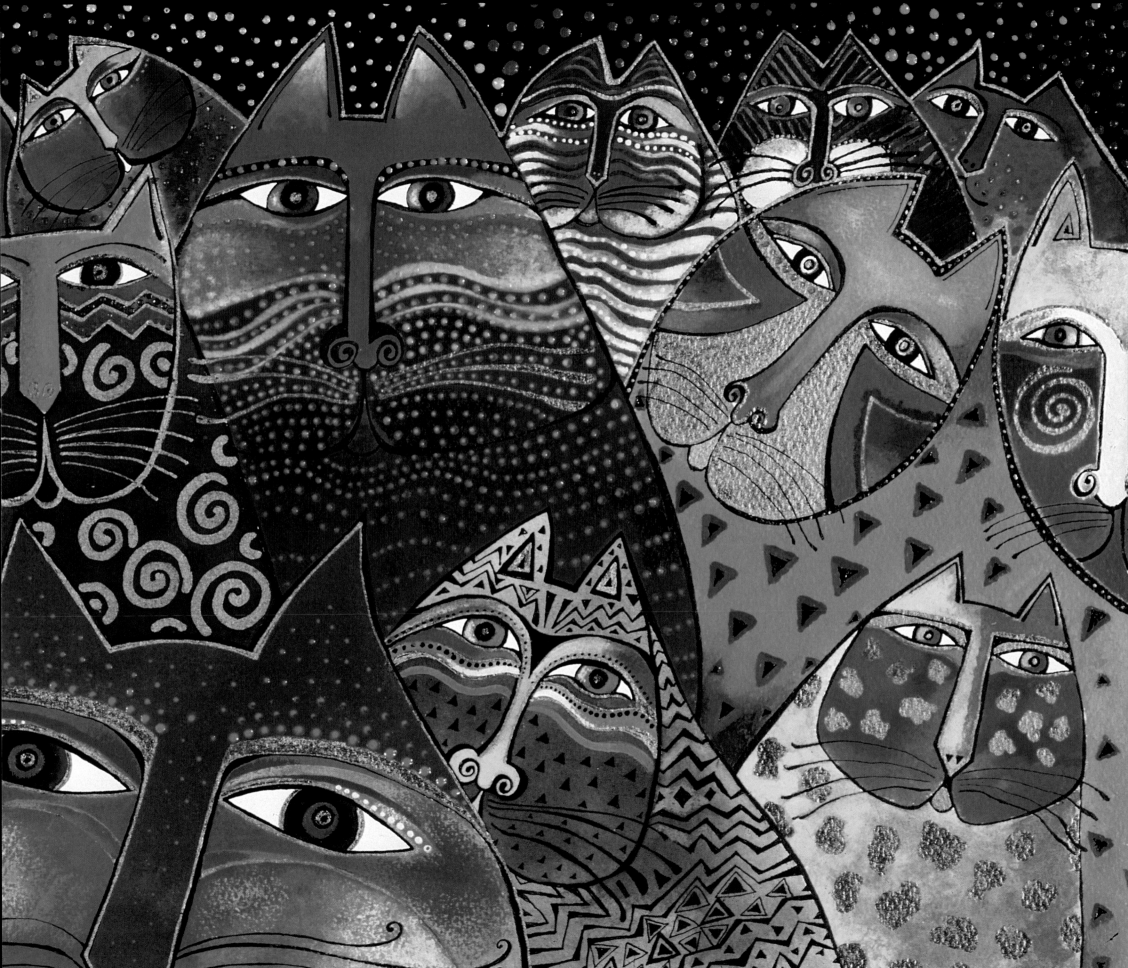

SANTA FE FELINES

I SEE YOU, I HEAR YOU, I KNOW YOU
AS MY TRIBE

THE YOUNGSTERS, THE ELDERS,
THE MOTHERS AND SONS,
THE DAUGHTERS AND GRANDFATHERS.

SPIRITS OF THE EARTH AND SKY
WRAP US IN WOVEN WINDSTARS
AND RAINBOW BLANKETS

COMMON THREADS
BIND US TOGETHER, AS ONE

I FEEL MY TRIBE, I KNOW MY TRIBE,
I HEAR THE ANCIENT VOICES OF MY TRIBE.

Santa Fe Felines, *1995.*

Previous pages: Fantasticats, *1996.*

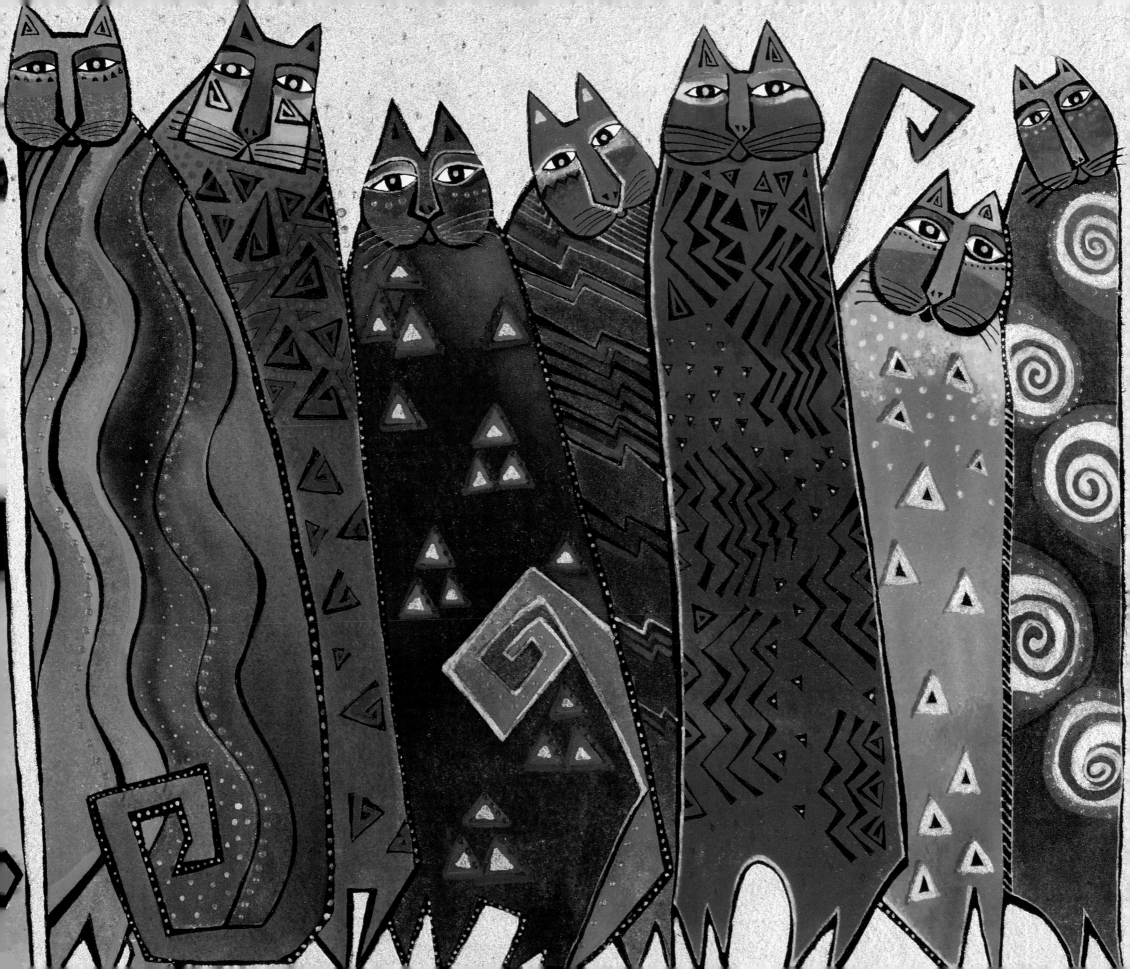

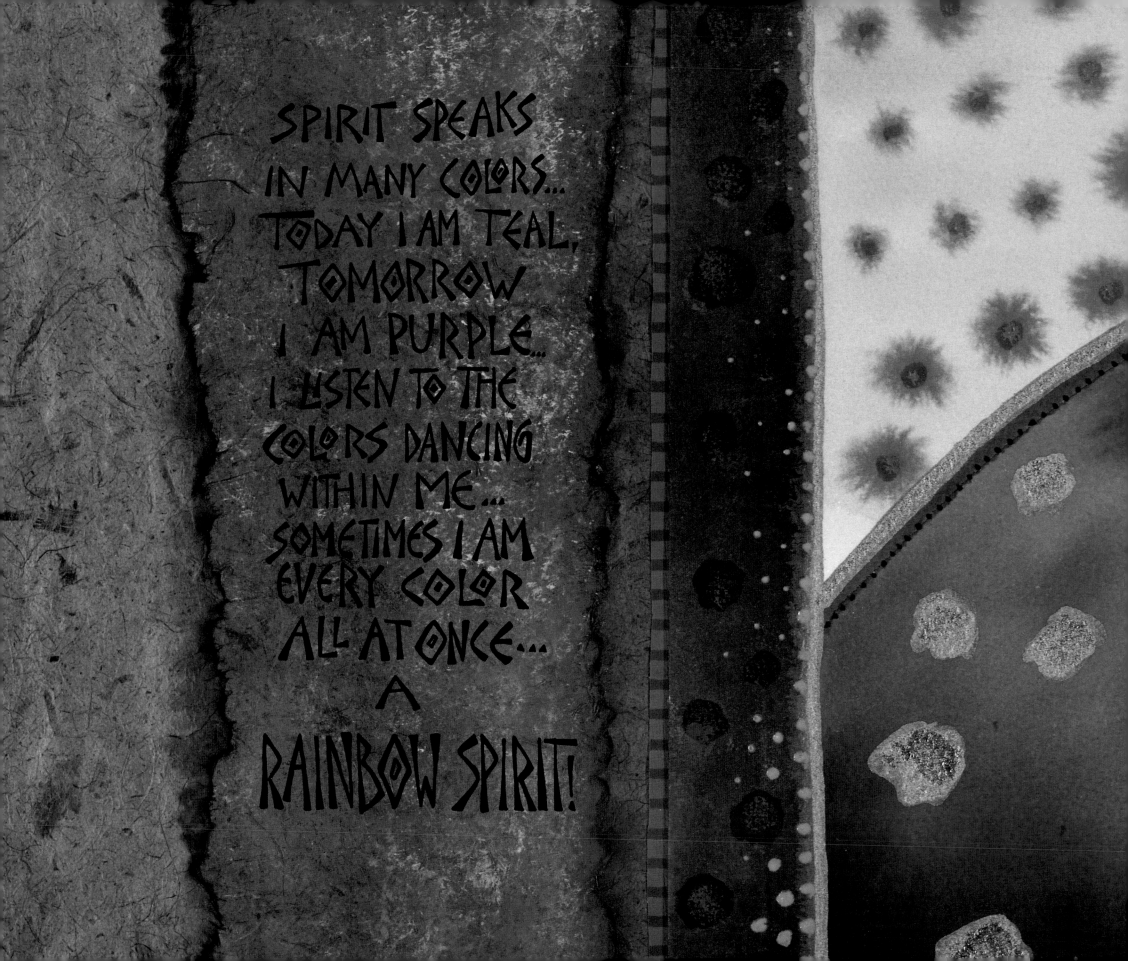

SPIRIT SPEAKS
IN MANY COLORS...
TODAY I AM TEAL,
TOMORROW
I AM PURPLE...
I LISTEN TO THE
COLORS DANCING
WITHIN ME...
SOMETIMES I AM
EVERY COLOR
ALL AT ONCE...
A
RAINBOW SPIRIT!

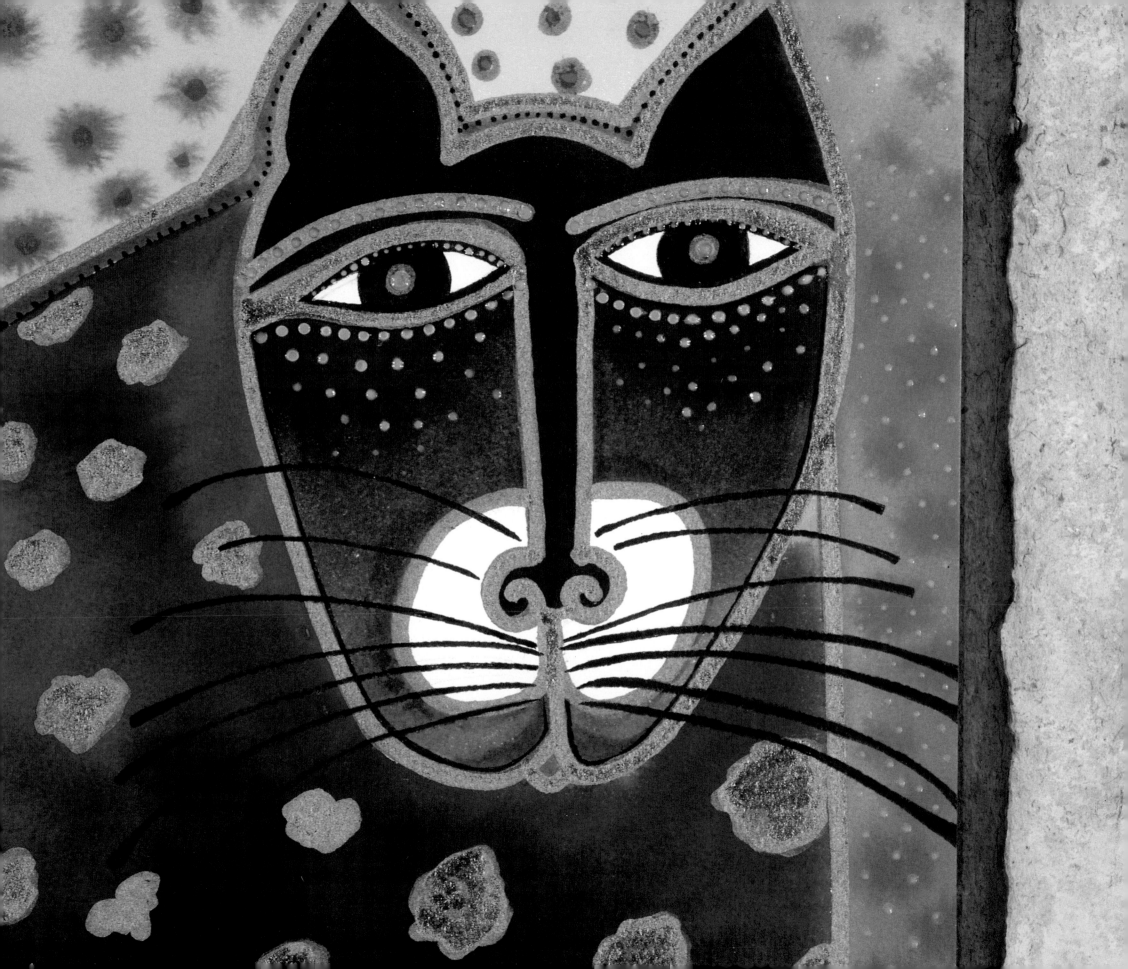

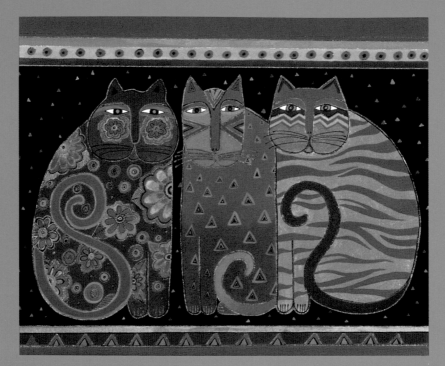

Feline Femmes Fatales, *1993.*

Previous pages: Azul, *1996.*

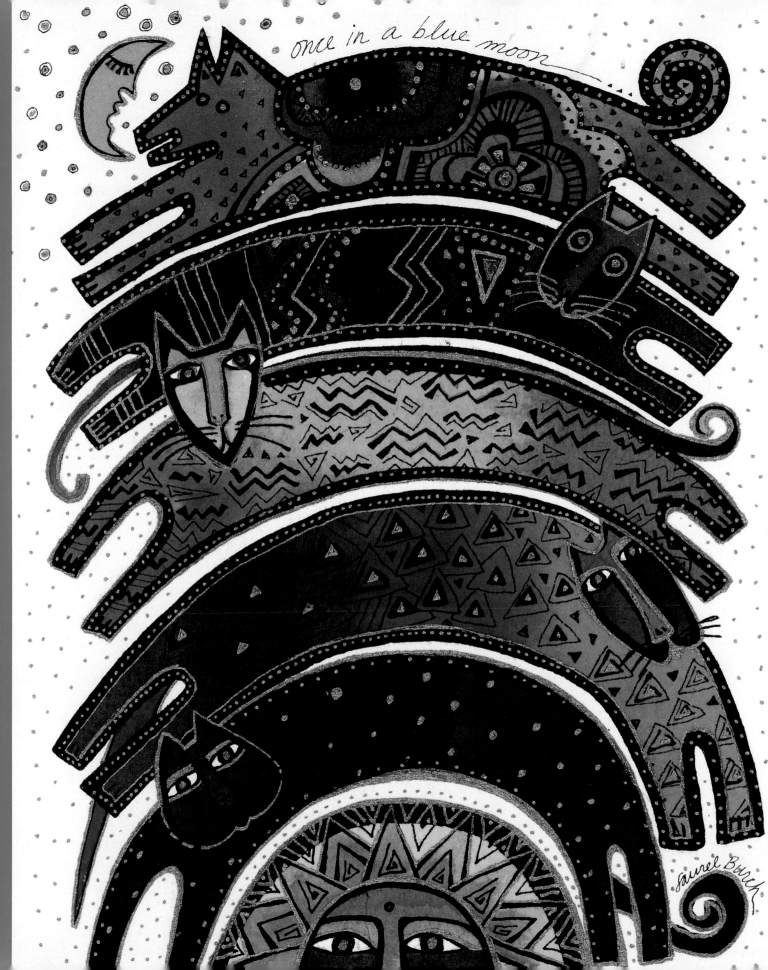

we can
thank our
lucky
stars
when
once in a
blue moon
we find
rare and
kindred
souls
along the
pathways
of
our
Lives
◎

Once in a Blue Moon, *1994.*

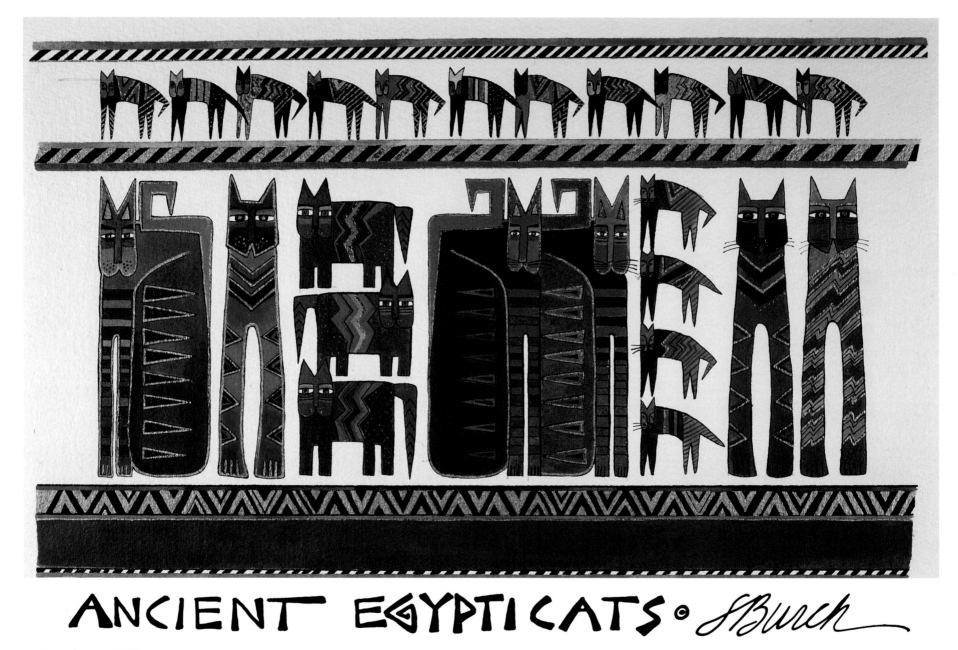

ANCIENT EGYPTICATS © *S Burch*

Egypticats, *1989.*

Opposite Page: Soulmates, *detail from* Egypticats.

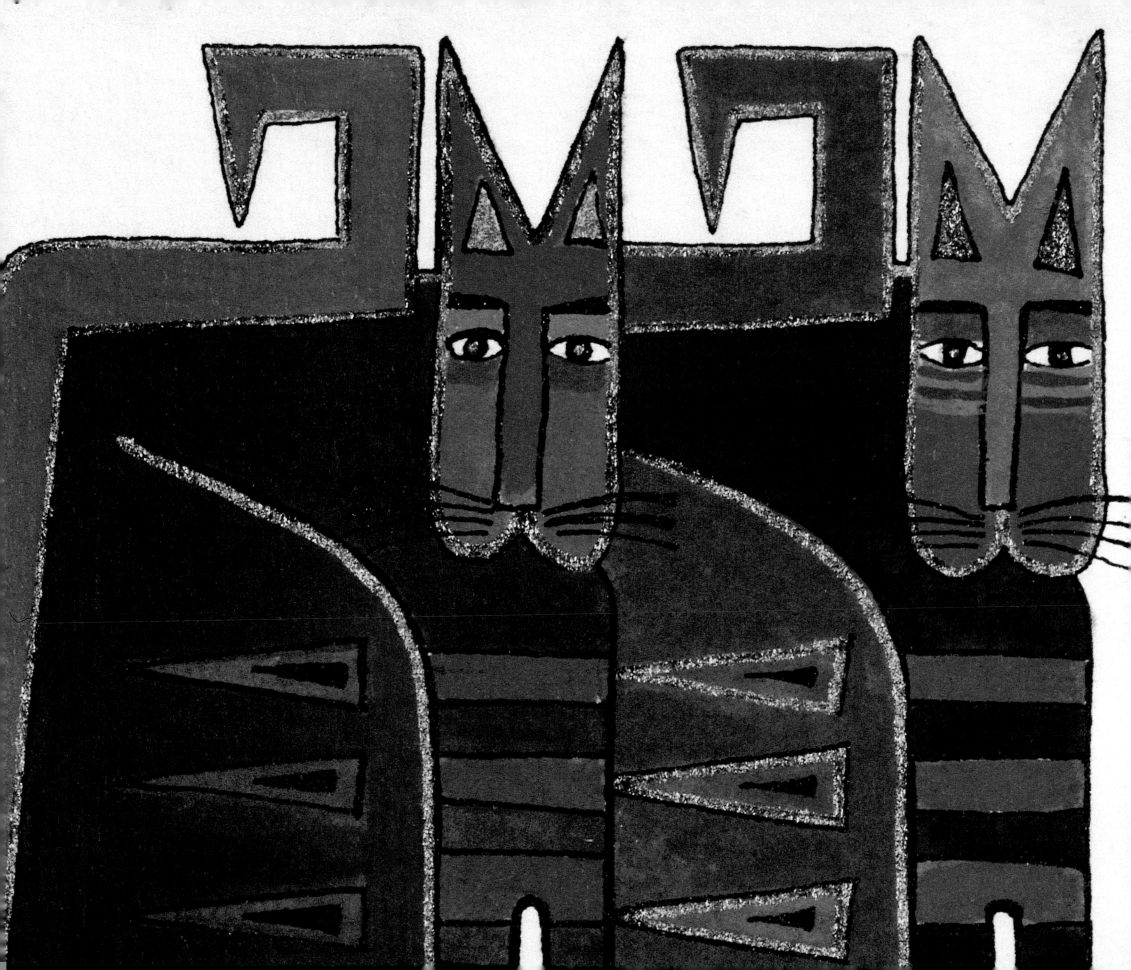

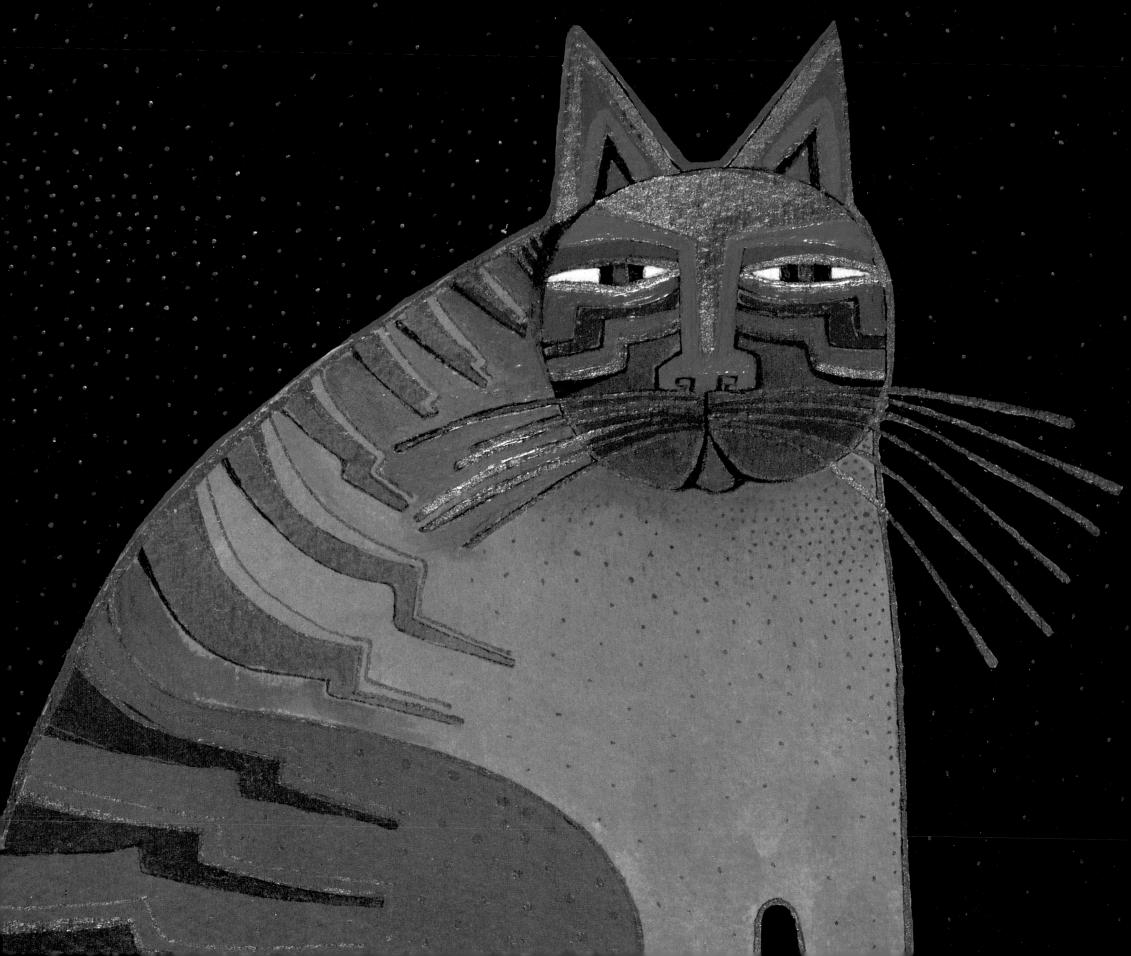

REACH FOR YOUR DREAMS...
FOLLOW YOUR
OWN
SPECIAL STAR...

THE MAGIC OF
THE COSMOS
IS WITHIN YOU...

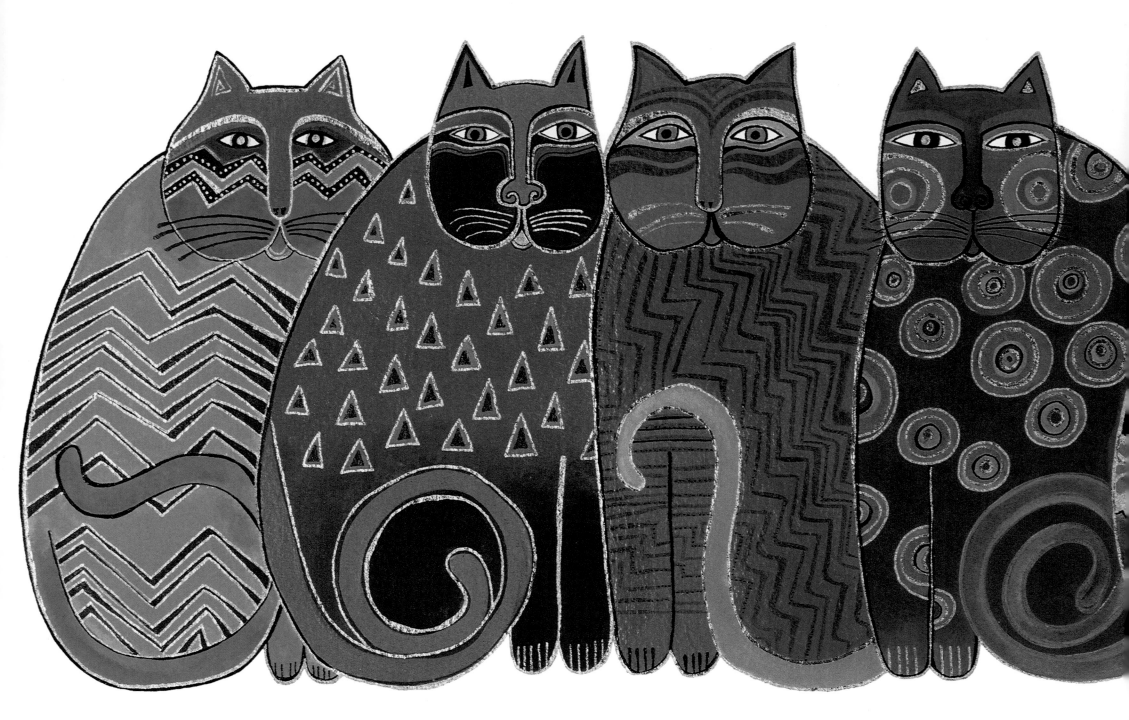

FELINE FAMILY PORTRAIT ● FANCIFUL, FESTIVE, FLIRTA

Feline Family Portrait, *1993*.

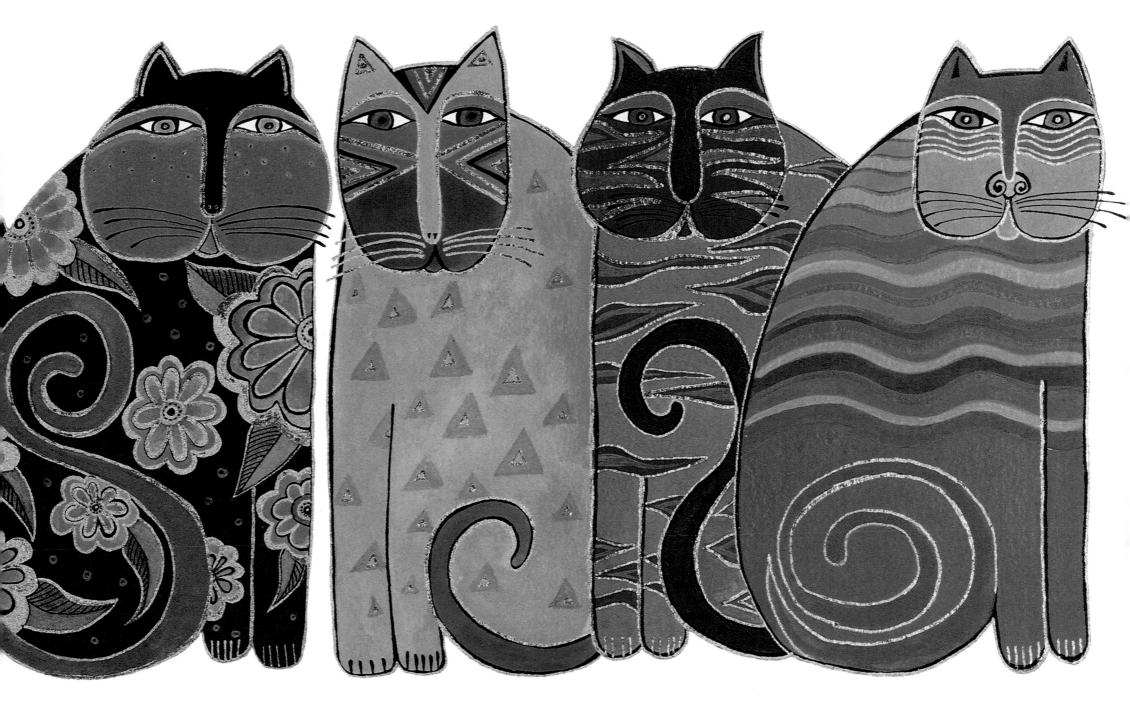

OUS, FANTASTIC, FABULOUS, FEMMES FATALES FELINES

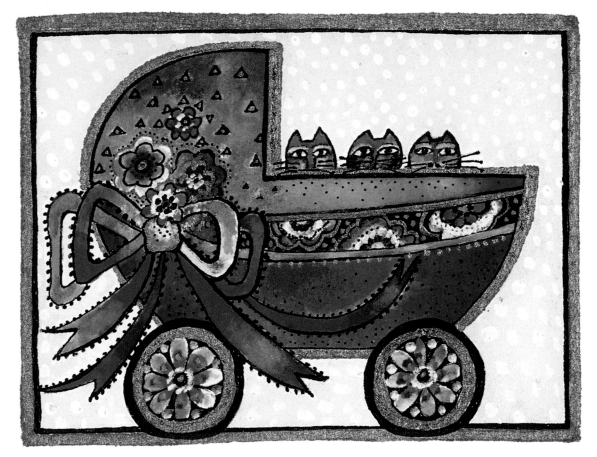

Kittens in a Carriage, *1995*.

New Beginnings...
we see a bright
and shining world
through the sparkling
eyes of babes!

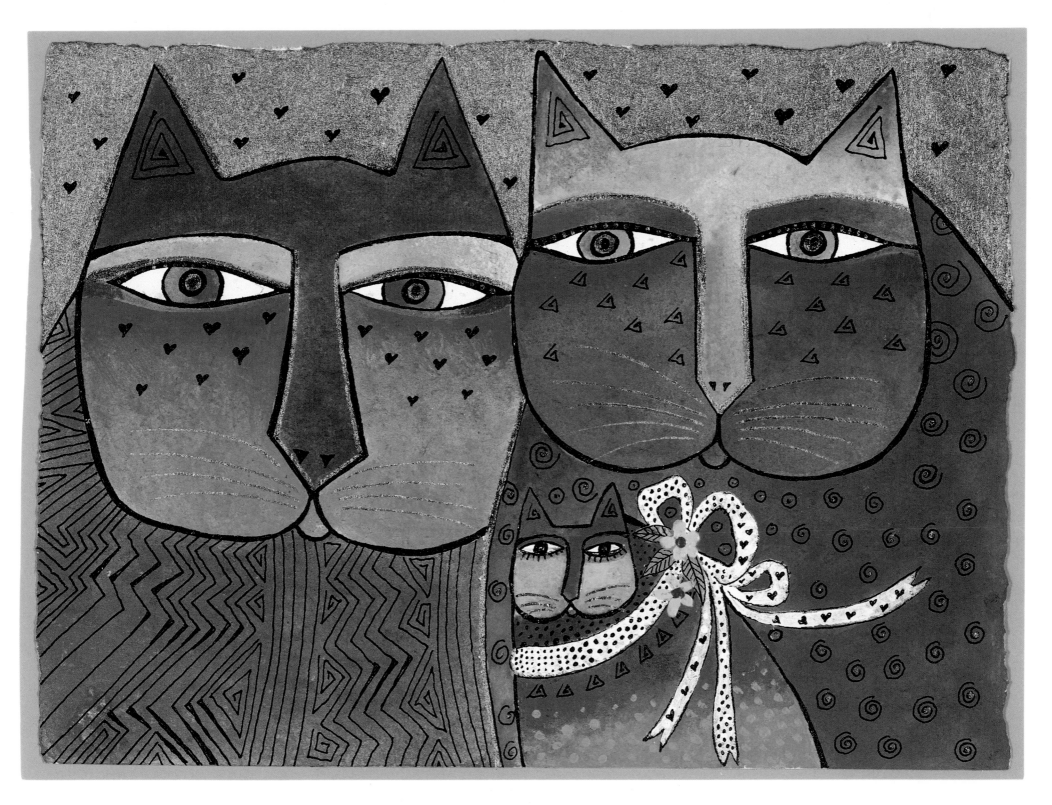

Feline Family, *1995.*

Folkloricats, *1995*.

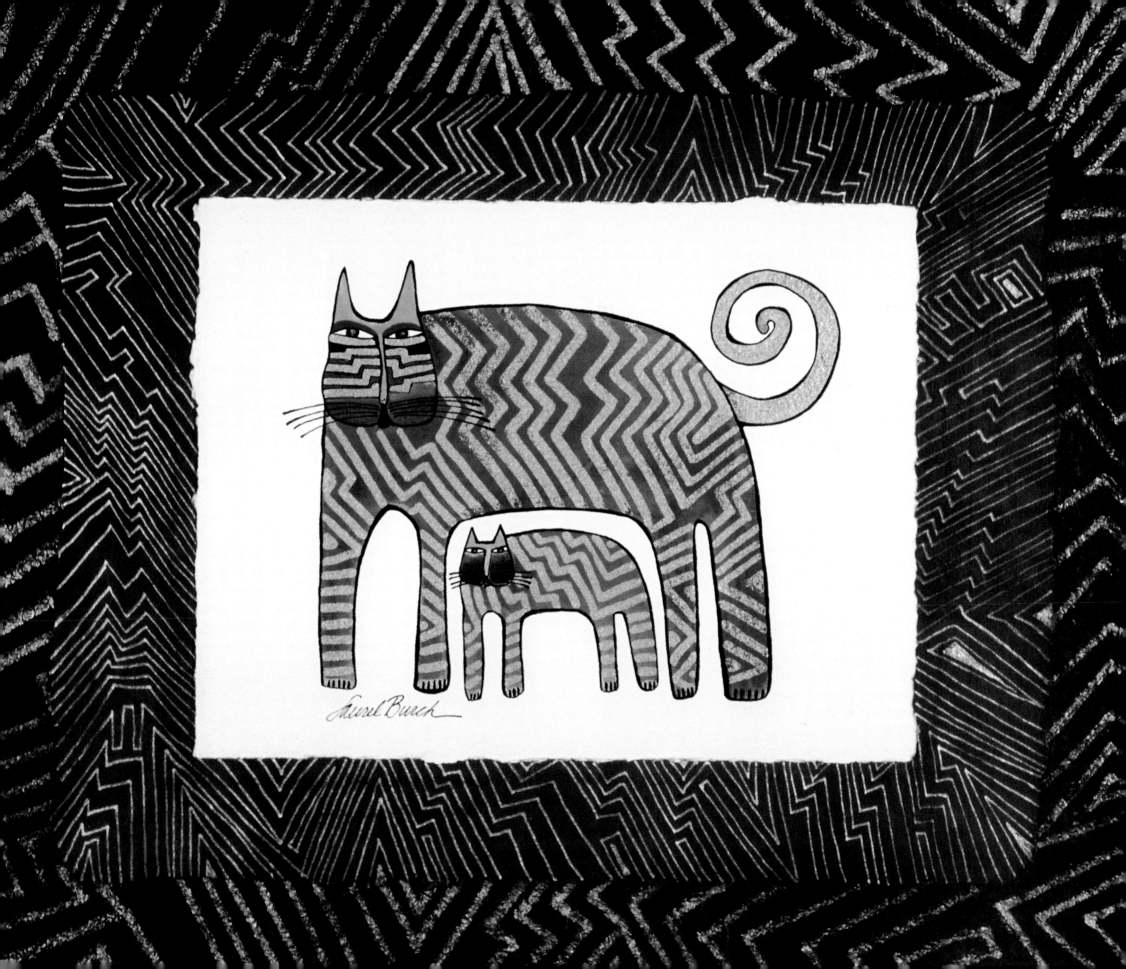

THERE IS A WONDERFUL PLACE
WHERE FLOWERS GROW IN COLORS
BEYOND THE WORDS OF POETS...
TREES SING WITH THE
SONGS OF BUTTERFLIES.
AND MYTHICAL TIGRESSES LOOK
AT YOU WITH FIERY GOLDEN EYES...
OPEN YOUR HEART
AND FEEL THE COLORS OF MAGIC
BLOOMING INSIDE YOU...

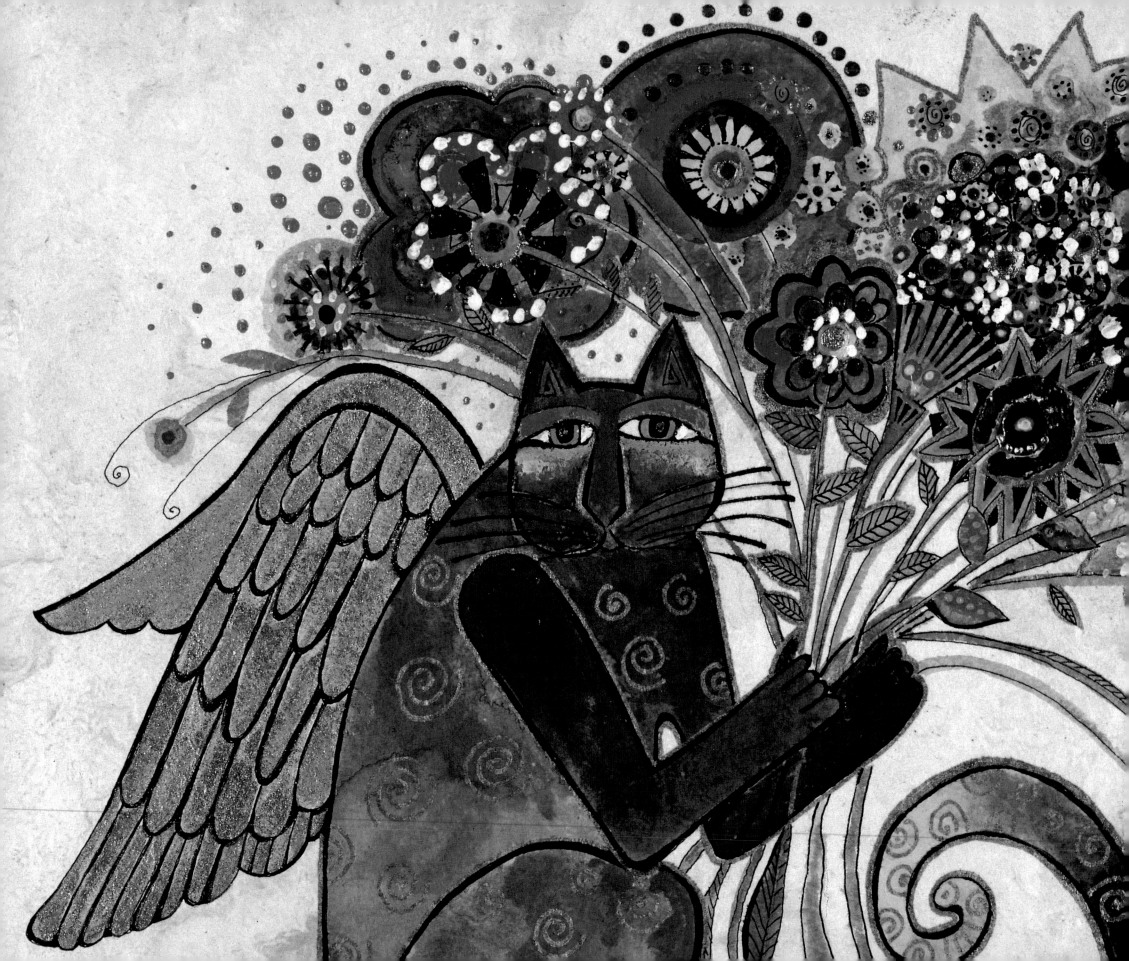

GATHER WILD FLOWERS, DRINK MOONLIGHT, THANK THE STARS, REMEMBER TO DREAM, TO LAUGH TO SING AND MOST OF ALL... PRETEND YOU HAVE WINGS, AND USE THEM.

Angel Cat, *1995.*

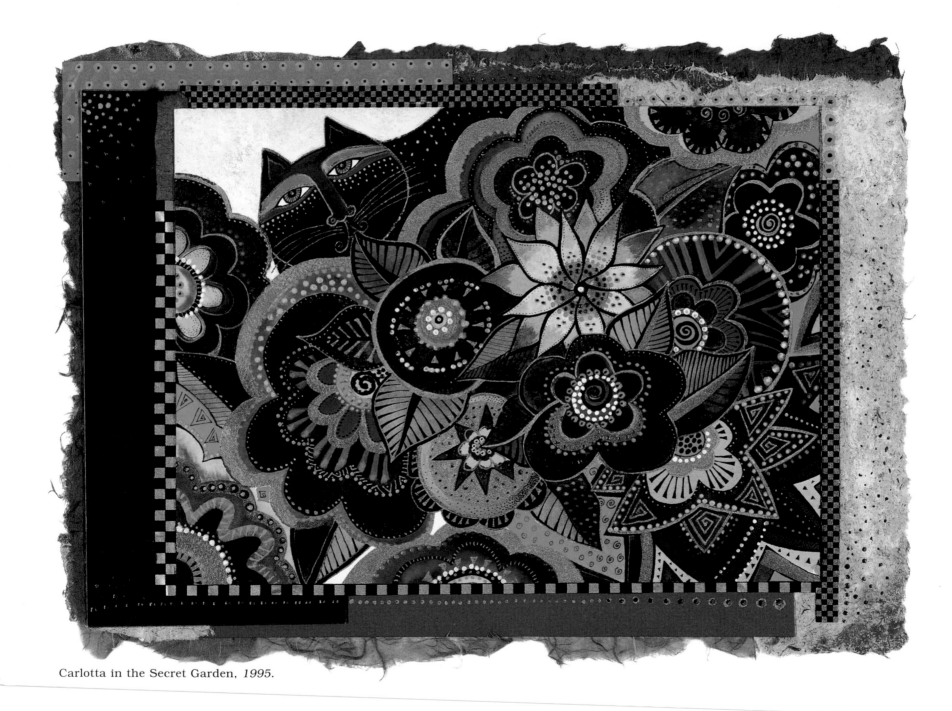

Carlotta in the Secret Garden, *1995*.

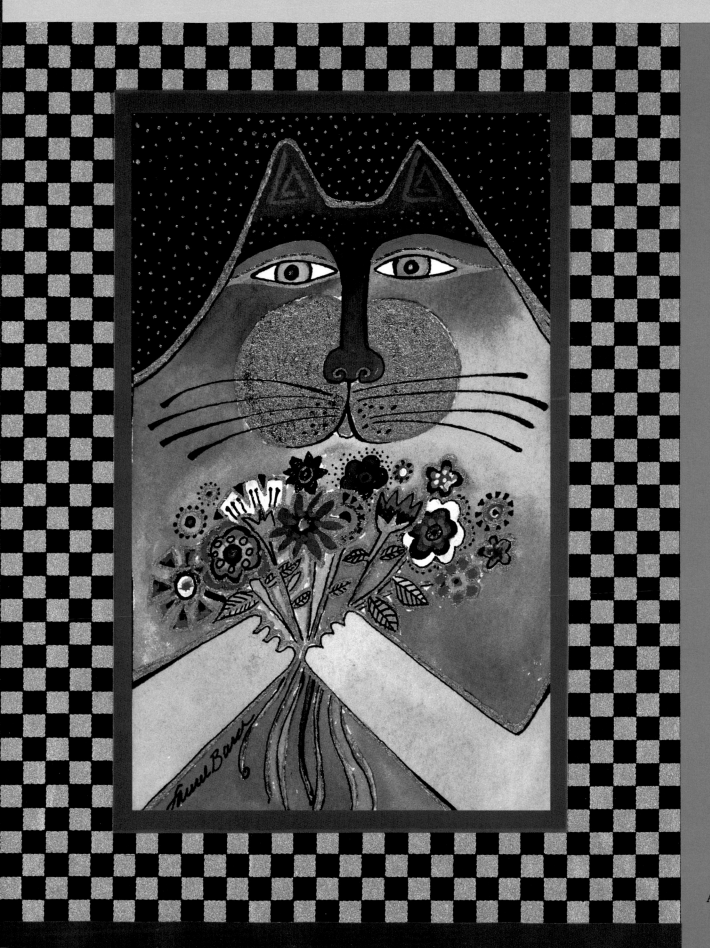

A Bunch of Love, *1995*.

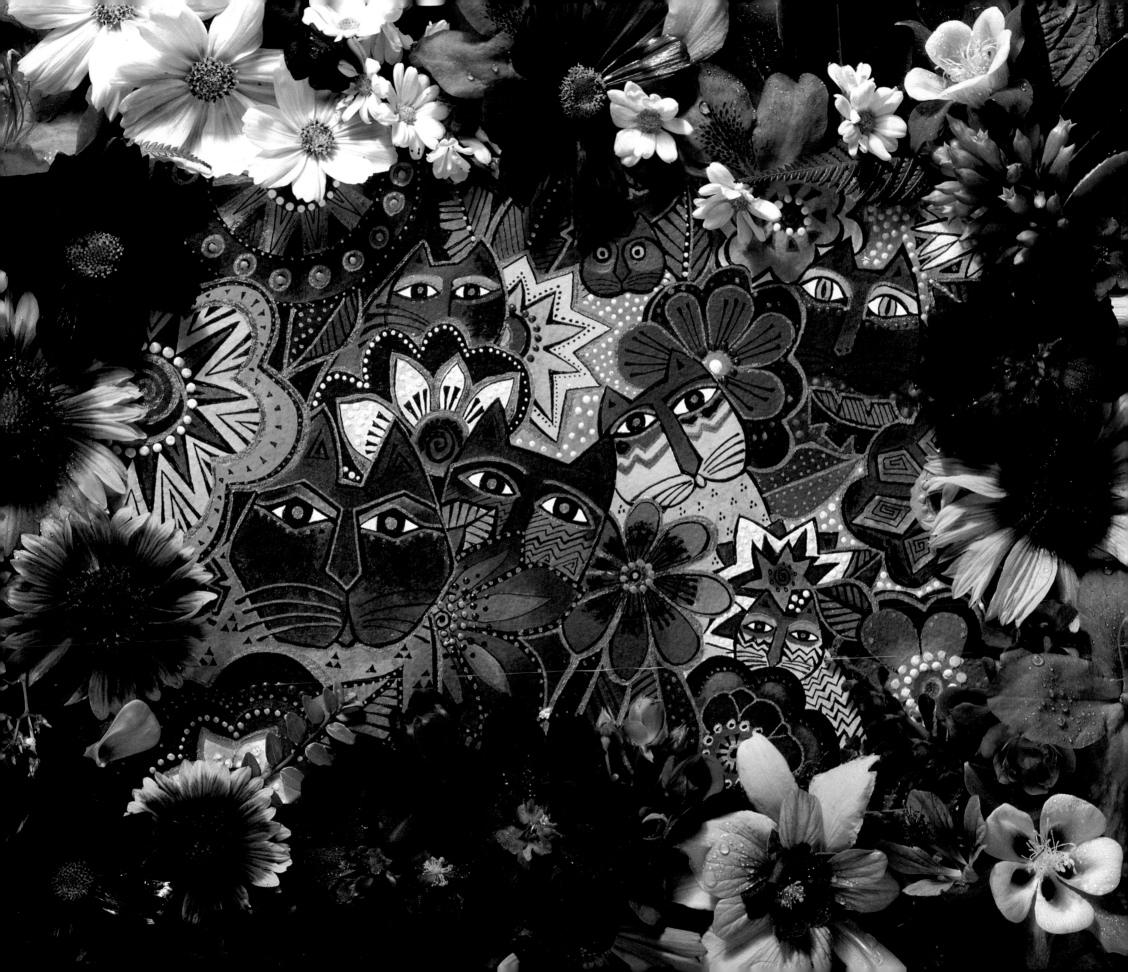

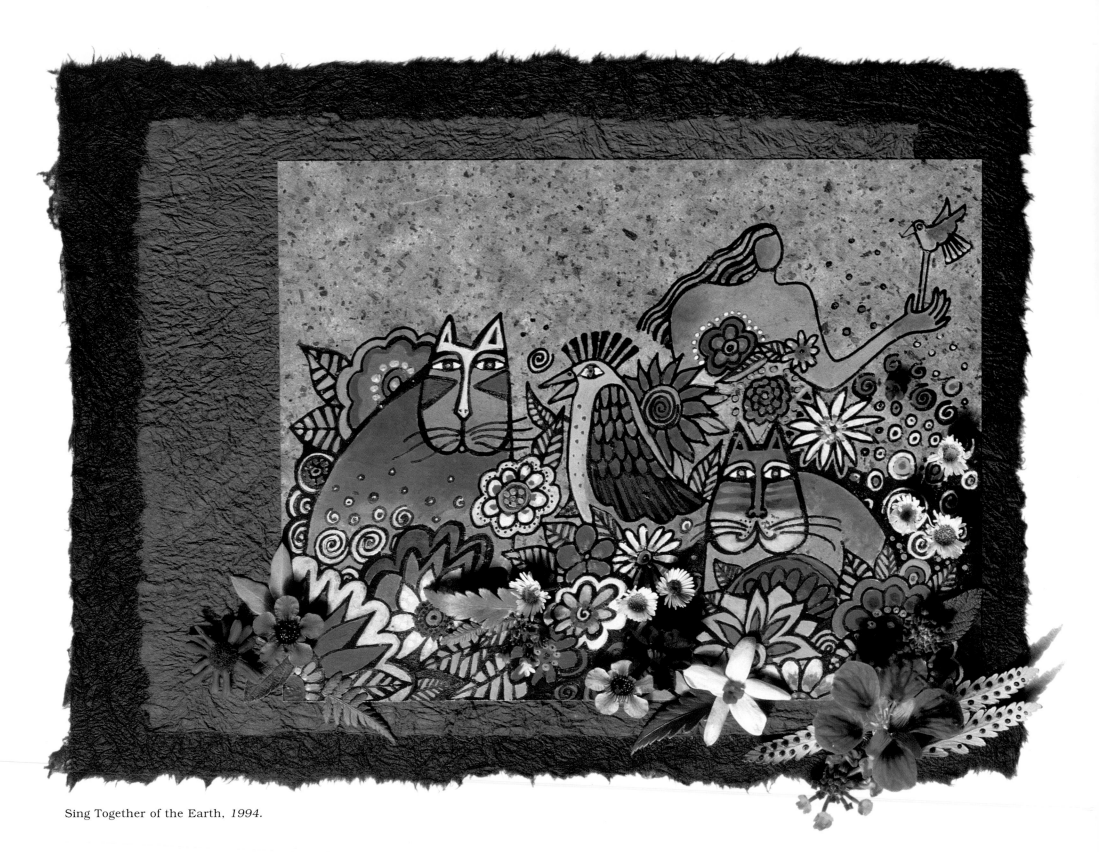

Sing Together of the Earth, *1994.*

Previous Page: Felines in the Flowers, *1994.*

DREAMLAND

let me take you to a land,
a land so far away, only dreams
can travel fast enough.
if you're ready to do that, to dream,
i'll take you there.
and once you're in the land,
i'll let you go so you may
find what you will.

you may hear the wind flowers growing.
dance with a rainbow cat,
or play with the birds of paradise...
who knows what will happen in this land.

but when you return, you will be full of songs
ready to sing, and full of magical stories to tell
if you are ready to do that,
to dream.
let me take you there...

May JOY fill YOUR HEART and SOUL

Botanical, paper and ink dot collage, 1994

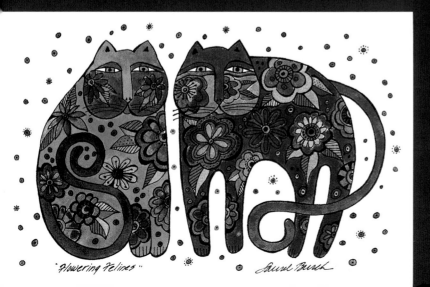

"Flowering Felines"

Laurel Burch

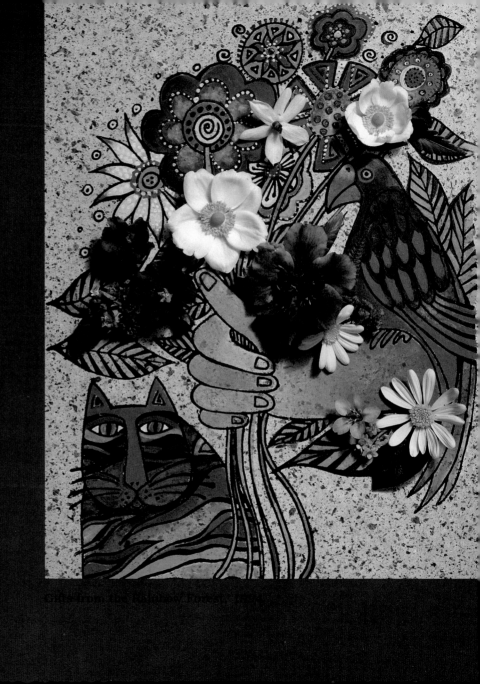

Gifts from the Rainbow Forest, 1994

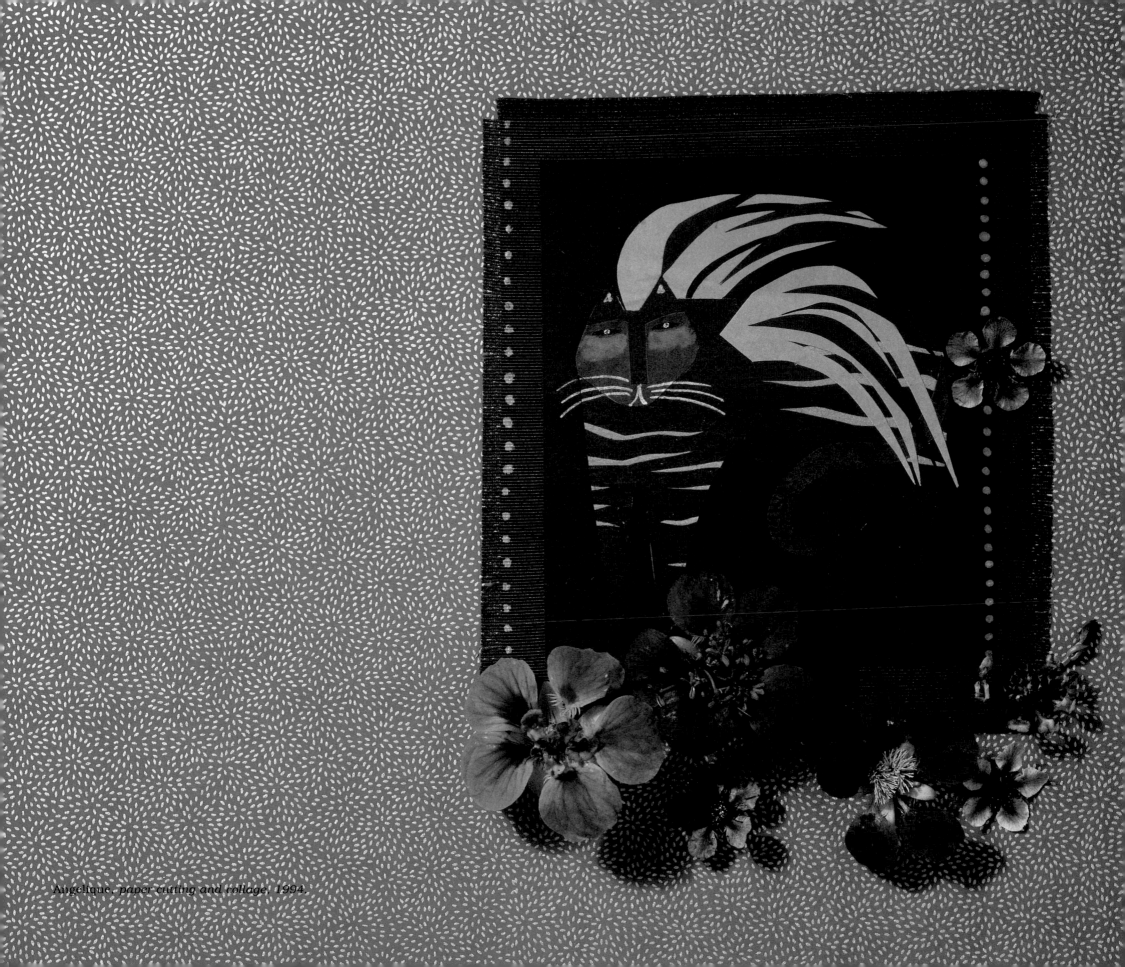

Angelique. *paper cutting and collage.* 1994.

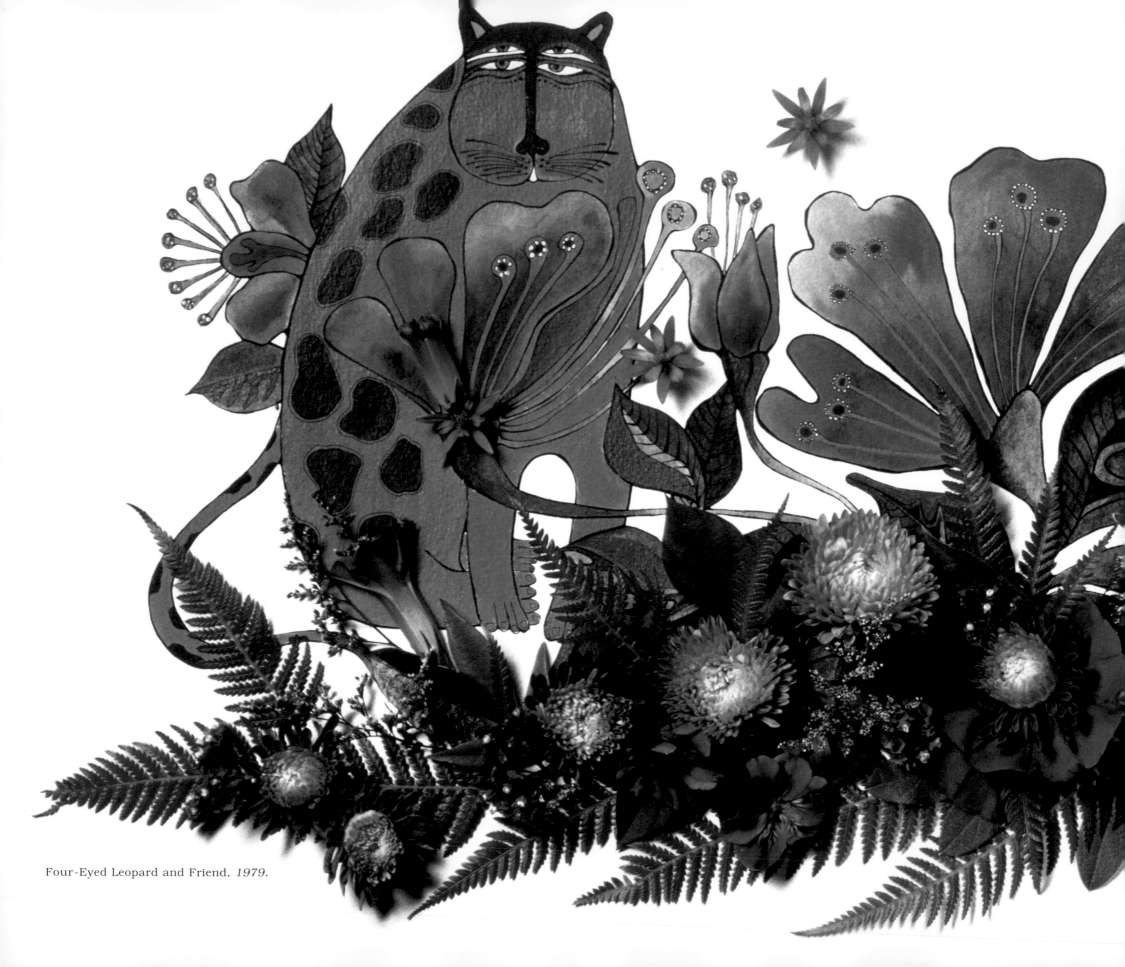

Four-Eyed Leopard and Friend, *1979.*

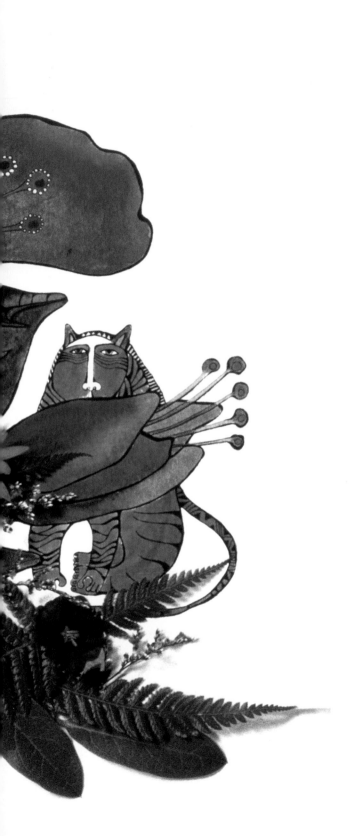

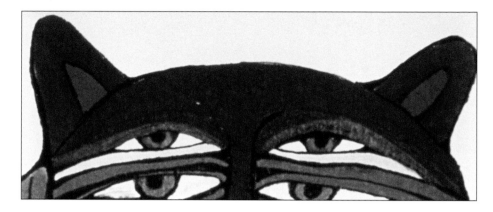

How the leopard got four eyes

Once a leopard came out
of a cave. He ate four apples
then he got four eyes.
The apples were magic.
Now the leopard can look
in all directions.

By Michal Yadegari
age 6

Valentina, *1996.*

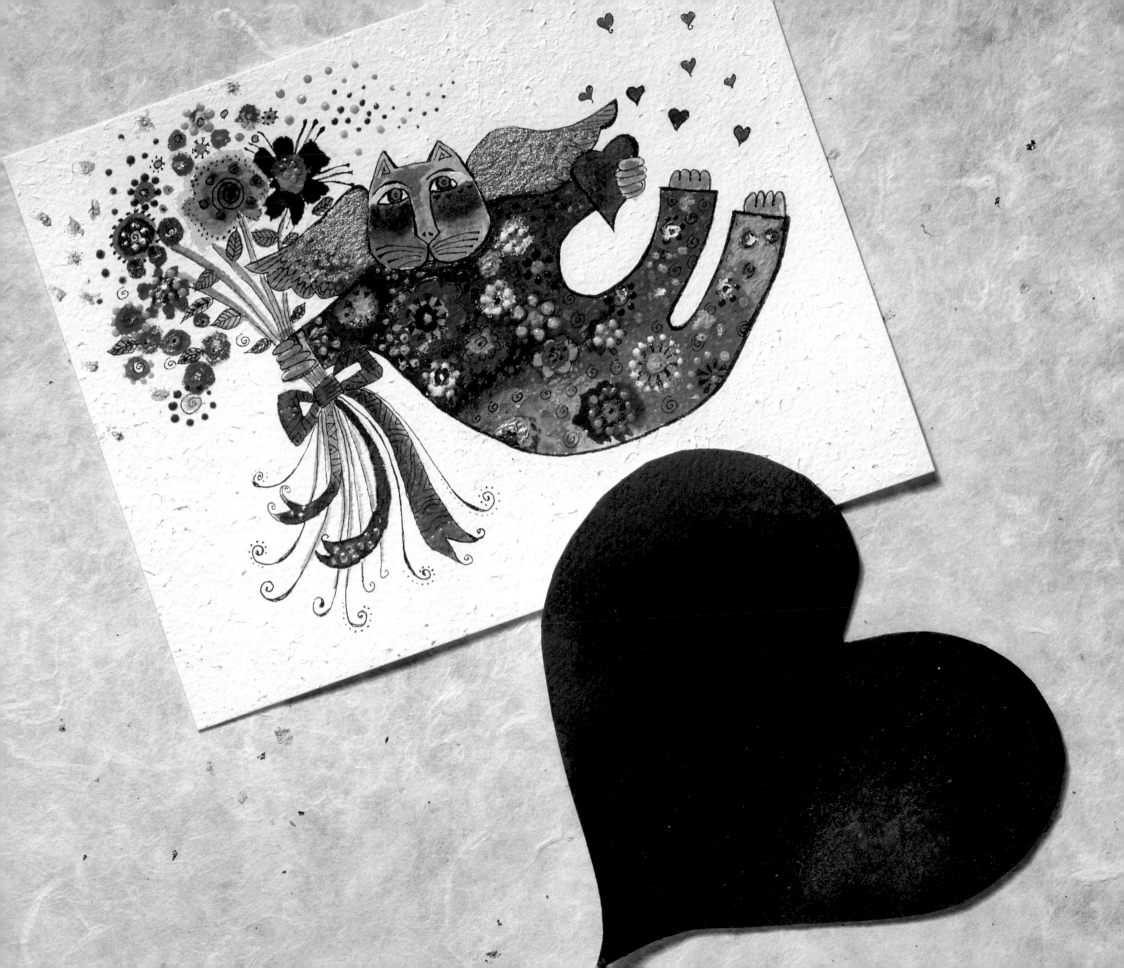

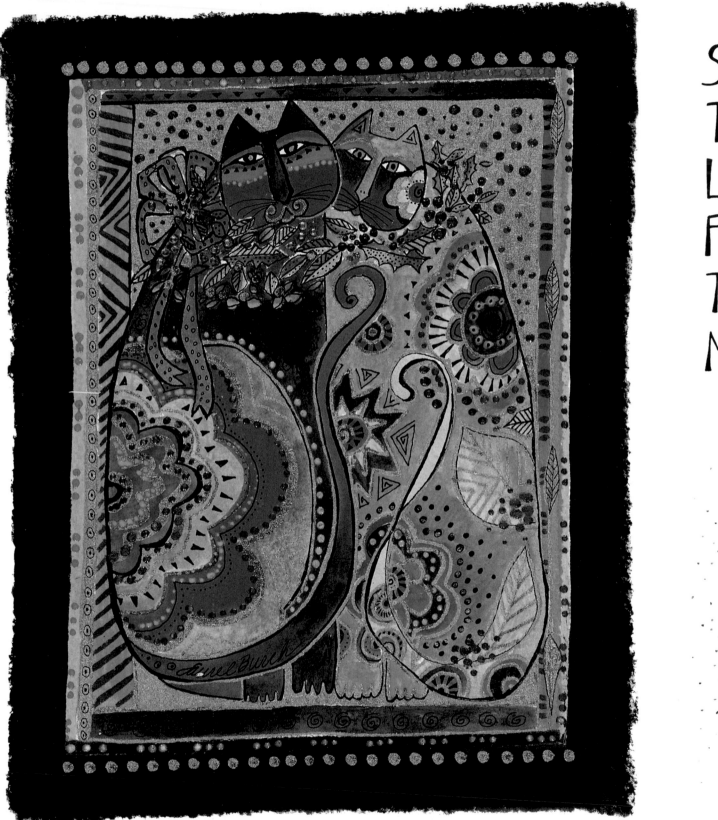

SHARE
THE ♥
LOVE,
FEEL
THE
MAGIC...

Festive Feline Friends, *1995.*

Noel and Noella, *1994.*

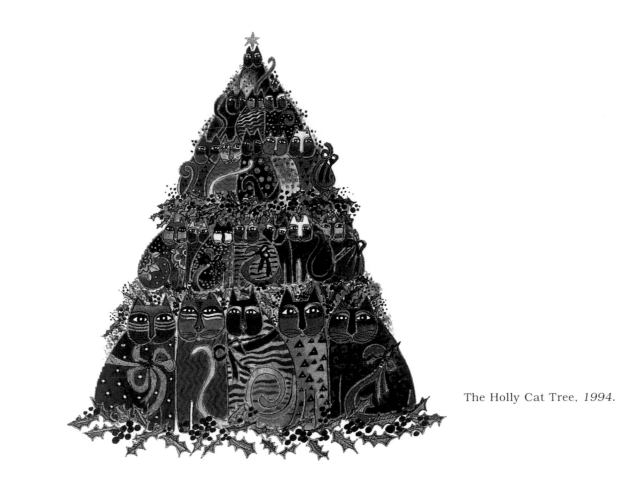

The Holly Cat Tree, *1994.*

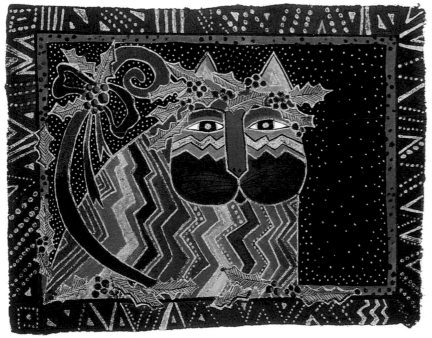

Festive Felines, *1994.*

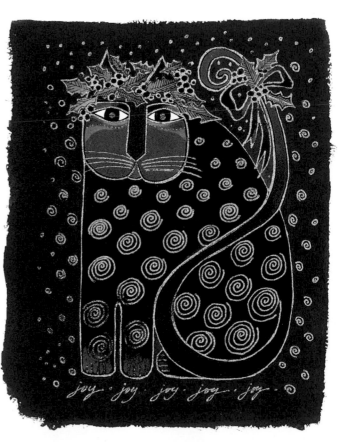

Christmas Cat, *1993.*

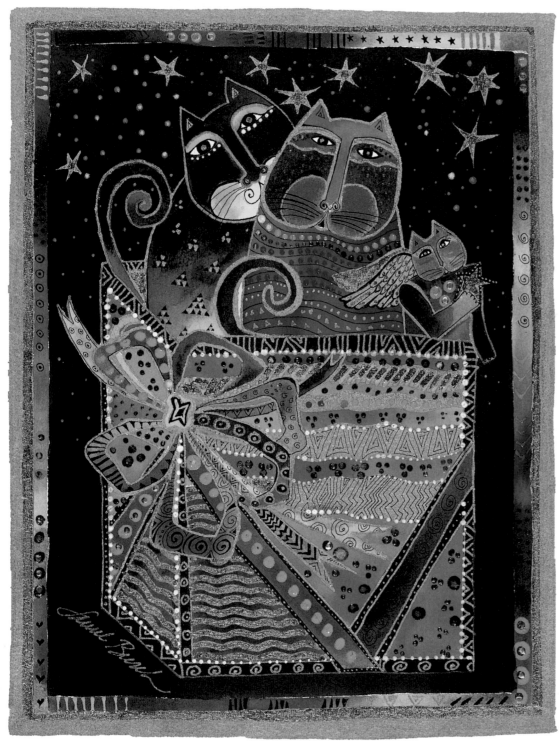

Surprise Box, *1996.*

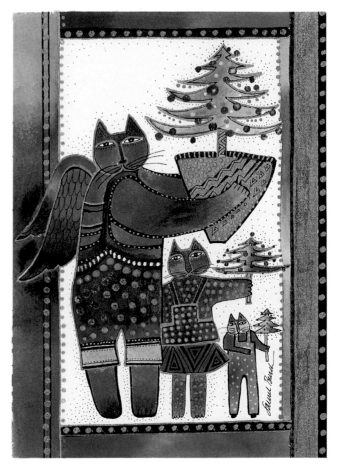

The Giving Trees, *1996.*

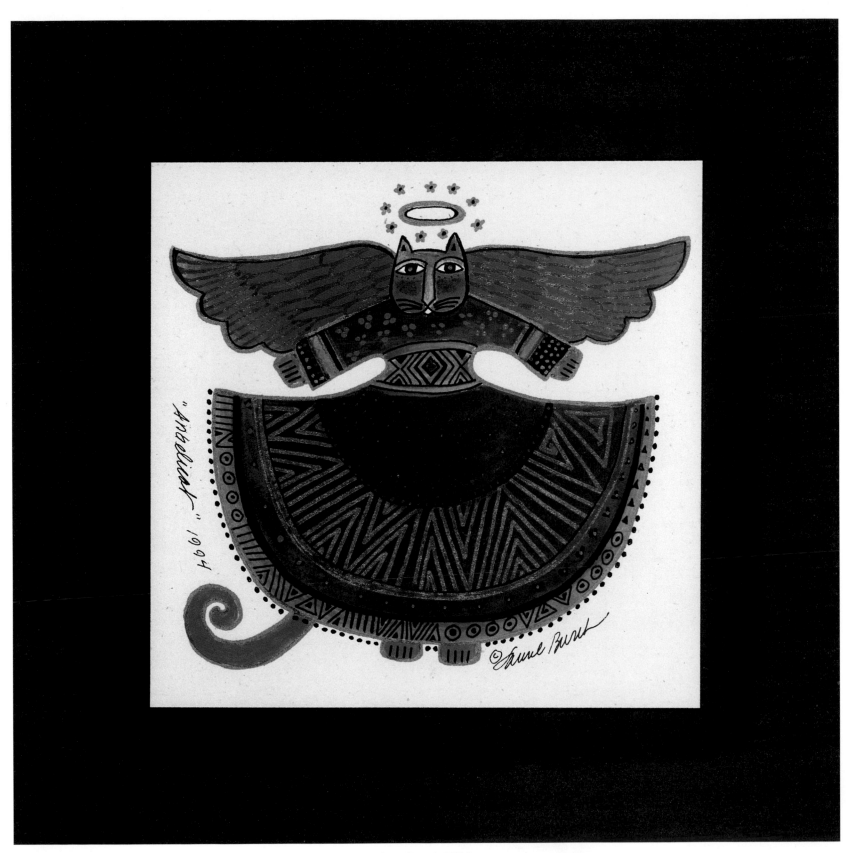

Angelicat, *1994*.

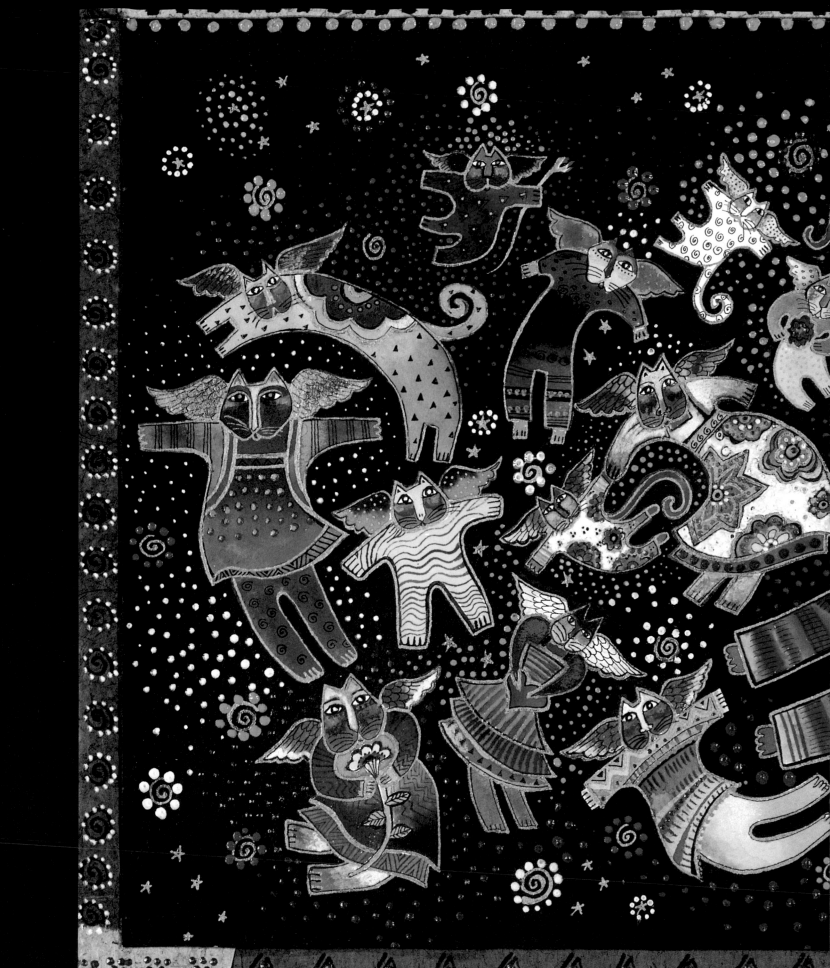

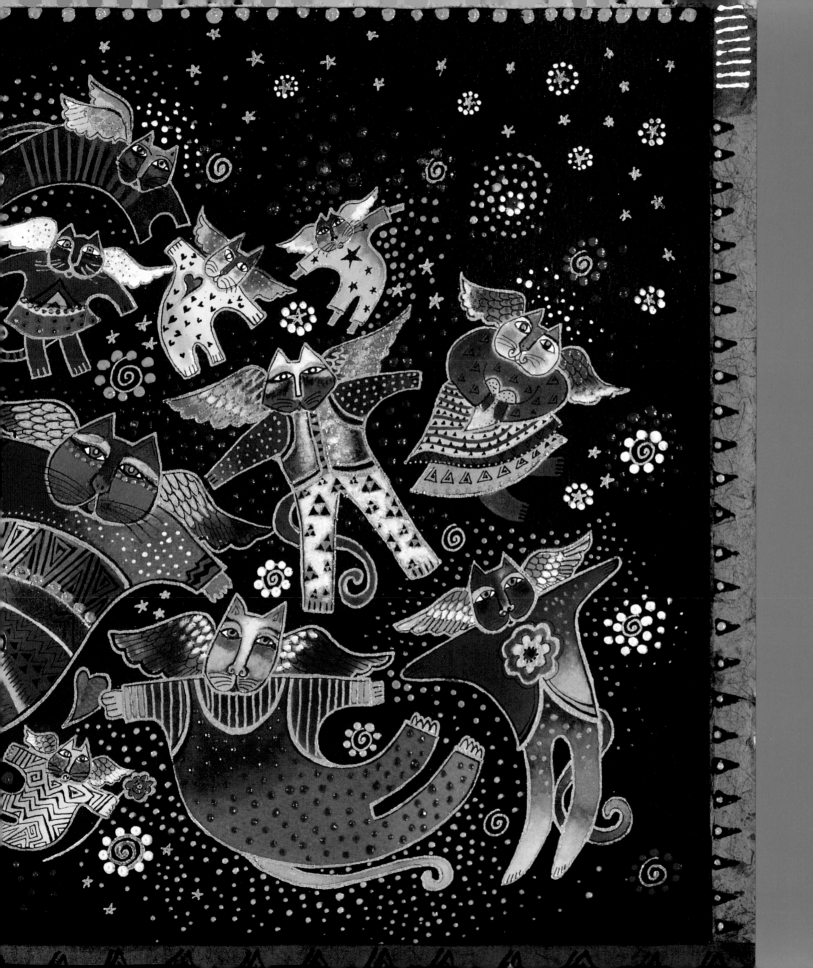

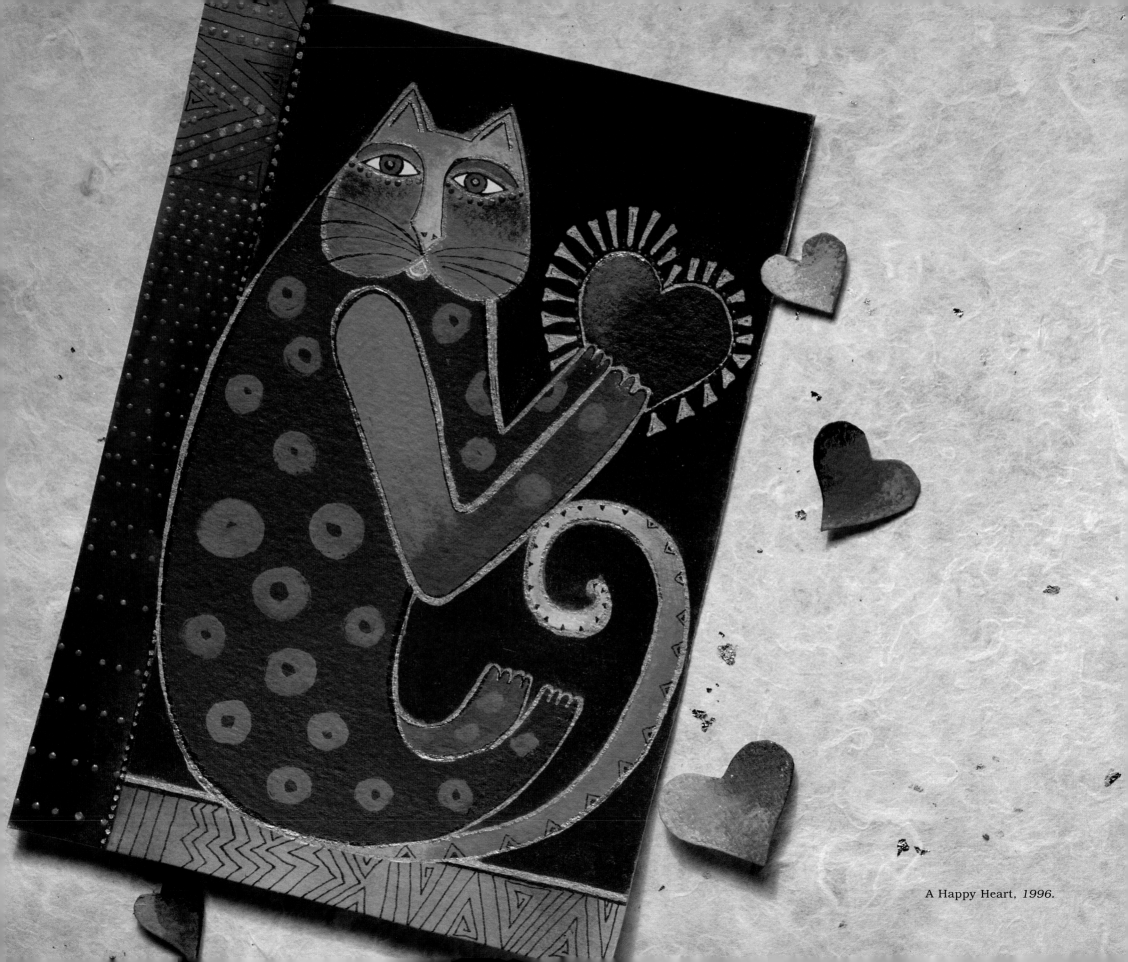

A Happy Heart, 1996.

O n New Year's Eve in 1945, I was born Laurel Harte. Not surprisingly, my mother, father, sister, and I put hearts on everything as I was growing up. This seemed to be our special family symbol of love. Being a New Year's baby, Mom changed my childhood birthday celebrations to Valentine's Day so my friends would be more available. I felt like the "Harte of Hearts," an honor I always cherished. No wonder my drawings often portray messengers of joyful and loving hearts.

Hearts, *1996.*

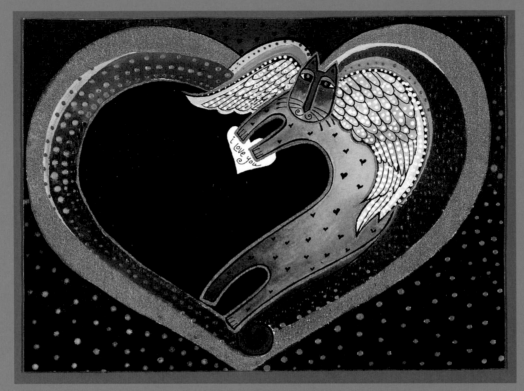

Angelicat Heart, *1995.*

look at the world
through the eyes of your heart.

speak to the world
with the voice of your heart.

share with the world
from the heart of your heart.

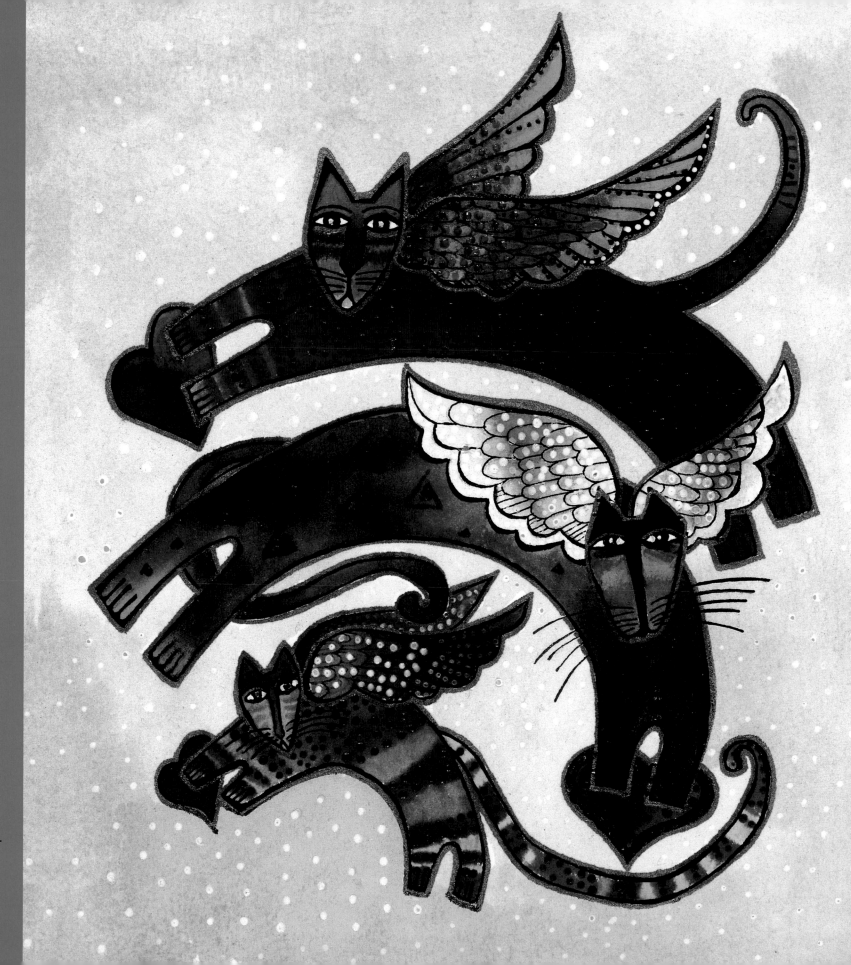

Flying Felines, *1994*.

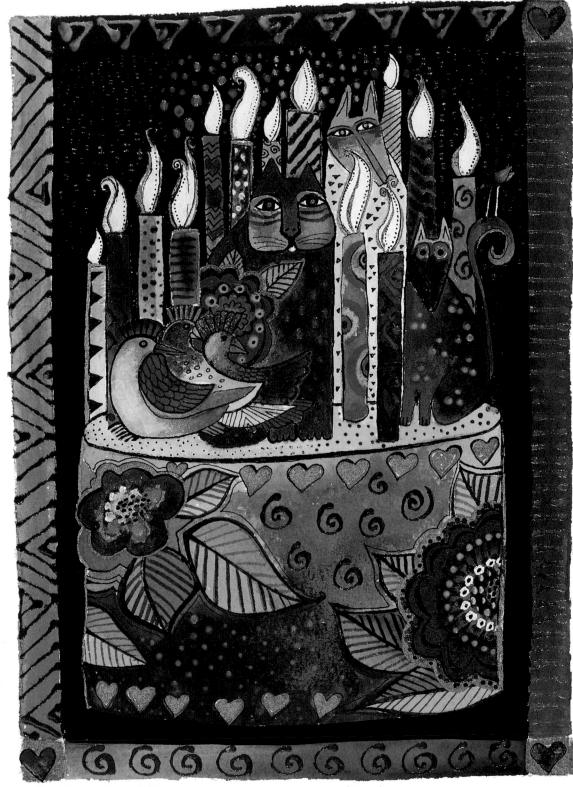

The Wish Cake, *1996.*

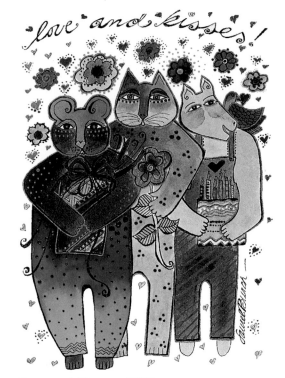

Love and Kisses, *1996.*

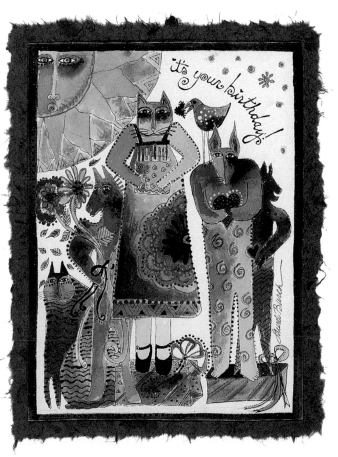

The Gift Givers, *1995.*

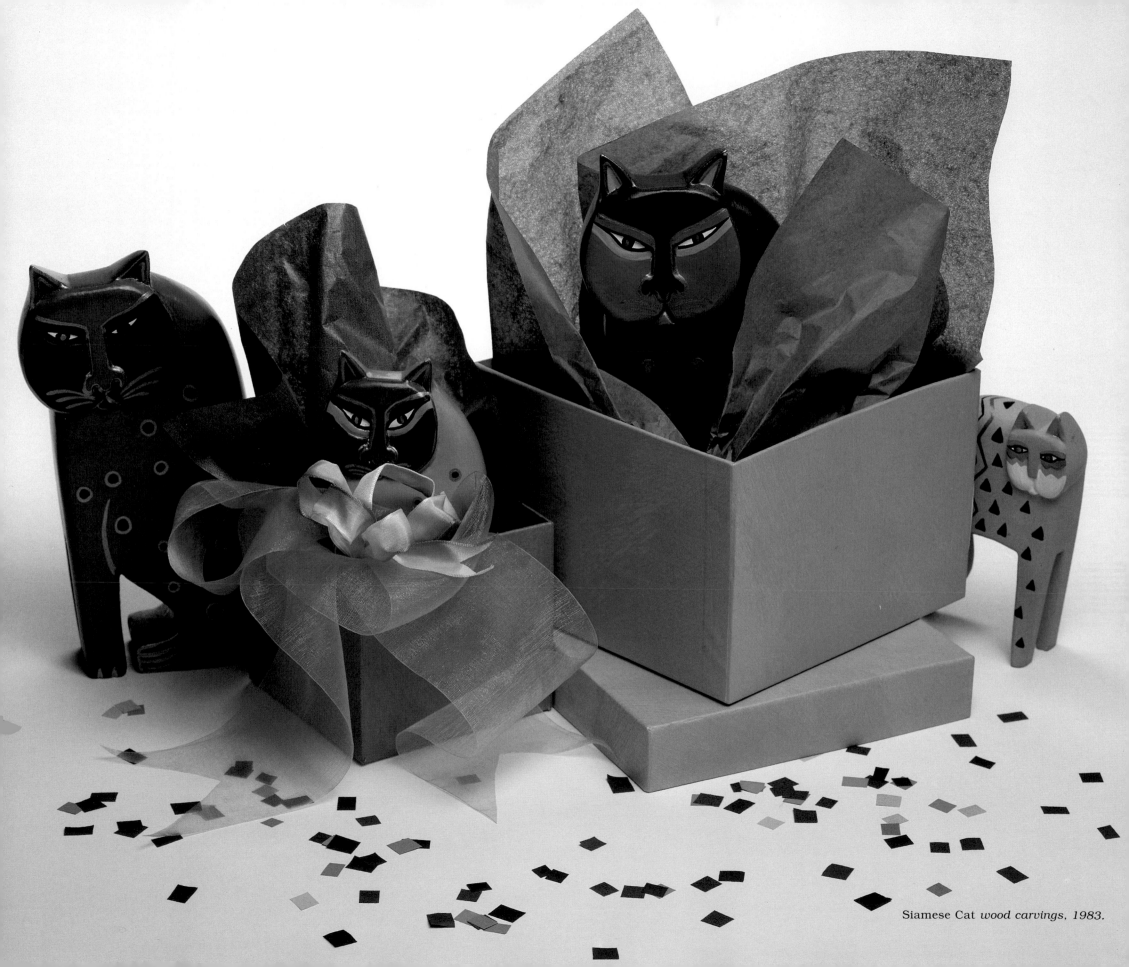

Siamese Cat wood carvings, 1983.

HOW ENRICHED LIFE IS BY FRIENDS!

GOOD FRIENDS, NEW FRIENDS, OLD FRIENDS,

FEATHERED FRIENDS, FELINE FRIENDS,

FRIENDS OF FRIENDS...

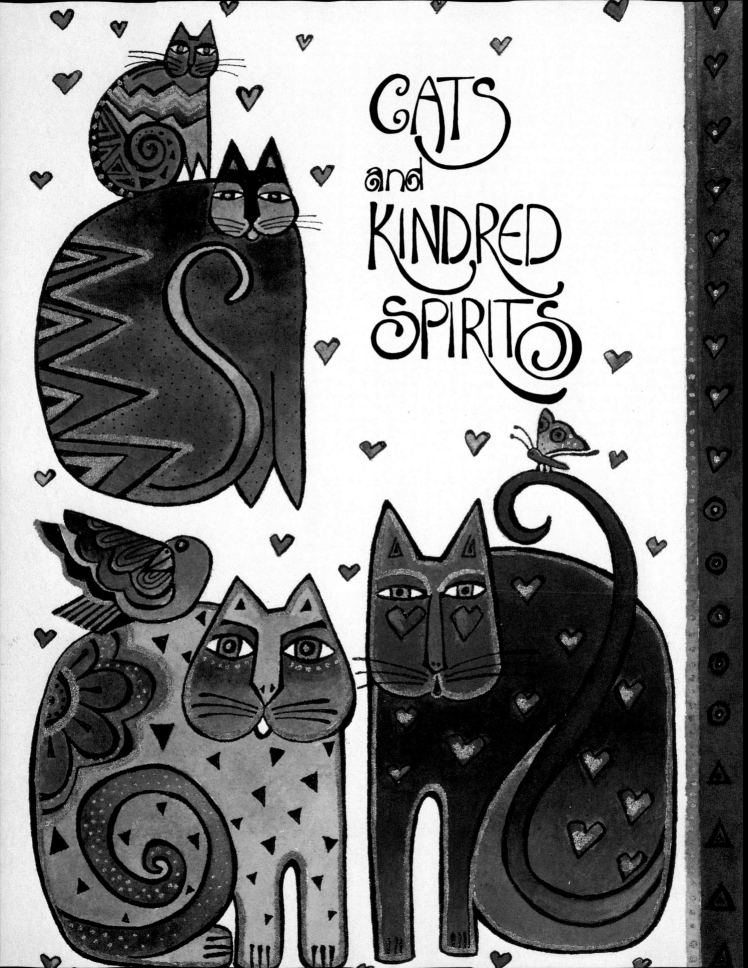

CATS and KINDRED SPIRITS

It seems that as soon as I paint one charac-
ter, another will soon appear. A butterfly
on a bird's back, a kitten beneath its mother—
the joys and woes of relationships are what
life is all about, and with each painting I find
myself delving into the mysteries of creatures
and their friends—animal and human.

One day a few years ago, I realized I
was sharing my life with 23 animals! The
number has vacillated up and down over my
lifetime, but I can't even imagine a life without
a diversity of animals.

Baby orphan lambs have slept at the
foot of my bed, my parrots make frequent
visits to the trees in the garden while I paint
outside, and my burro Corazon and I go for
walks up the mountain.

It's no wonder that I find the love affair
with animals to be a tremendous source of
happiness and inspiration, which of course
shows up profusely in my art.

Fat Cats, *1995.*

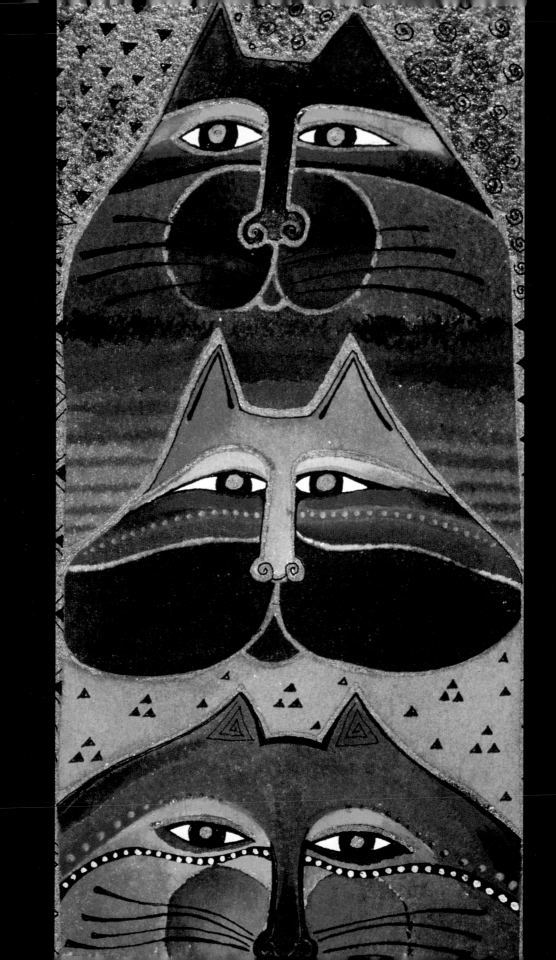

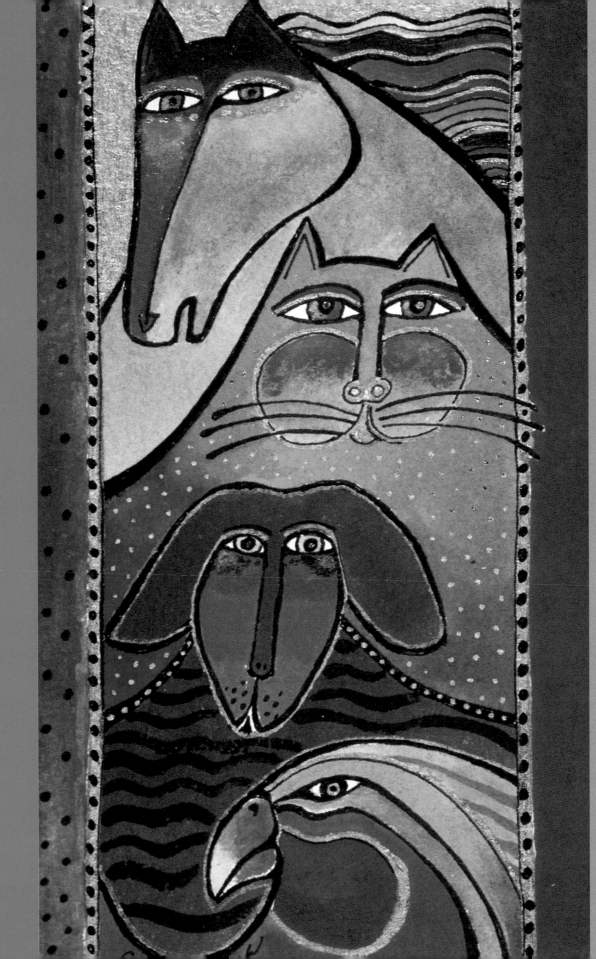

Friends in Laureland, *1995.*

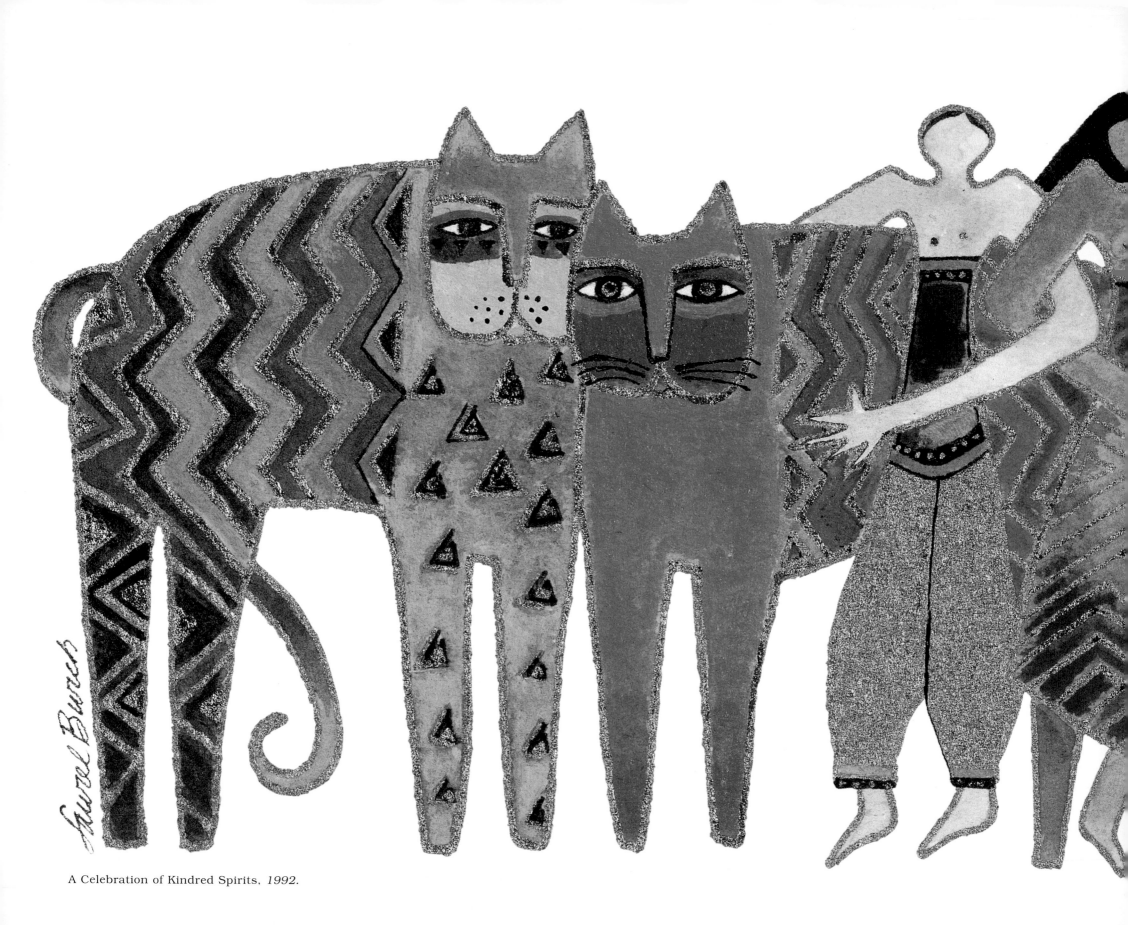

A Celebration of Kindred Spirits, *1992.*

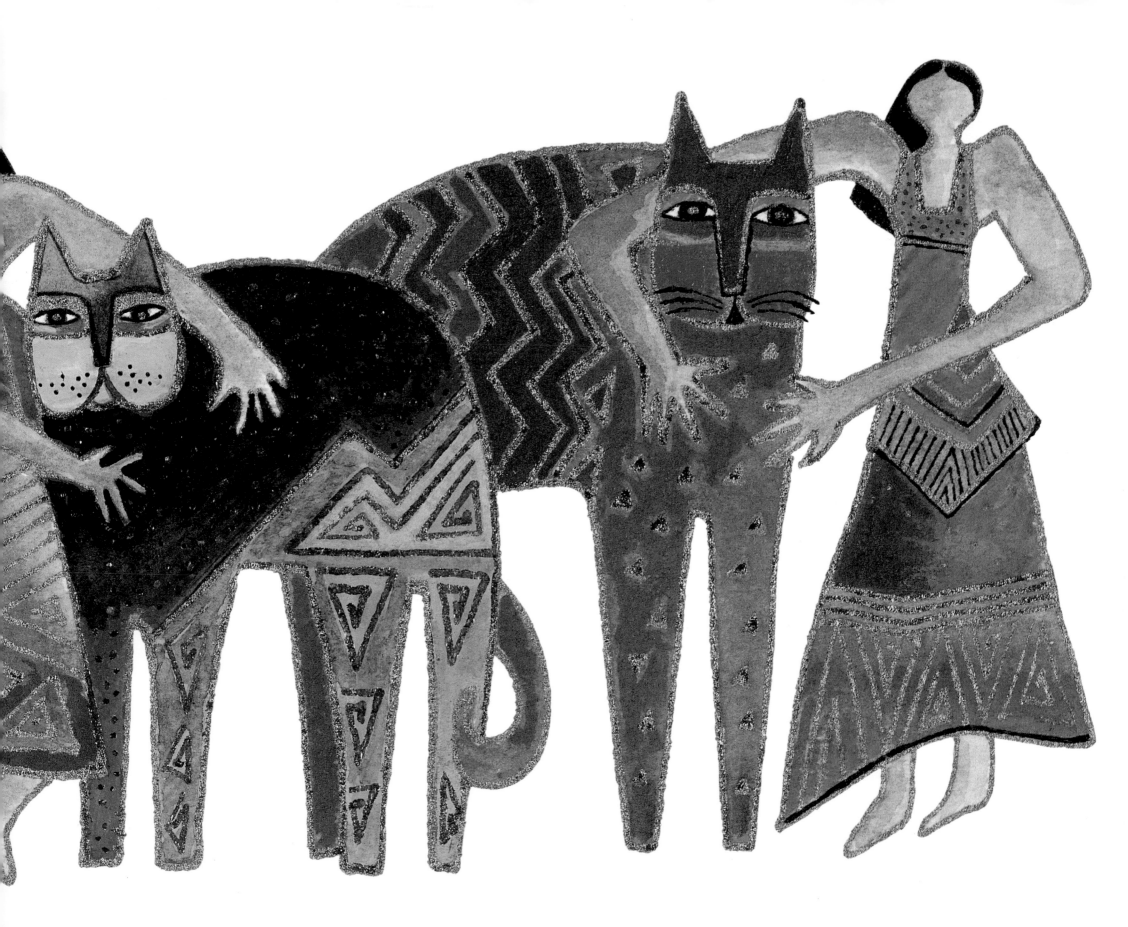

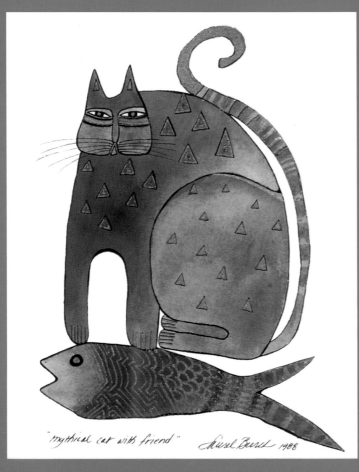

Mythical Cat with Friend, 1988.

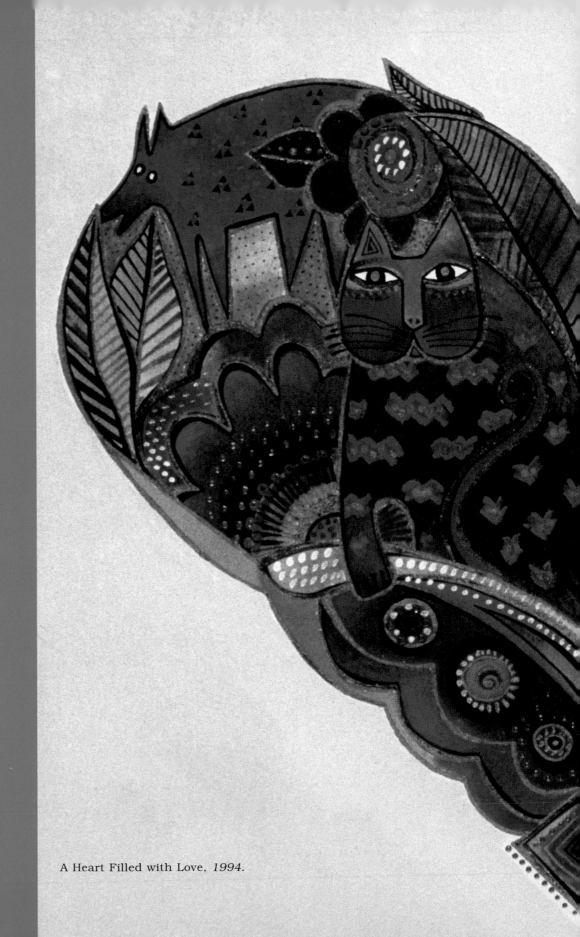

A Heart Filled with Love, *1994.*

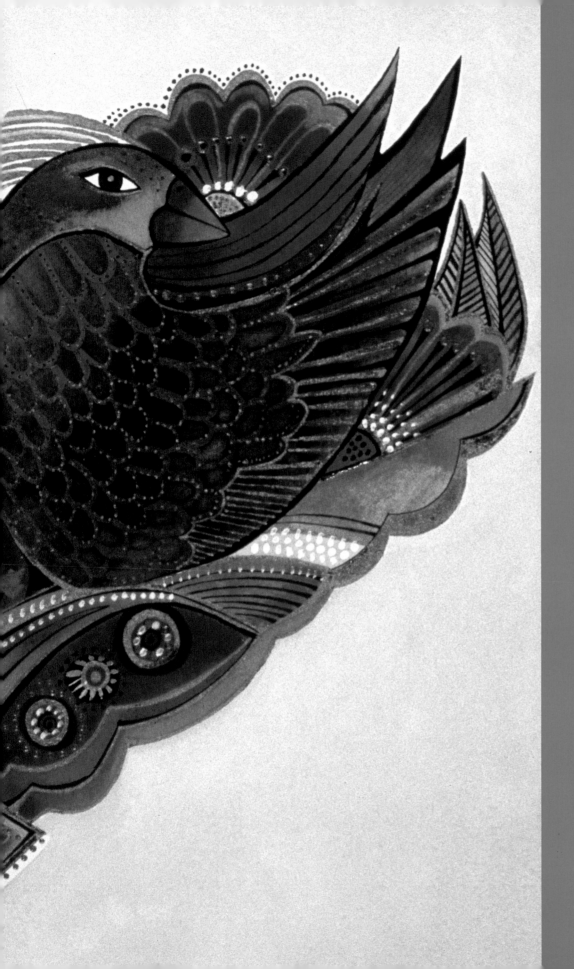

Think Big, Start Small, *1991.*

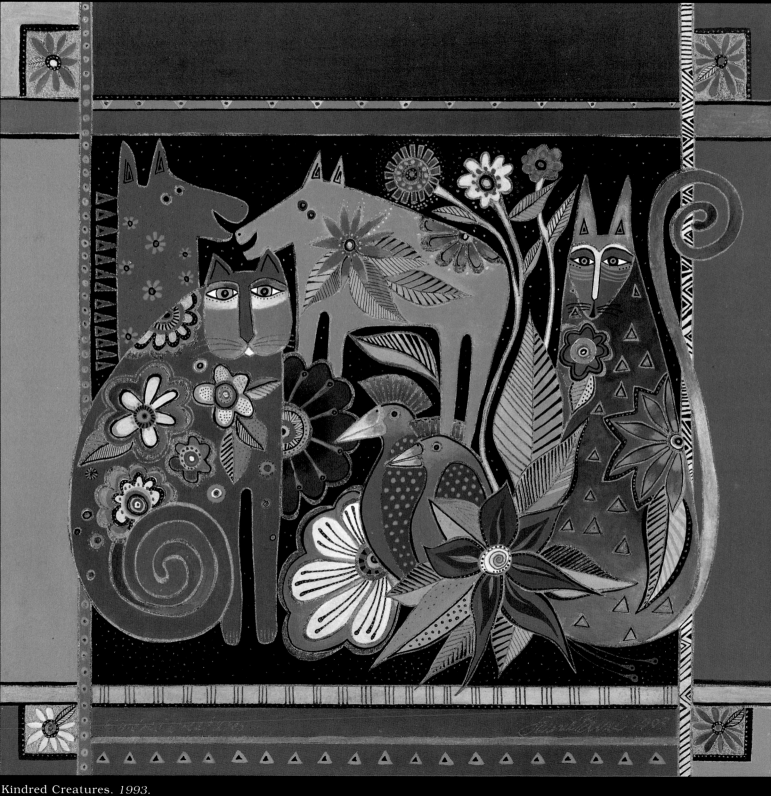

Kindred Creatures. *1993.*

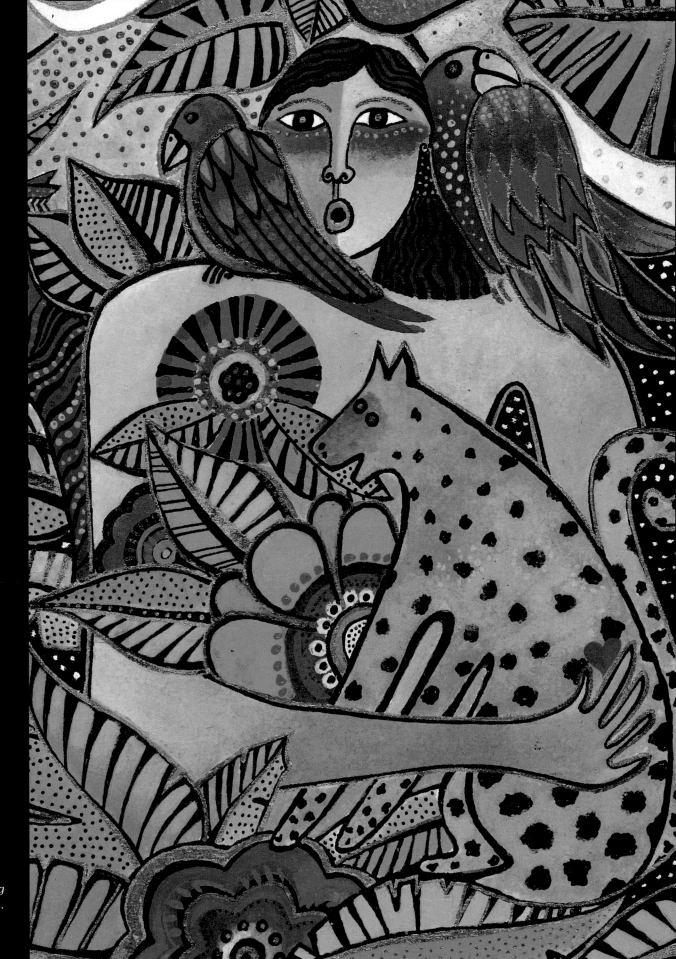

in
a
beautiful
dream,
giant
scarlet
macaws
sat
upon my
shoulders
and
we danced
with
a
saffron
leopard

Detail from the painting
Songs from the Rainbow Forest, *1994.*

The Oakland SPCA Peoplesoft Adoption and Education Center, Oakland, California.

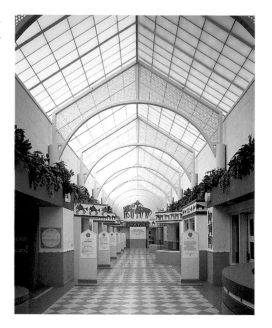

S tories of the extraordinarily rewarding relationships between animals and humans seem to sing in these halls.

A dream came true for me in 1994, when I was able to participate in creating a state-of-the-art Oakland SPCA facility for animal adoption and education. Its purpose was not just to provide an adoption facility, but to communicate the responsibilities and joys of animal companionship at the same time.

The stunning shapes of the structure, with its abundance of skylights and crisp white walls, made it a perfect canvas for my brilliantly colored animal murals, wall details, and decorative doorways.

Elijah Burch with adoptive kitty at the Oakland SPCA, 1996.

The exciting and dramatic environment, combined with the essential dedication and hard work of the directors, staff, and people in the community who care about the welfare of animals, has helped the center become one of the most sophisticated and successful adoption facilities in the United States.

With open arms, we welcome your visit.

Best Friends, *1994.*

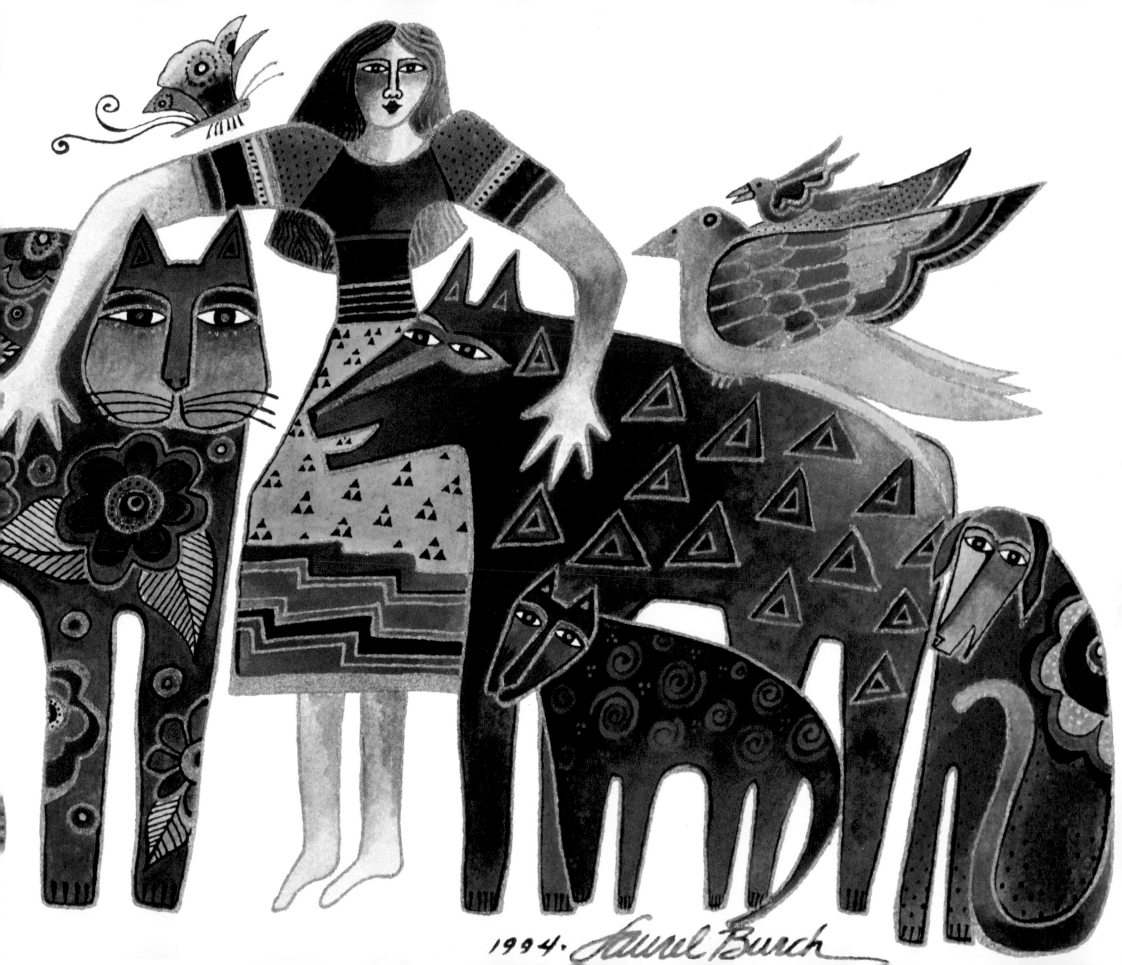

1994. Laurel Burch

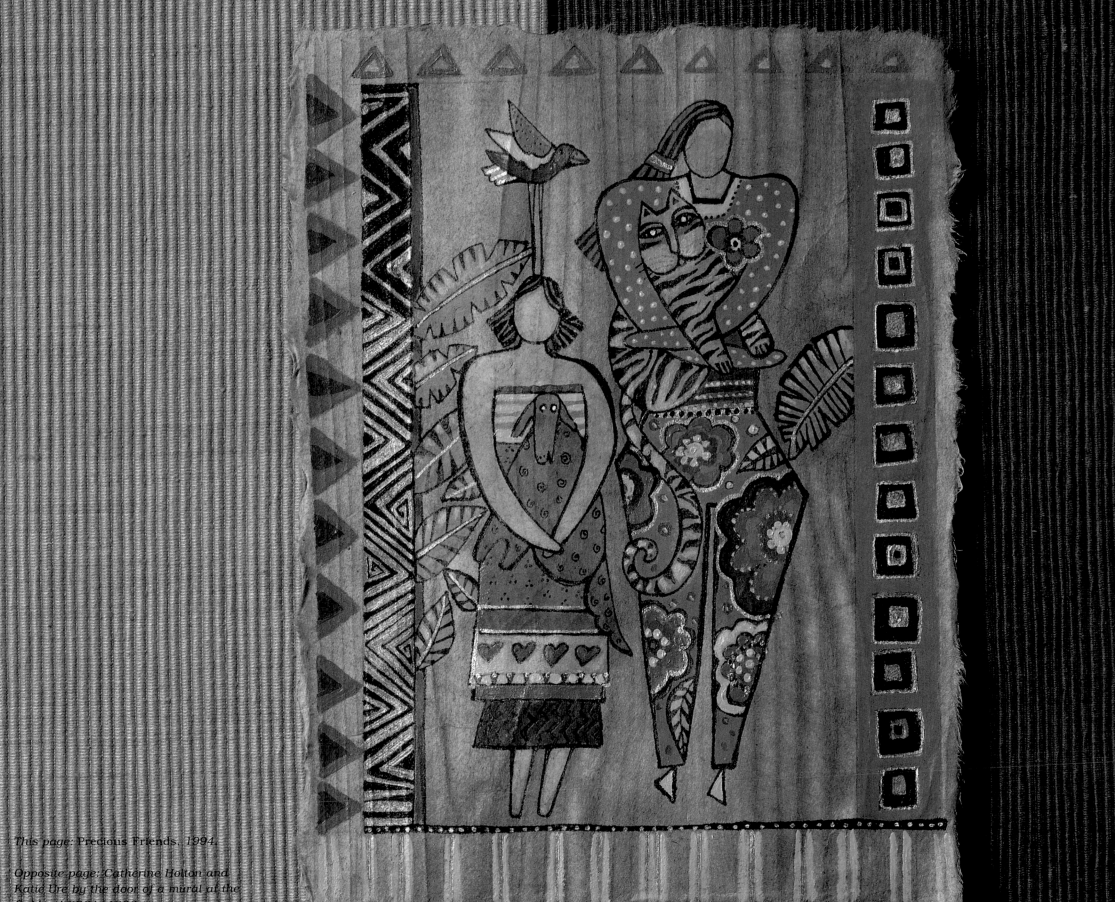

This page: Precious Friends, 1994.

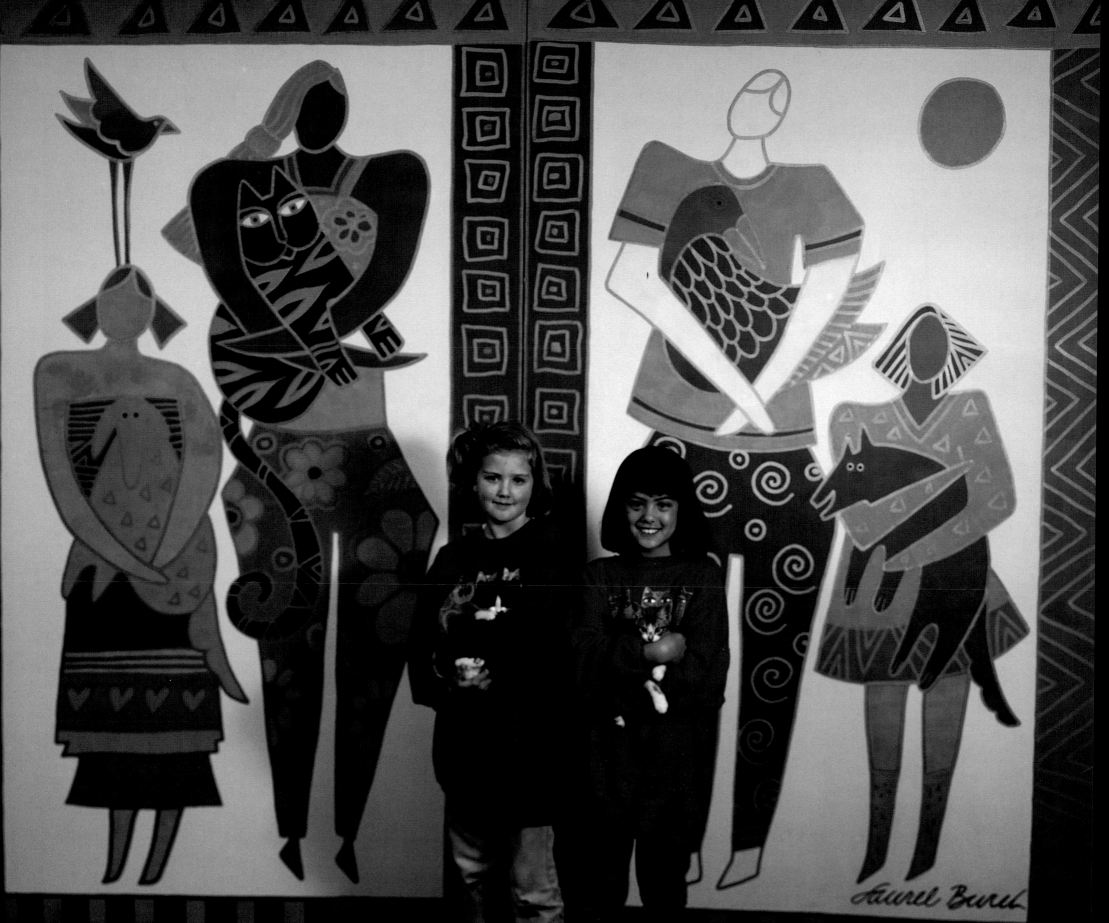

Laurel Burch

My first journey to the magical Indonesian island of Bali was in 1982. For years, I had collected masks from places all over the world, including Bali, and though my own art was entirely different in style, color, and motif, I could envision the possibility of bringing my mythical animals to life in the skilled hands of Balinese woodcarvers.

I arrived on the island with packages of my cat and mask paintings, and began to search for a carver whose eyes would sparkle when he saw my wild creatures with their vibrant colors and mysterious smiles.

This was the beginning of a love affair with this tiny little dot on a map of the Southeast Asian seas, and the relationship has lasted for a good many years.

Here is the tale of *Rainbow Cats* and *Mythical Tigers* coming to life, in Bali . . .

Woodcarving detail of Sun Lion, 1982.

JOURNEY TO BALI

Siadja is a seventh-generation master carver and traditional Balinese dancer in the village of Ubud.

He greets me at the doorway of his home, a 700-year-old masterpiece of beauty and mystery. And this doorway is only a taste of the magic hidden behind it.

It is October of 1989, and I am making another excursion to Bali with a new collection of animal paintings under my arm. The trip was planned in time to see the carving and painting of cat designs I had created earlier in the year. It is so exciting to watch the steps necessary to prepare them for their journey across the ocean to the United States.

Siadja opens the door to his garden, and I can hear the sounds of chipping, carving, and sanding coming from the workshops behind the courtyard. As we approach, I begin to see paint cans dripping with magenta and teal, purple and crimson—my heart is leaping with anticipation.

Siadja and Laurel, 1989.

Preparing wood stencils.

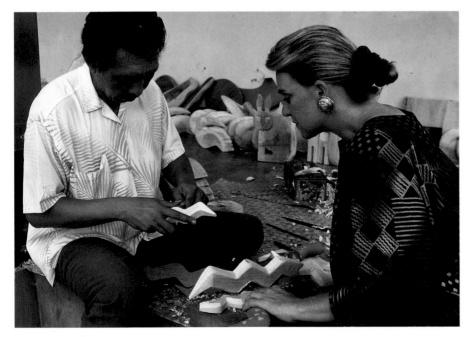

Siadja perfecting a carving.

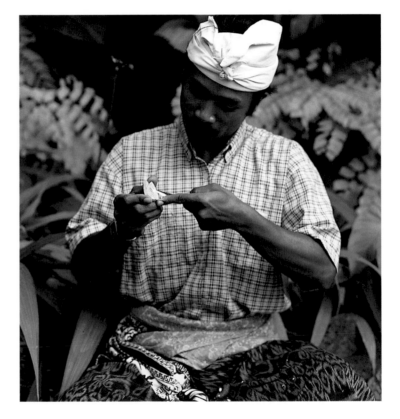

E ach carving takes several days to create, from start to finish. The first pieces are made directly from my paintings by the master carvers, and then duplicated by other carvers throughout the village. Each piece, therefore, has its own unique spirit, as an eye slants or a tail curves slightly this way or that.

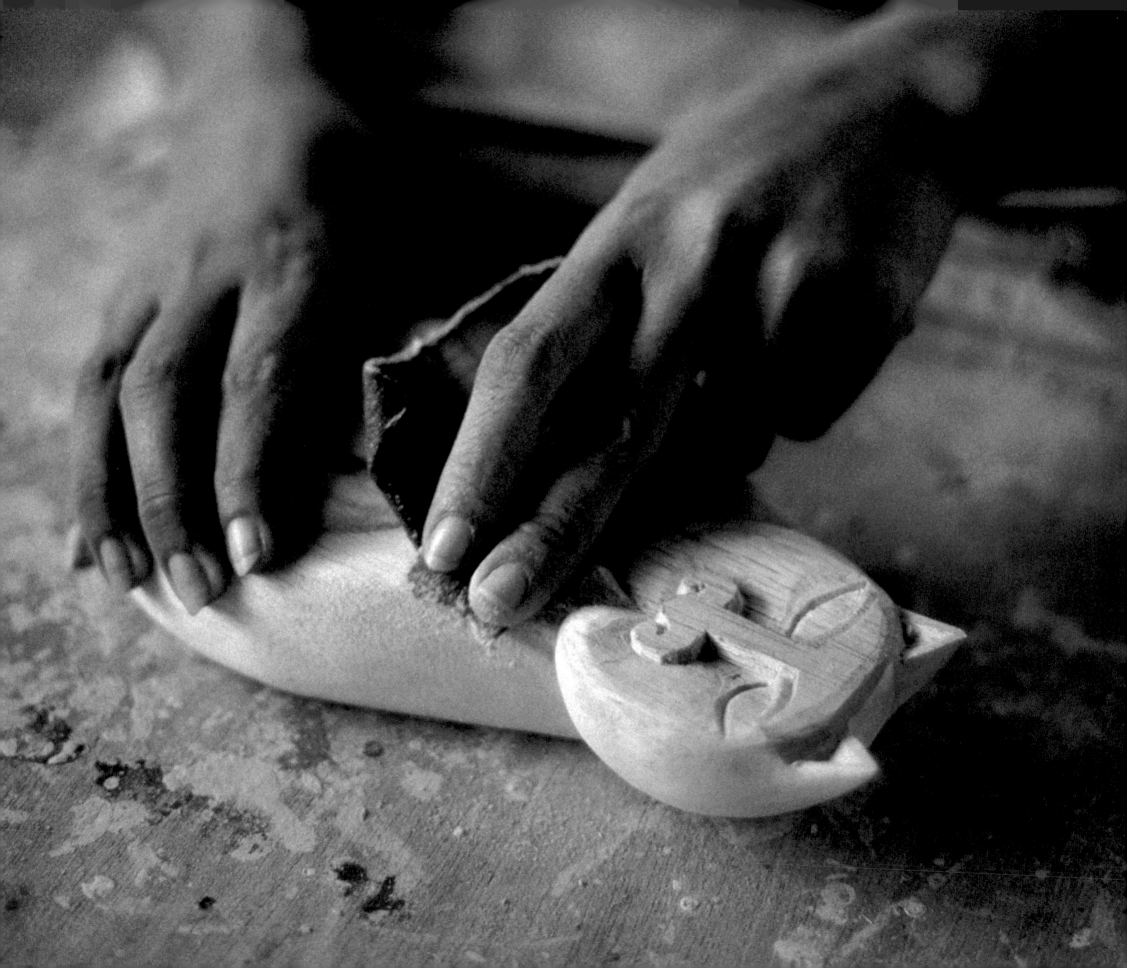

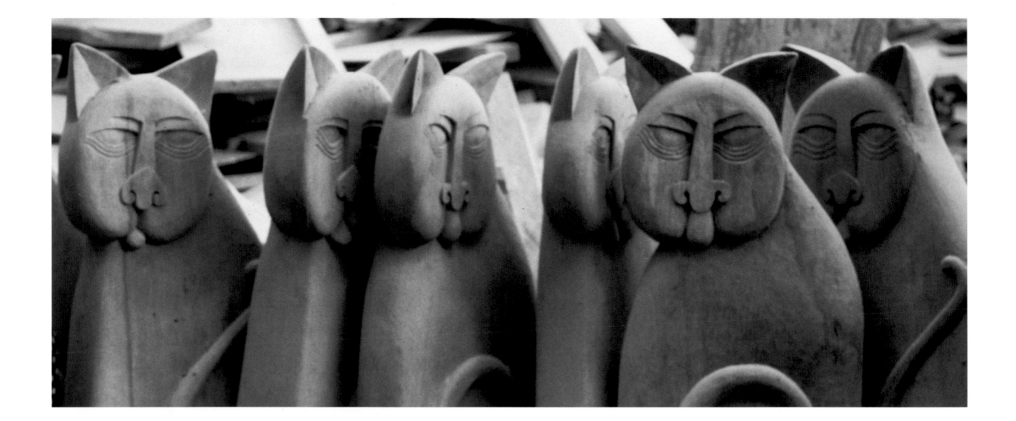

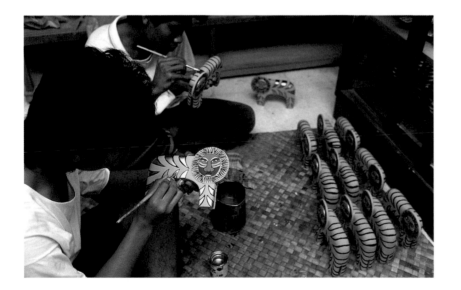

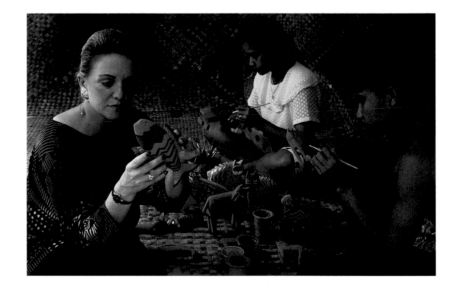

As one journeys through the villages of Mas and Ubud, the painted and unpainted feline carvings can be seen peeking through the doorways and windows of the workshops.

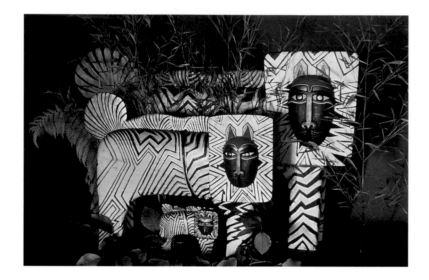

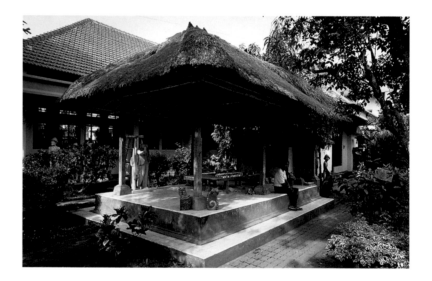

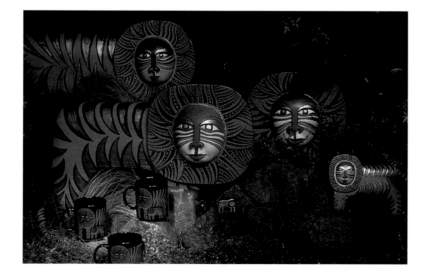

Though I am known in Ubud as "the American artist who brought bright colors, modern mask images, and cat designs to Bali," my greatest gratification comes from the thrill of collaborating with artisans skilled in ancient carving traditions. This has made it possible for me to retain the folkloric quality of my art and to make the pieces available to collectors all over the world.

Opposite page: Laurel with parrots and felines
Zebracat and Leonardo, 1989.

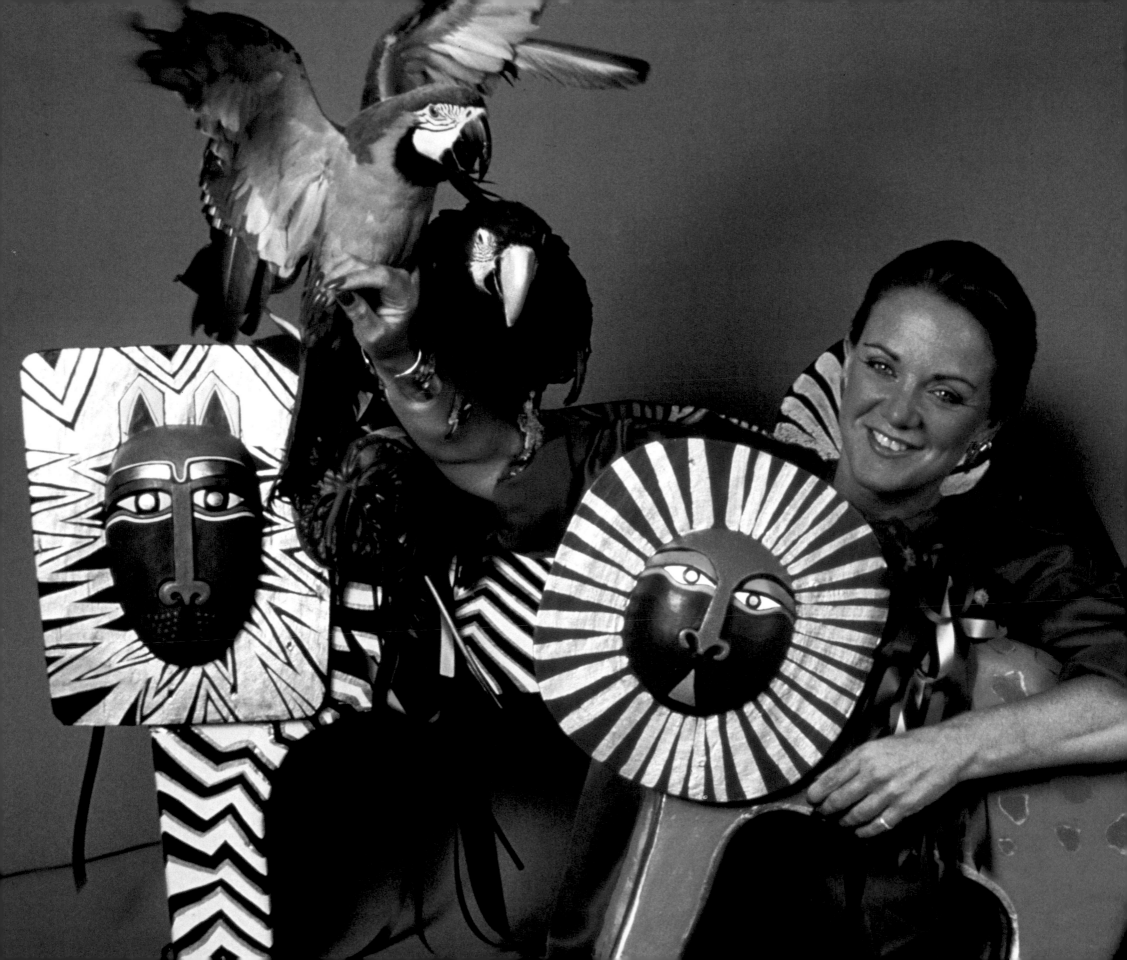

COLLECTIONS

EACH PIECE OF ART

FULFILLS ITS GREATEST PURPOSE

WHEN IT ENHANCES A PERSON'S LIFE

OR FINDS ITS HOME IN SOMEONE'S HEART.

THE MAGIC CONTINUES

WHEN THIS FEELING IS SHARED

WITH A LOVED ONE OR FRIEND.

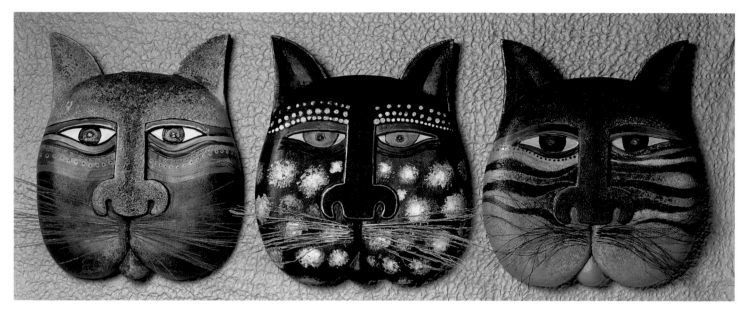

Mythical Cat *masks, 1996.*

*O*ne of my greatest joys is making my original paintings and art pieces. Many of them are held in private collections or shown in public exhibitions. I am also inspired when I find ways of making my art and designs available in a variety of other mediums, so that they can be enjoyed by many people. I have always loved the spectrum of possibilities, and place as great a value on the simple and accessible pieces, such as the earrings, as much as the more elaborate original pieces. What is important is the pleasure each piece of art can bring into someone's everyday life, whatever its form.

This mythical cat mask collection was conceived on paper, carved in wood, and then textured and painted individually to bring out each piece's own unique spirit. Many of my one-of-a-kind art pieces are never reproduced, including these. This is a decision I usually make at the time I'm creating the piece.

Opposite page:
Mysticat *mask, 1996.*

Following pages:
Midnight Leopard *mask, 1996, and*
Sunset Spirit *mask, 1996.*

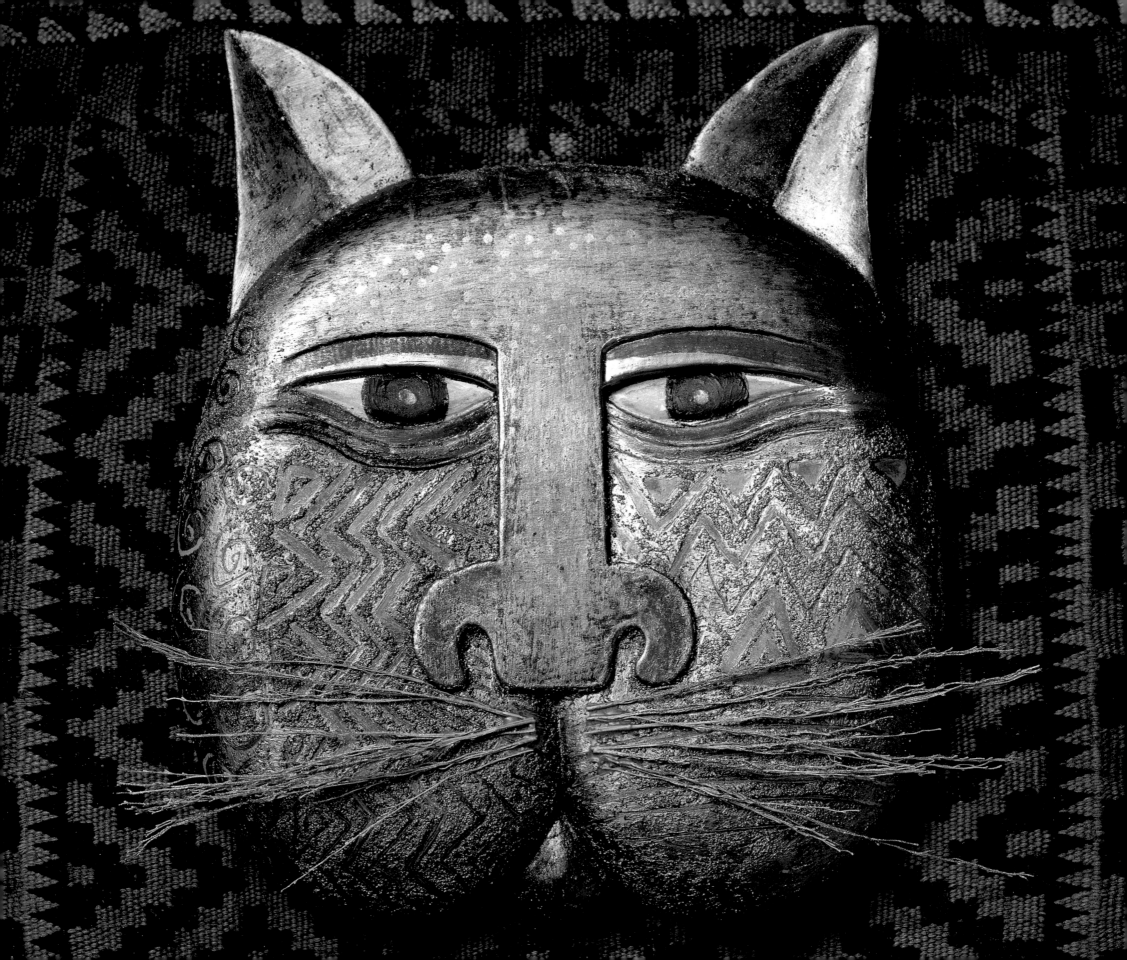

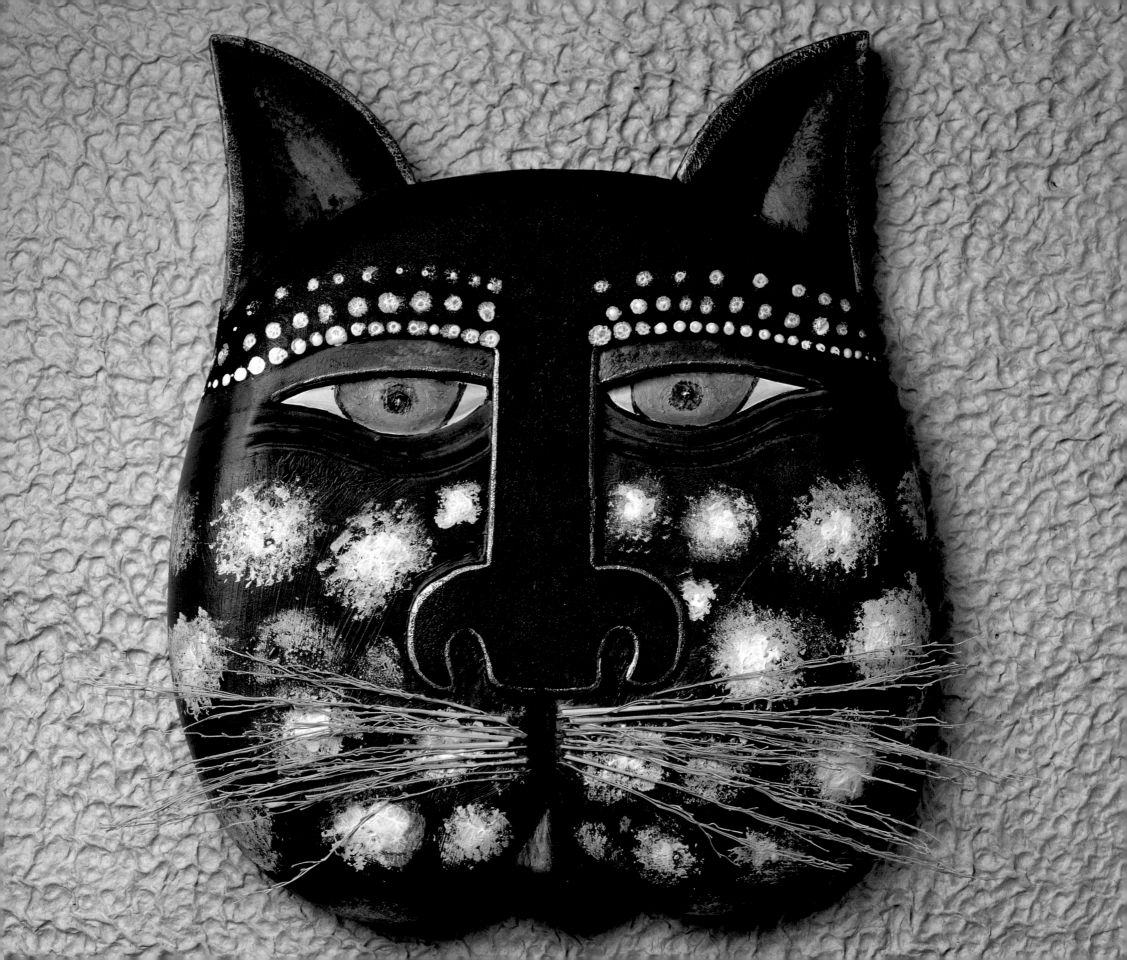

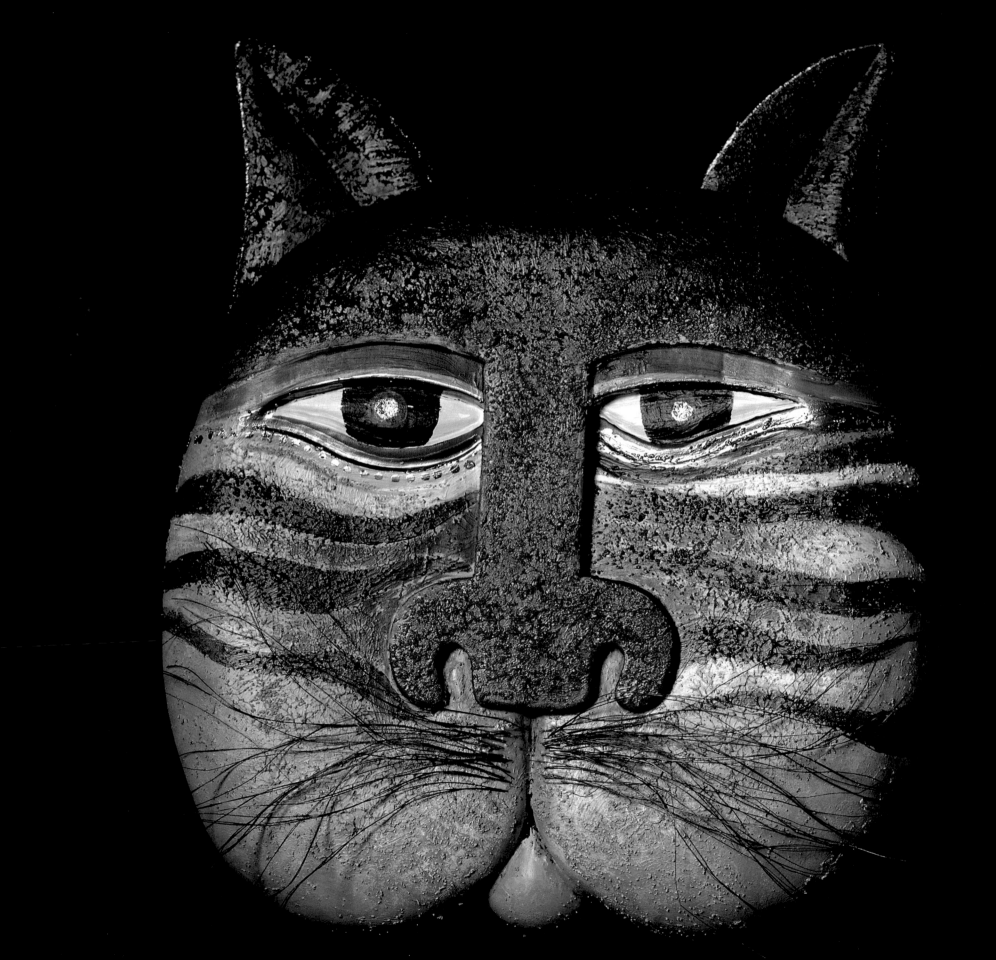

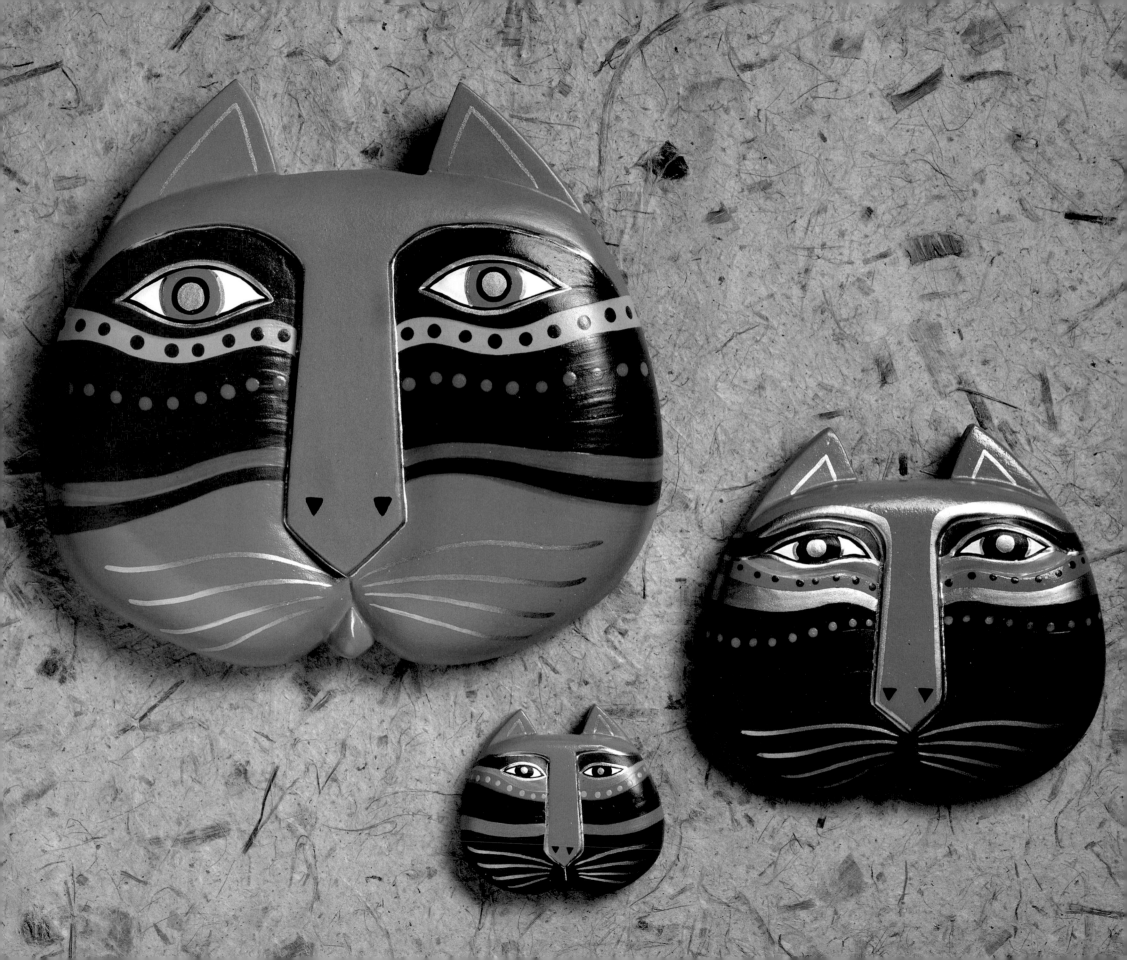

Though I love to create a diverse array of animal characters, my cat family seems to grow the most! These hand-carved and painted wood sculptures were introduced in 1996 and are part of the ever-expanding Fantastic Felines Folk Art Collection.

Fluttering Felines *wood carvings, 1996.*

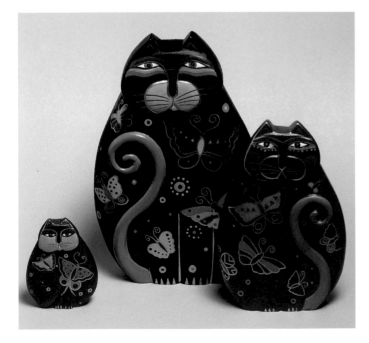

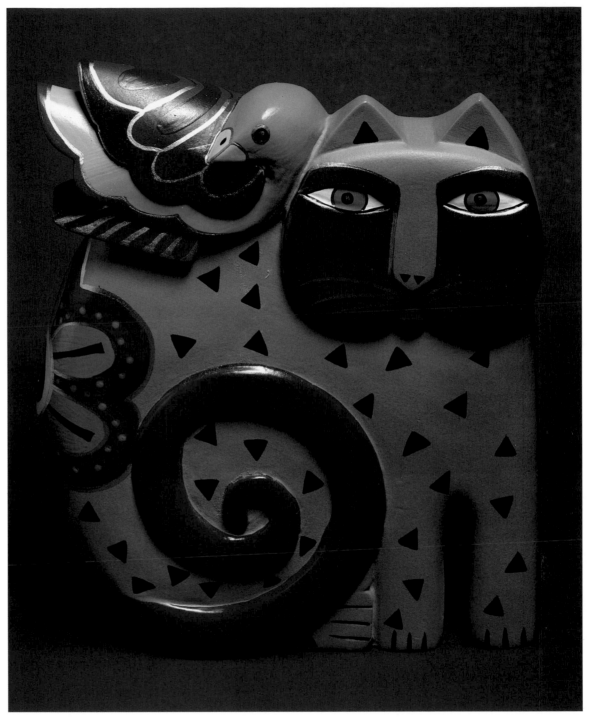

Cat and Kindred Spirit *wood carving, 1996.*

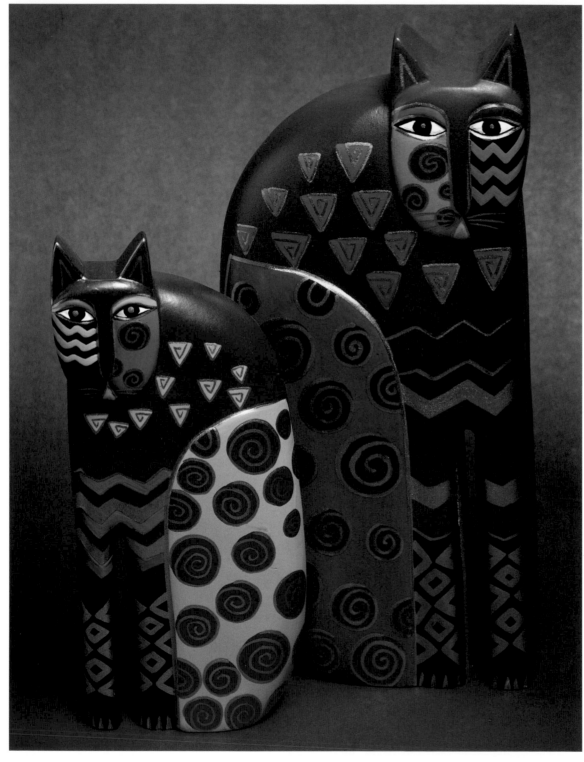

Native Cats *wood carvings, 1996.*

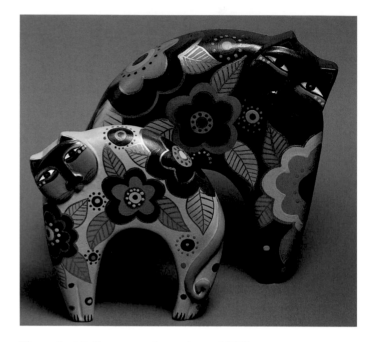

Flowering Felines *wood carvings, 1996.*

Opposite page: Rainbow Felines *wood carvings, 1996.*

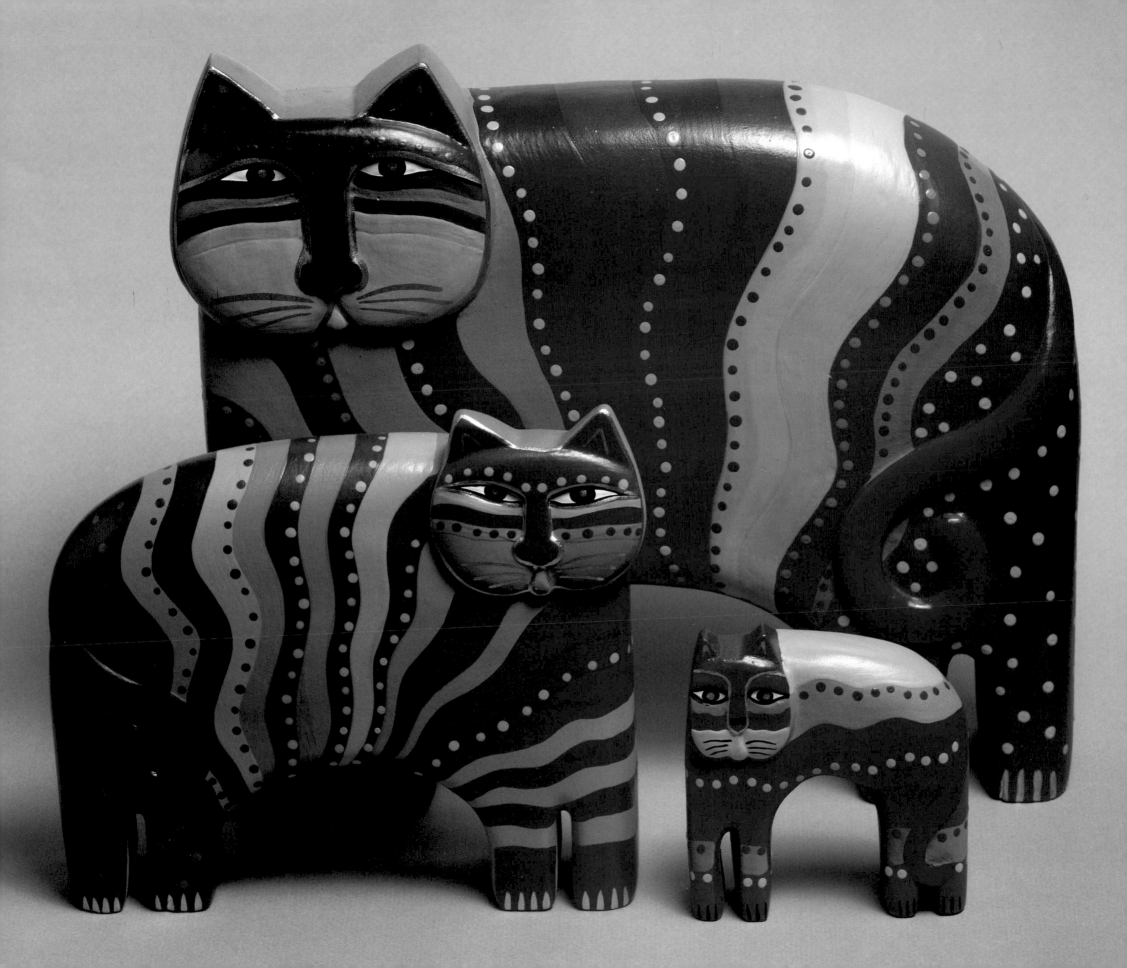

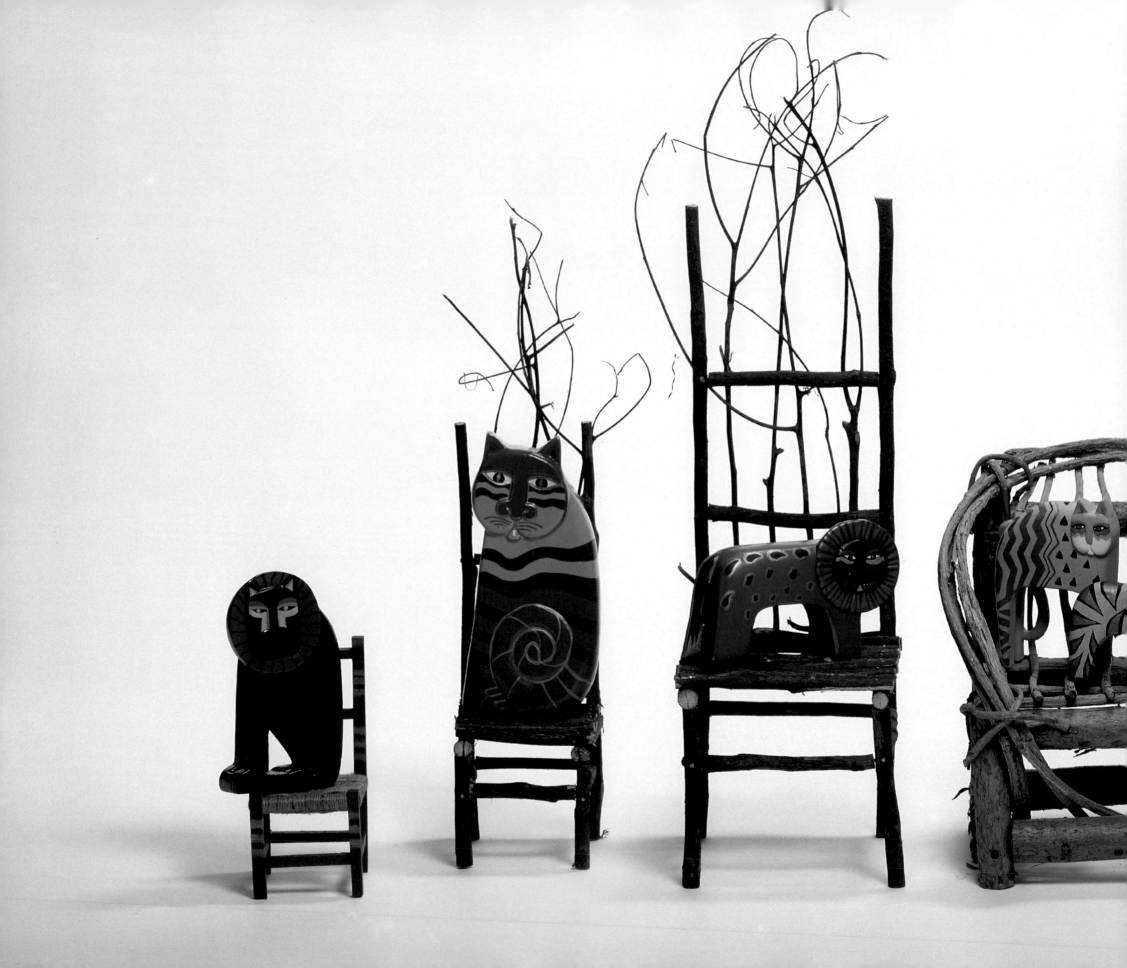

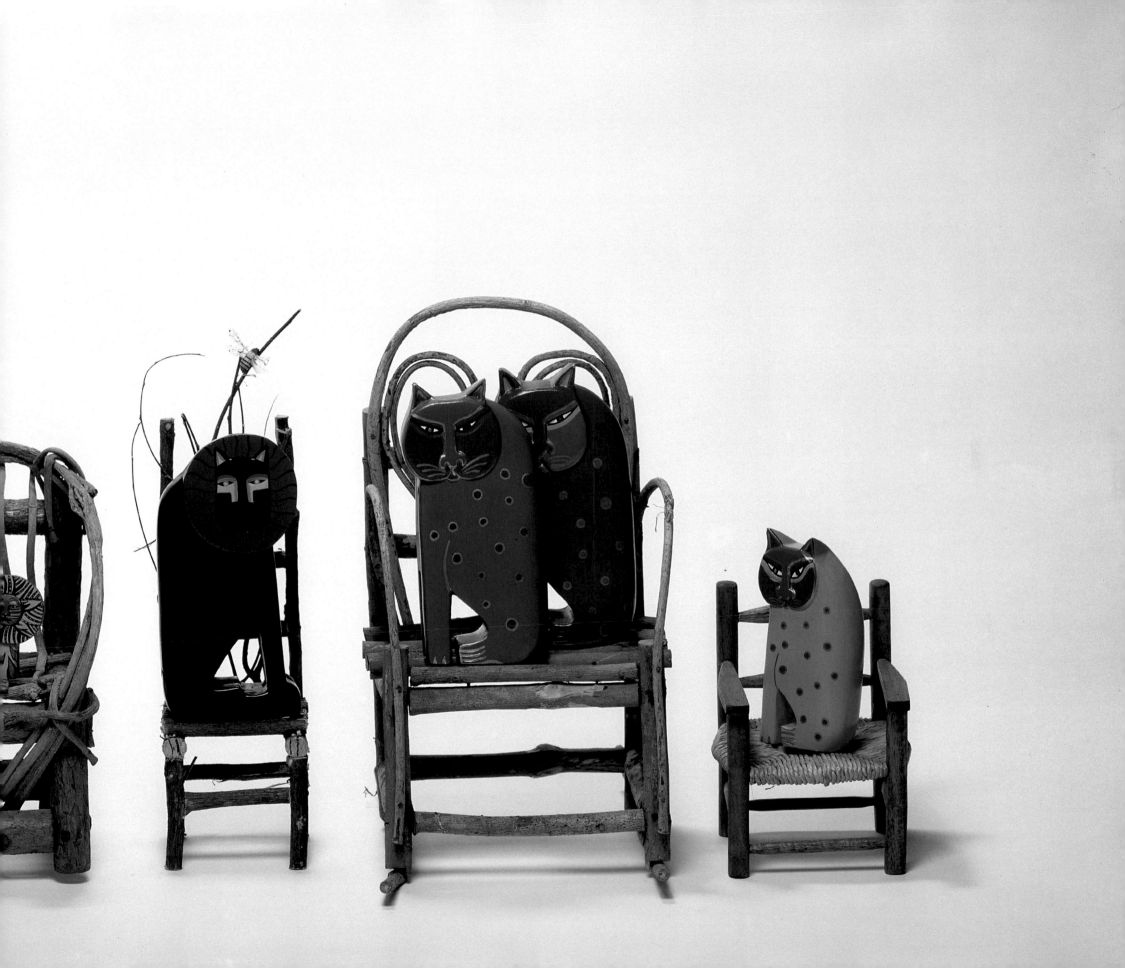

Native Cats *urn, 1996.*

O ne of my favorite passions
is hand-painting urns of
many shapes, colors, and sizes.
Having first painted these Native
Cats on paper, I was then inspired
to paint them on this 18" high urn.
Each cat's face is embellished
with different whiskers made of
natural grasses and reeds.

Previous Pages:
Carved-wood feline collection, 1996.

Native Cats *urn, 1996.*

Opposite page: Native Cats *urn, 1996.*

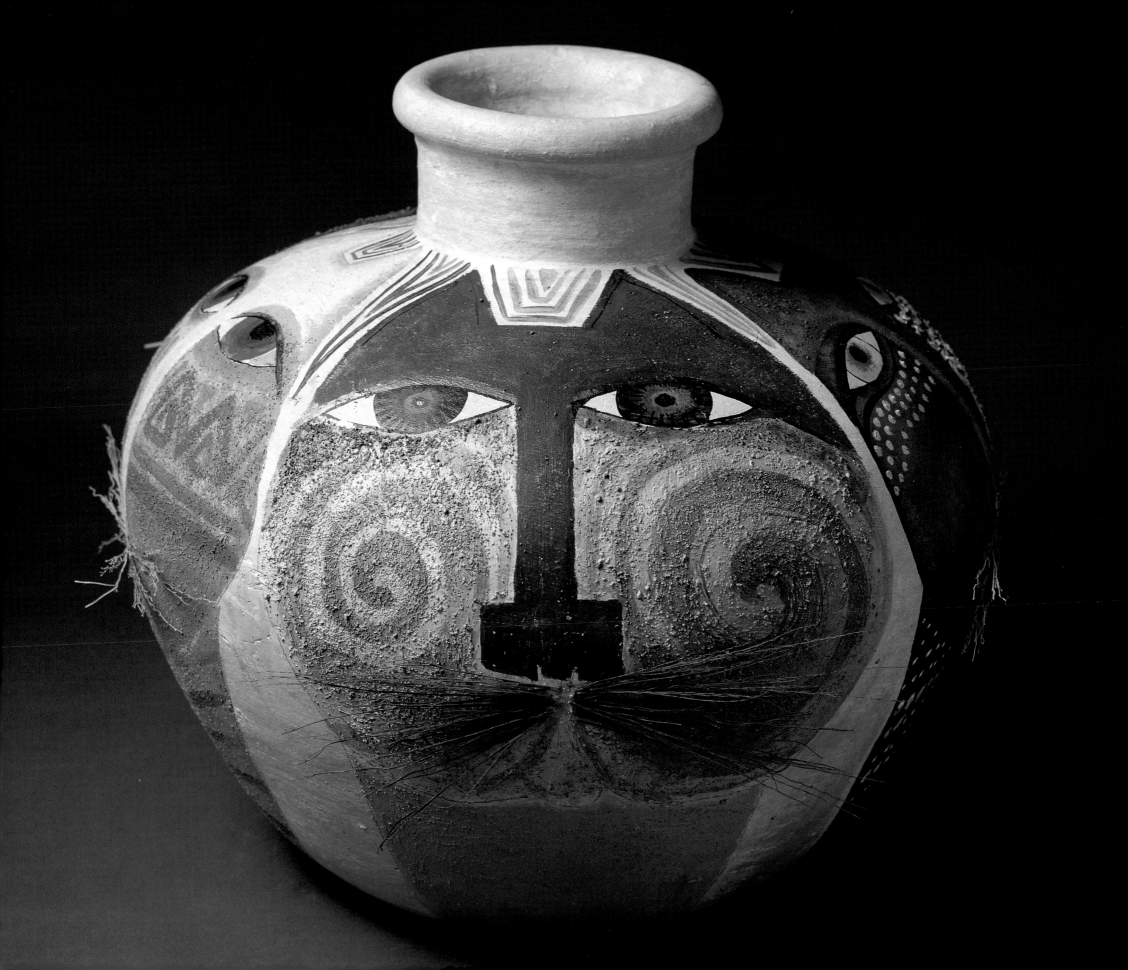

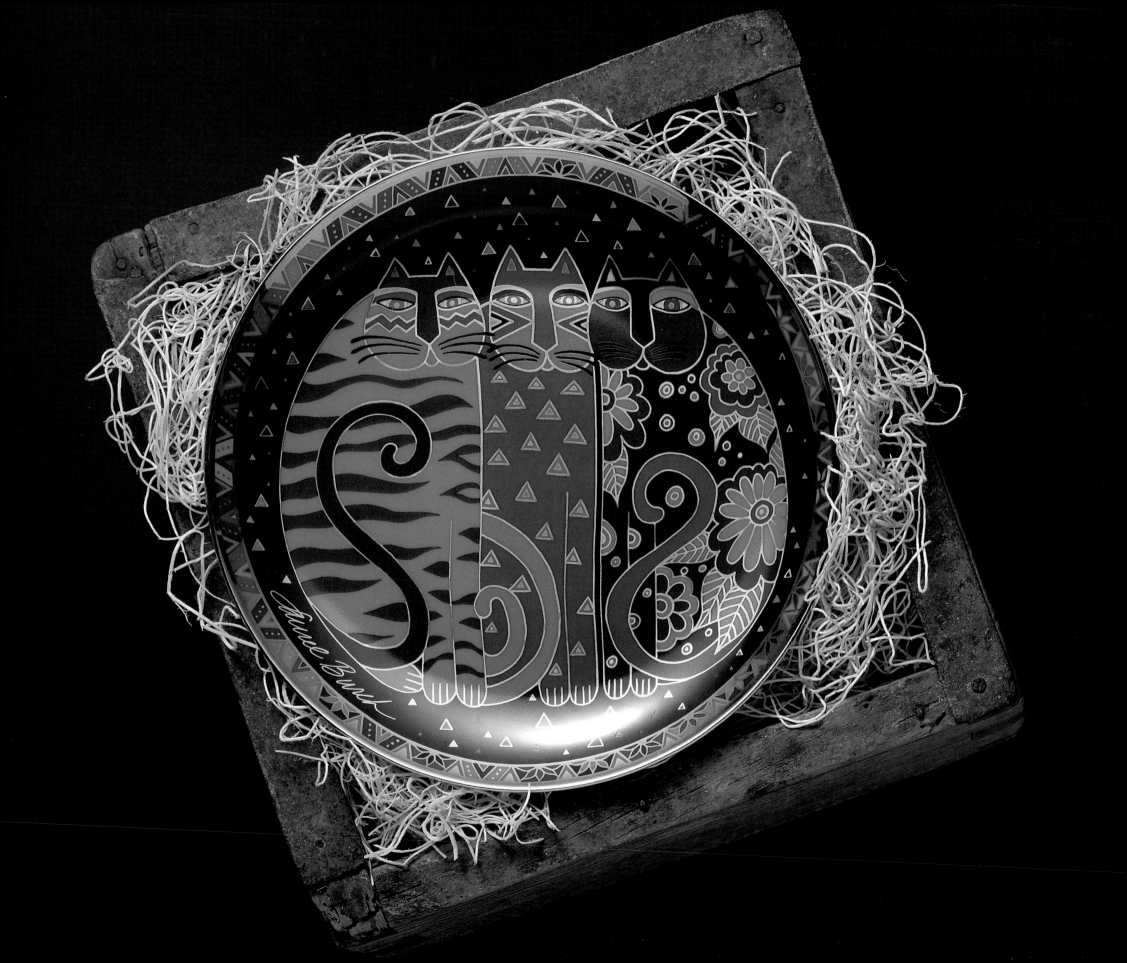

In 1995, my first limited edition collector plates were introduced throughout the world by The Franklin Mint. Each plate is detailed with gold and bears the image of some of my most famous felines.

Opposite page: Fanciful Felines, *1996.*
From left to right, Feline Family, Friendly Felines, *and* Fair Weather Felines, *1994.*

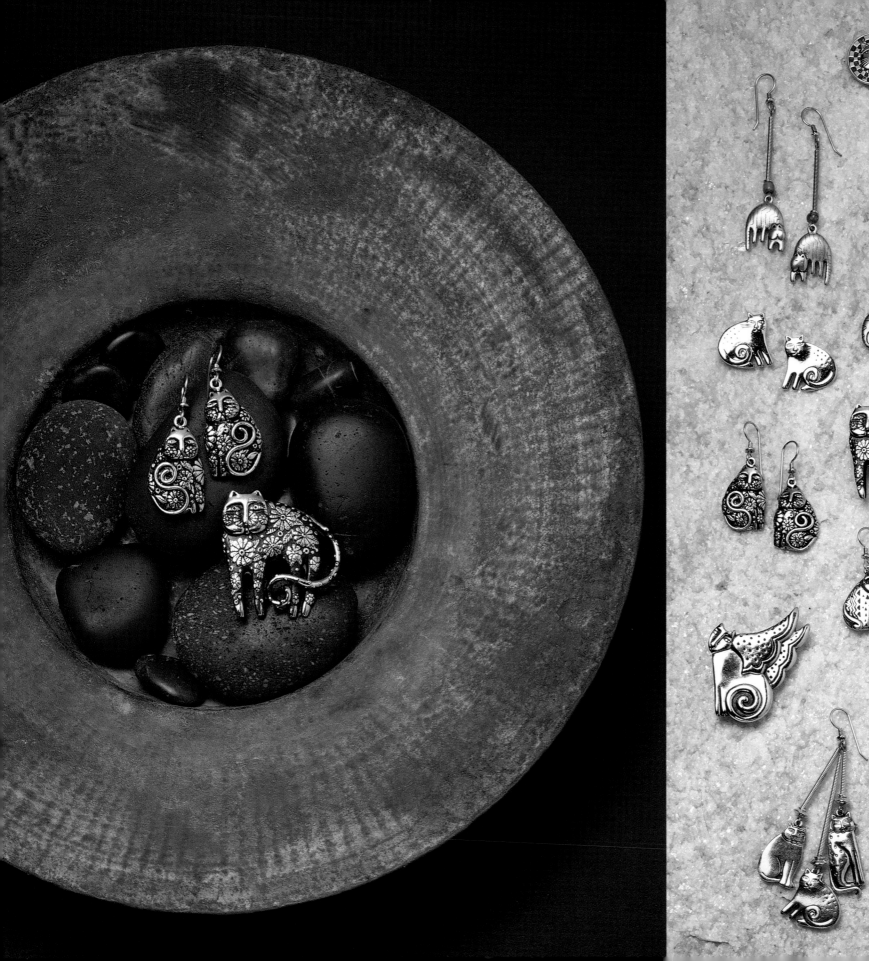

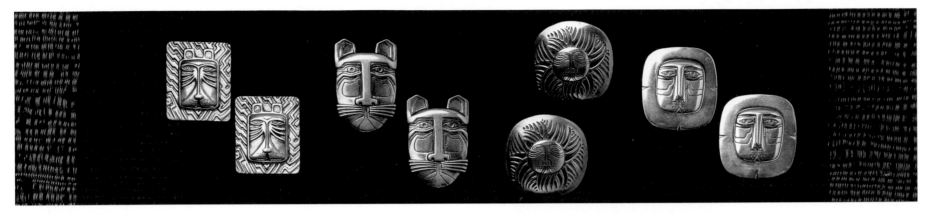

I am perhaps best known for my jewelry collections. I began creating earrings and necklaces by hand in the 1960s. Many collectors own more than one hundred pairs of earrings and have told me wonderful stories about how and when they acquired their favorite pieces. Over the years I have created hundreds of designs but my felines are by far the most popular.

Each piece of jewelry bears my signature along with the name of the feline. Some of my most classic cats make appearances in many colors, metals, and materials, including silver, gold, carved and painted wood, and—my favorites— hand-painted, brilliantly hued enamel.

From my first designs hammered out on a frying pan to the ones I am dreaming of today, I have always loved the challenge of putting an enormous amount of magic and meaning into the tiny little space of a piece of jewelry. I love that it becomes a part of you when you wear it, reflecting a bit of your spirit. Most of all, I love that in some special way this connects you and me to each other.

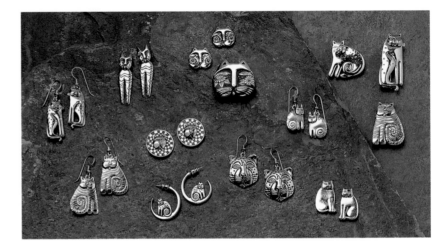

Cast metal earrings and pins, 1980s.

Miikio sterling pin, 1986.

Mythical Lion and Friends
cast silver pin, 1976.

Opposite page: Cast metal jewelry, 1980s.

Following pages: Cloisonné jewelry collage, 1979–1993.

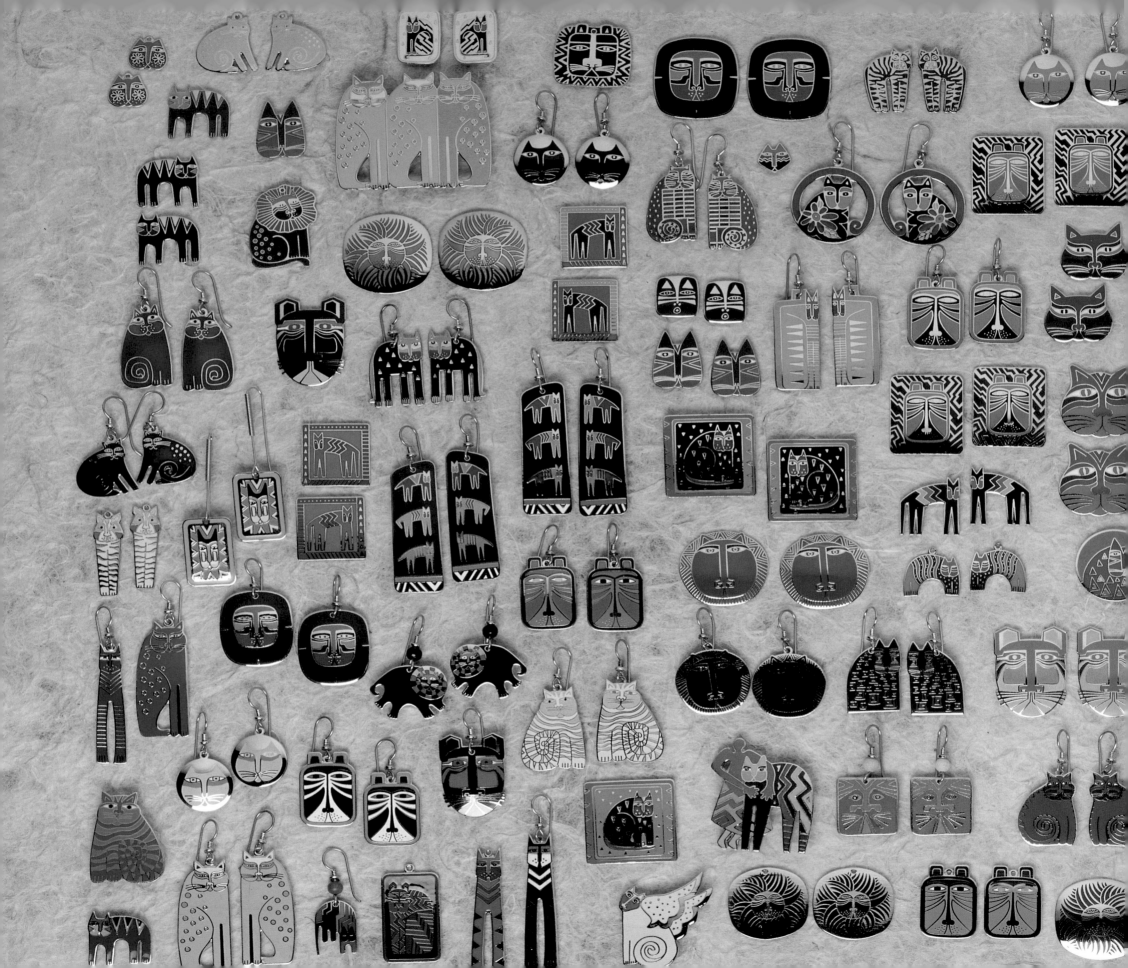

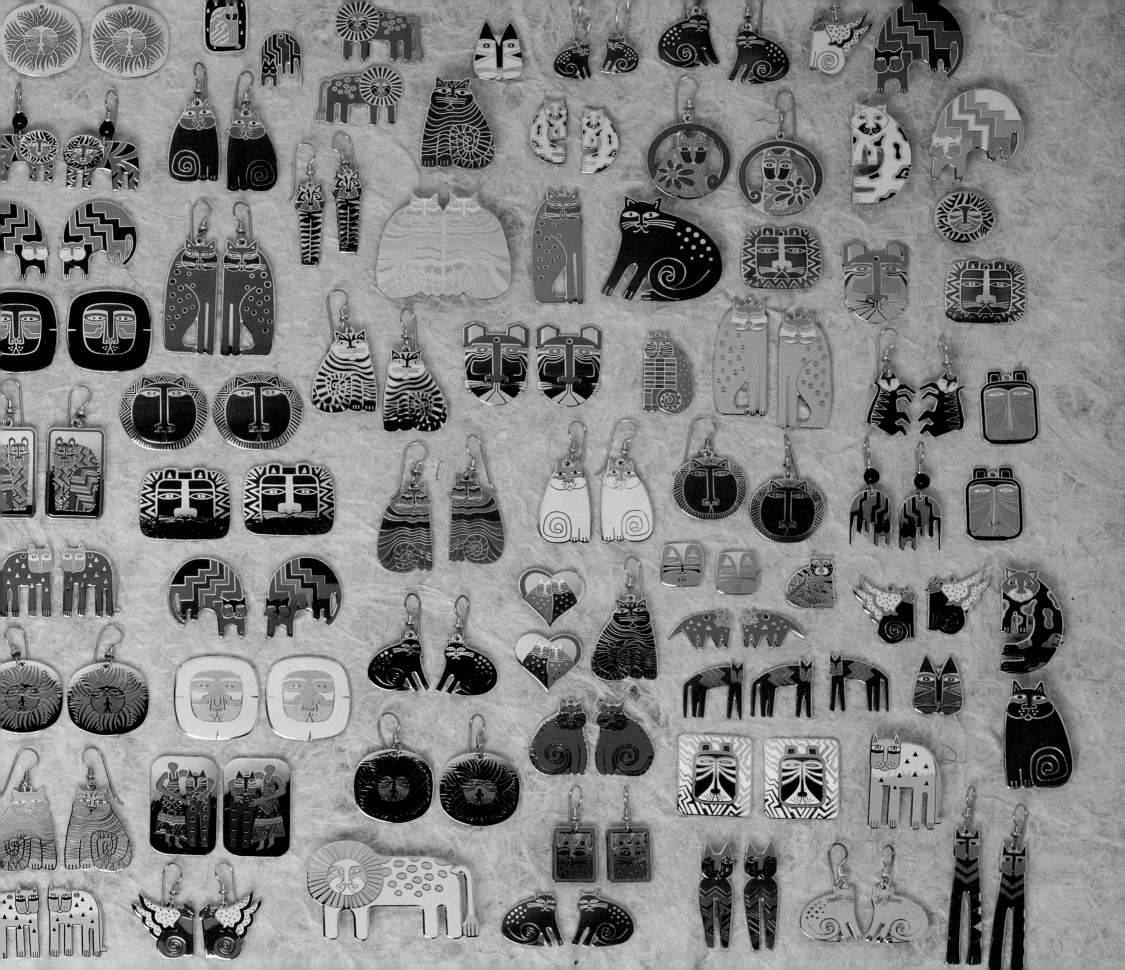

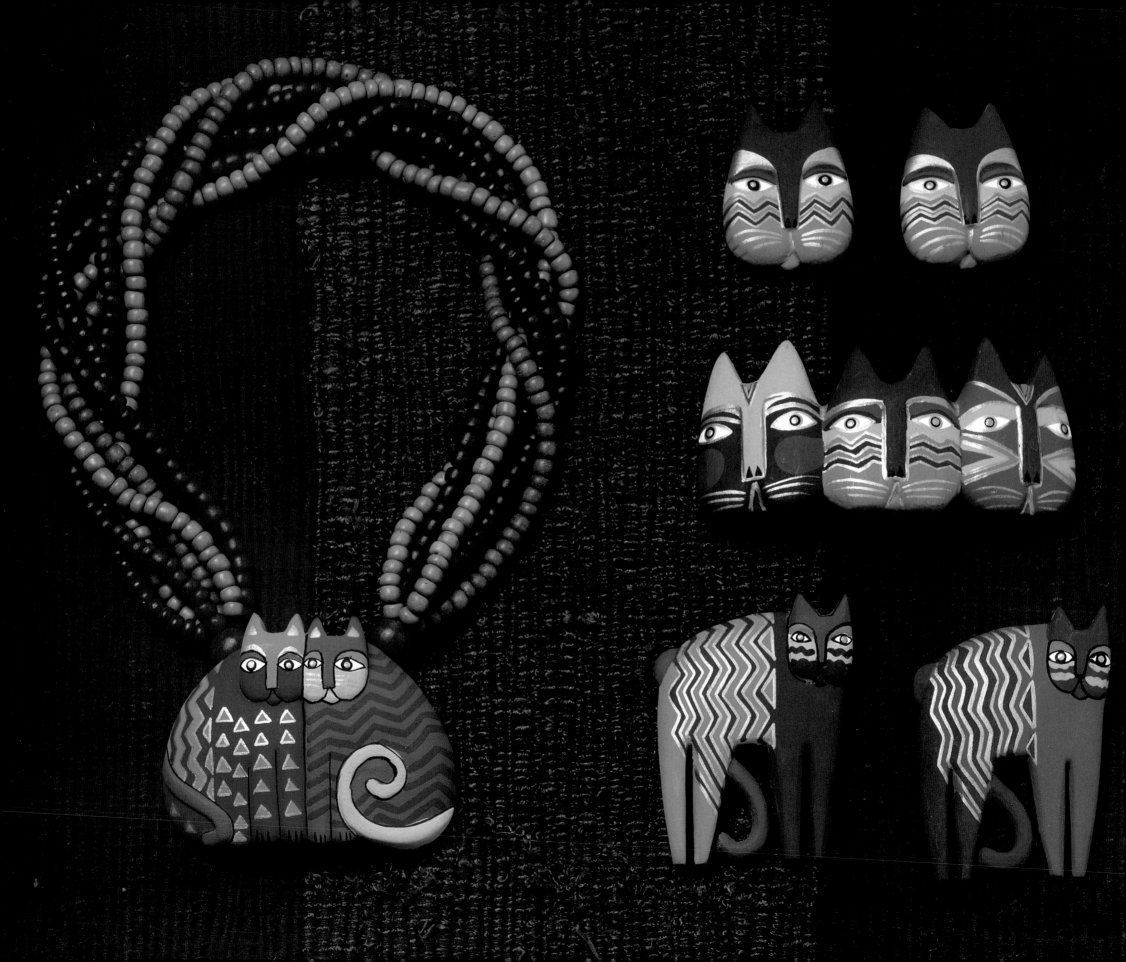

My drawings and paintings are the most intimate expressions of all that is precious to me. The originals are offered to art collectors, and many of the images are also published in a wonderful array of paper products, such as posters, wrapping papers, gift boxes, and greeting and art cards.

Laurel Burch gift wrap and enclosure card, 1995.

Opposite page: Individually hand-carved and painted wood jewelry, 1993.

Following pages:
Collage of feline cards, 1979–1996.

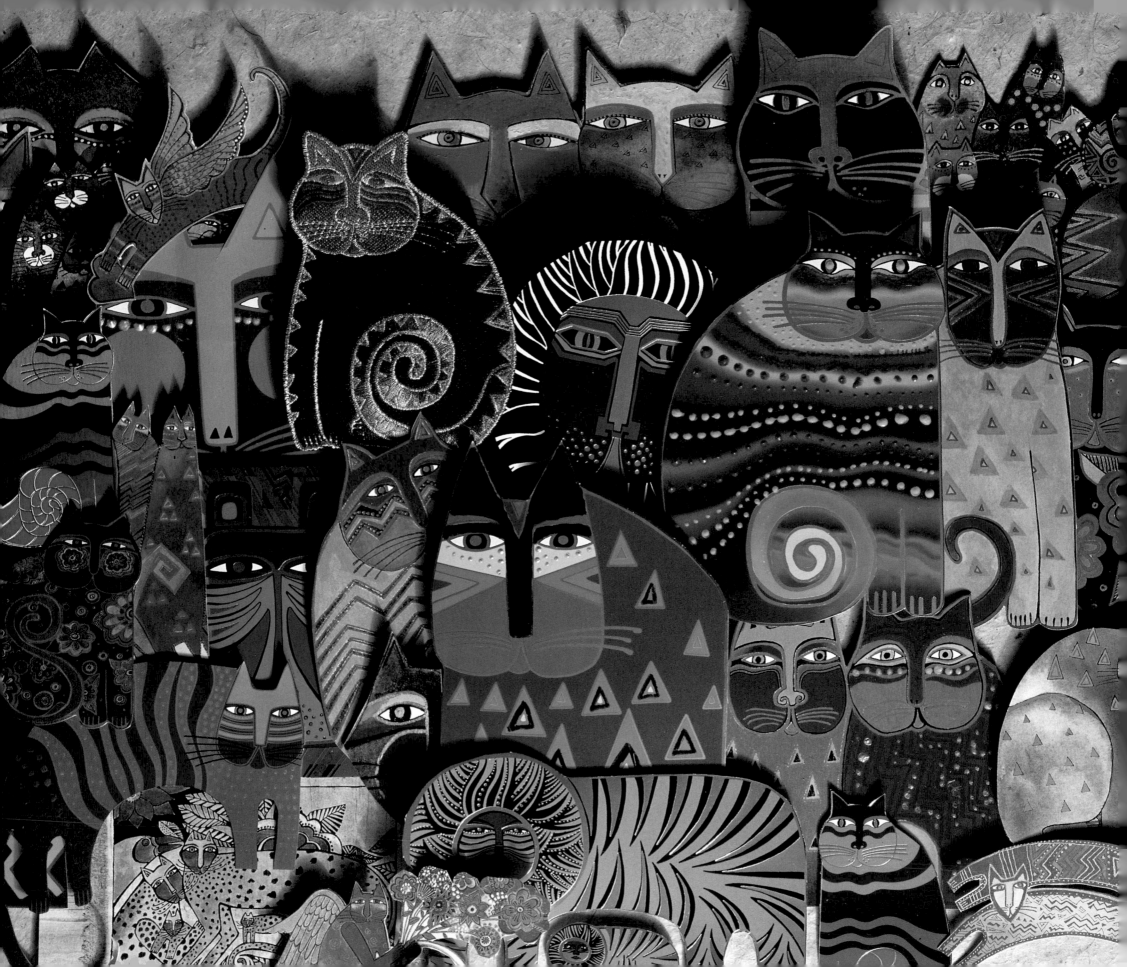

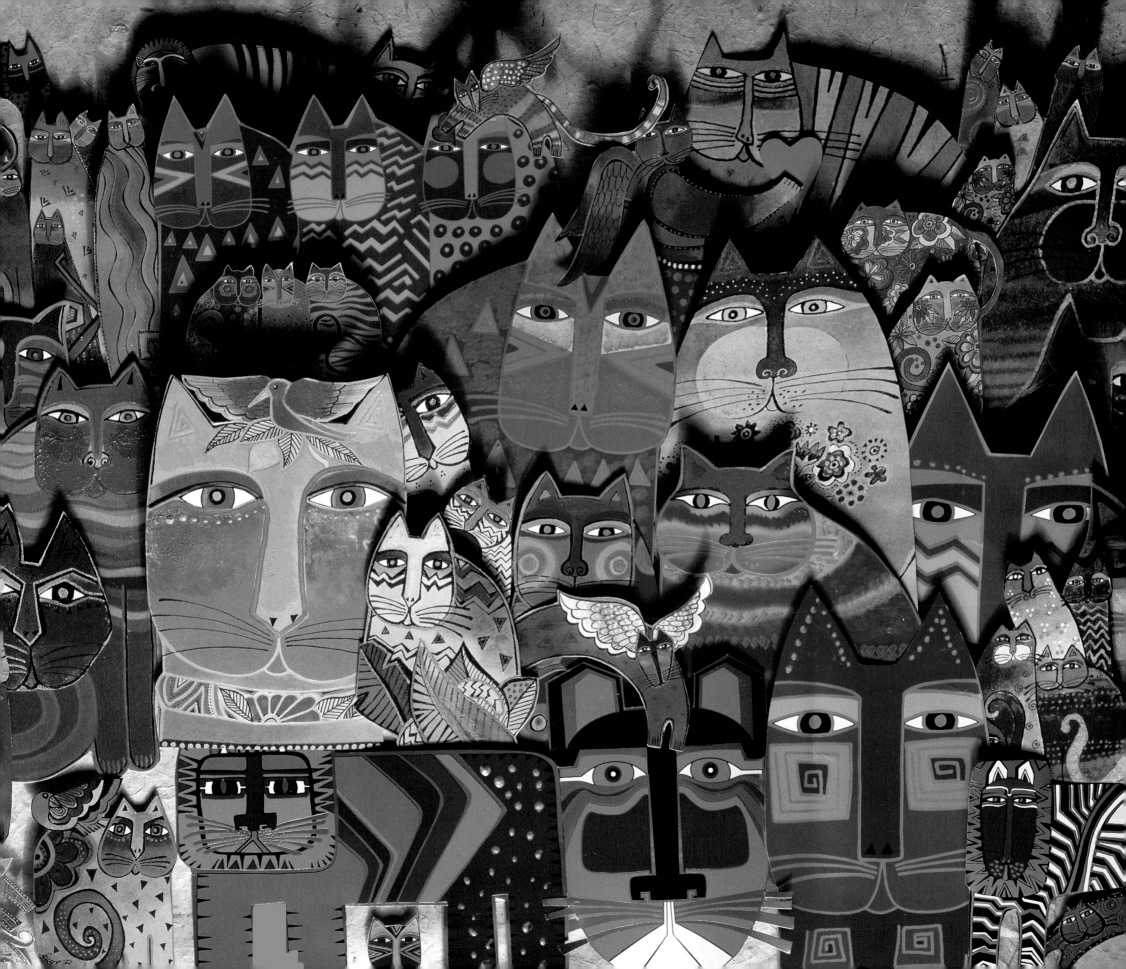

F requent journeys to the orient increased my love for beautiful silks. The vibrant colors and sensuous softness inspired me to design my own collection of scarves.

Kindred Creatures,
Rainbow Cat Cousins,
Feline Faces, *and* Wildcats
silk scarves, 1988–1996.

I n all their various forms—jewelry, scarves, posters, or mugs—each Fantastic Feline has a life of its own . . . to lift spirits, warm hearts, share dreams, and kindle friendships. These are the things that inspire me to create my art, and these are the things my feline ambassadors can express.

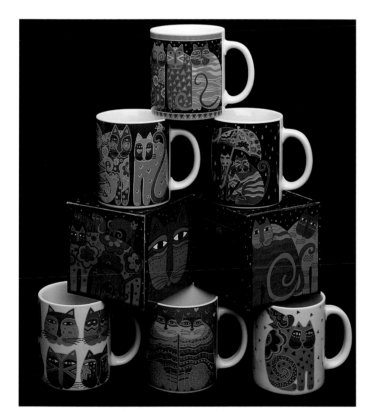

Fantastic Felines *mug collection, 1995.*

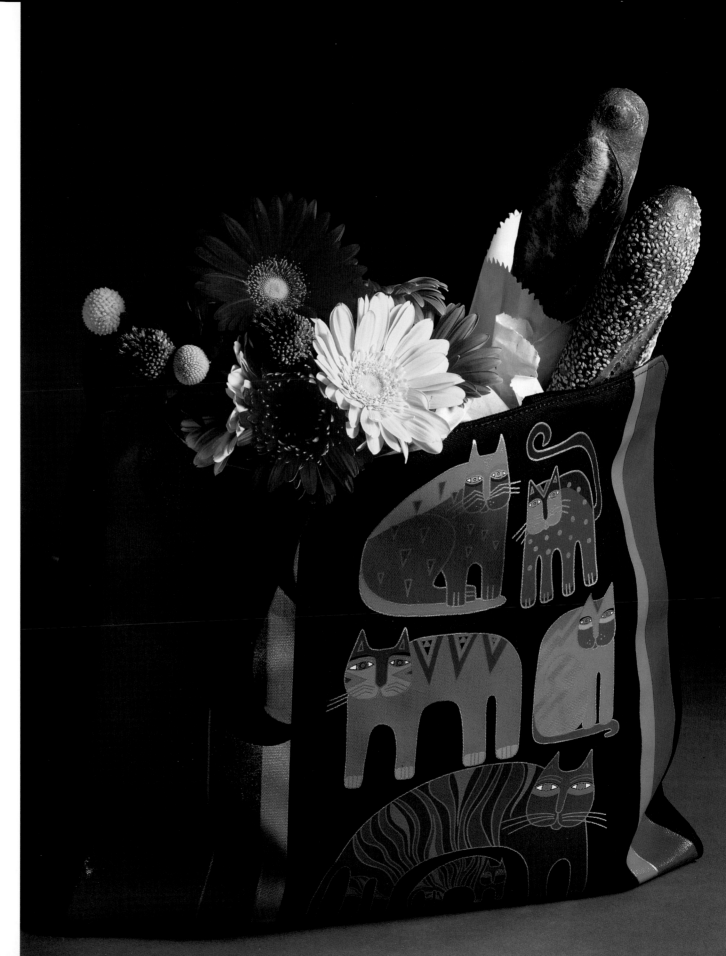

Fantastic Felines *totebag, 1992.*

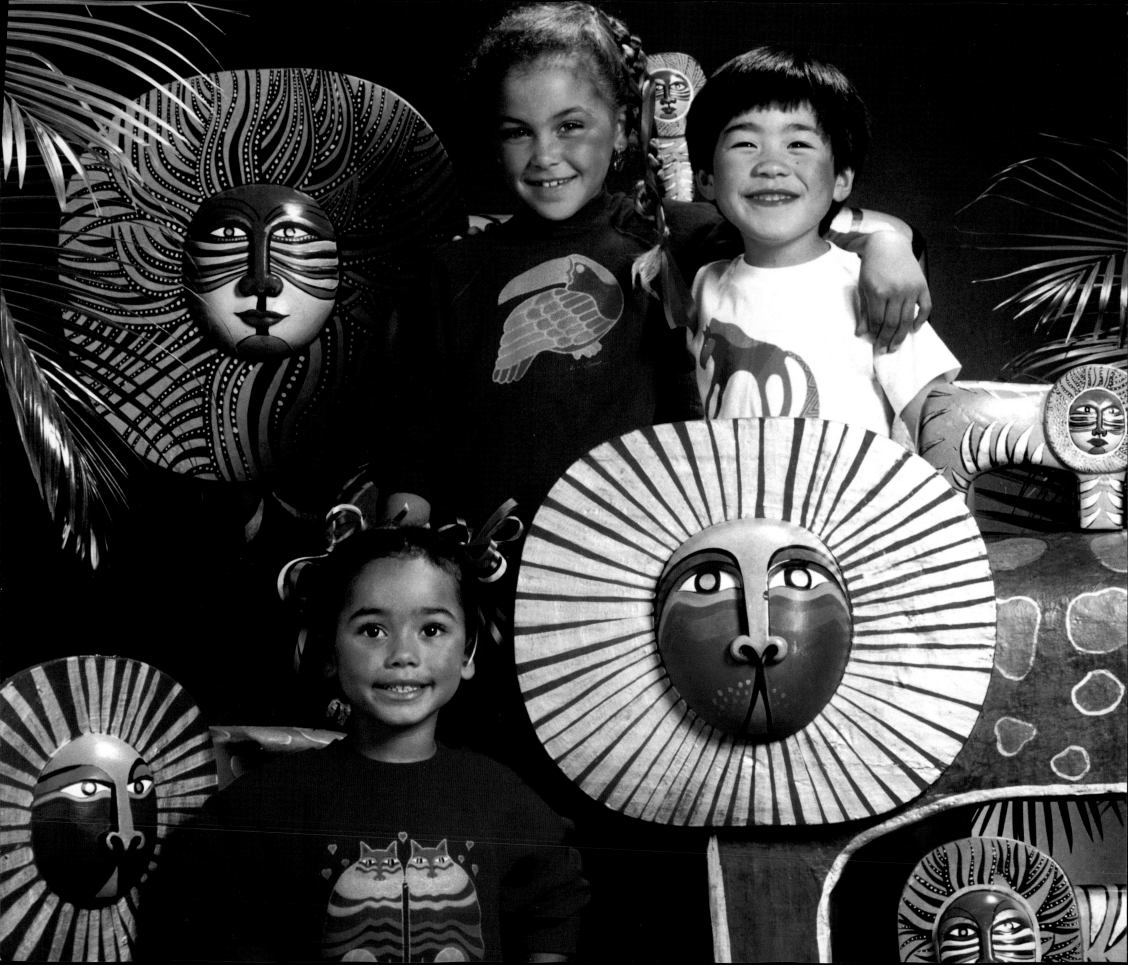

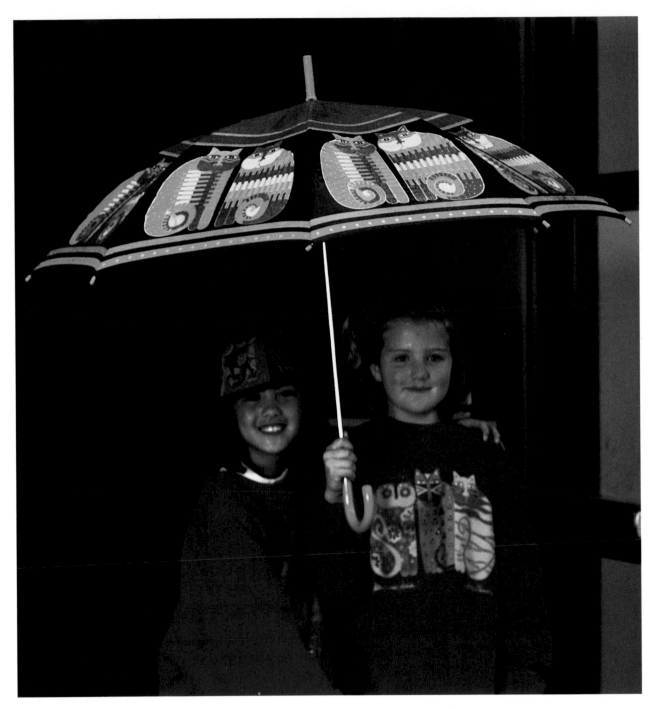

Budding collectors with Fanciful Felines *cap,* Feline Femmes Fatales *sweatshirts, and* Rainbow Cat Cousins *umbrella, 1996.*

Opposite page: Children in Laurel Burch shirts among carved mythical animals, 1984.

I f my art could convey a message of importance to children, I would hope for it to be for them to believe in themselves and their dreams, to value their own special abilities and spirit, and most of all, to find many ways to create, express, and share that spirit with others.

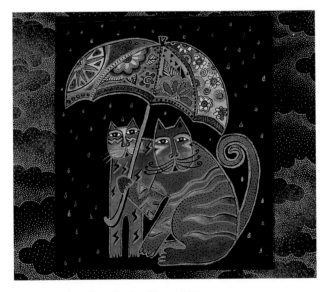

Cats Under the Umbrella, *1993.*

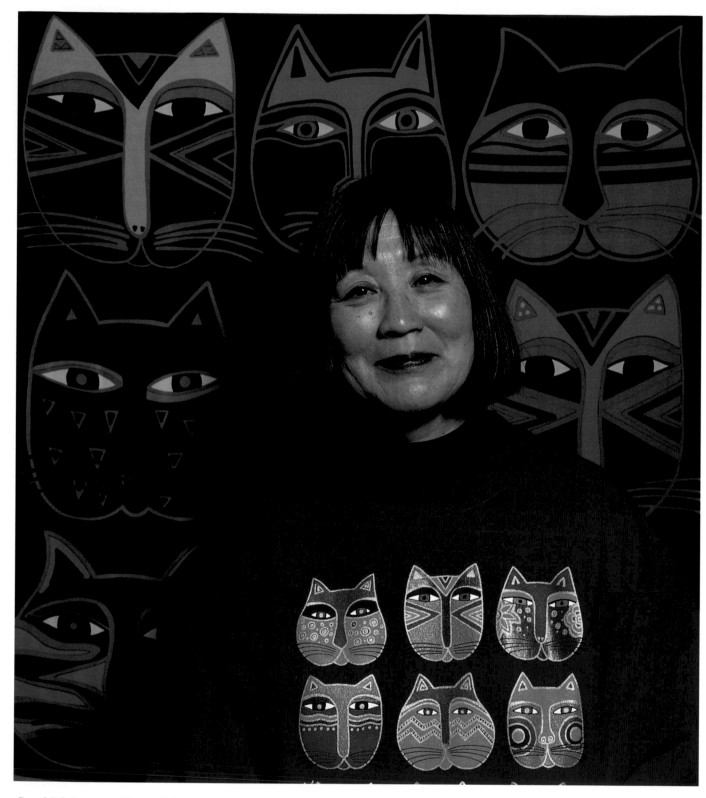

Carol Ishikawa with the Feline Faces *silk scarf behind her.*

C arol Ishikawa shares my mythical animals and stories with the first-grade students in her class. She says they are inspired by my posters on the walls and by the shirts she wears almost every day, which are patterned and colored with my images. She is a walking rainbow in the classroom. The children in turn have shared their creations with me, as have many children throughout the world. In seeing the common thread of global spirit that weaves its way into their artwork, I am reminded that it is the teachers like Carol—from Africa to Asia and North America to South America—that encourage, inspire, and nurture the precious creative spirit daily. These teachers value and appreciate the natural artistic and expressive nature of our children, and keep it alive and growing in them. A warm embrace for all these special teachers in the world!

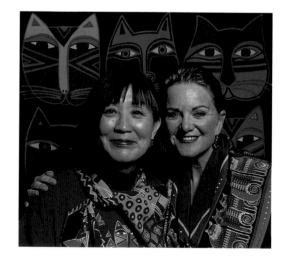

Laurel and Carol.

A WORLD OF THANKS!

Dear Kindred Spirits,

Art is a universal language, and through imagery that is understood and recognized by all people everywhere, I believe that we can share the grace of birds in flight, feel the warmth of friendships, explore the exquisite beauty and mysteries of the earth, and savor the preciousness of life.

When I design and paint, I remember that it is you, my friends and kindred spirits all over the world, who have inspired me to speak in a common language.

I wish to express my deepest gratitude—for your appreciation of my art and for the opportunity this has provided me to live my life with courage, purpose, and joy.

Thank you . . . for all you are, and for all we are to each other.

With love
Laurel

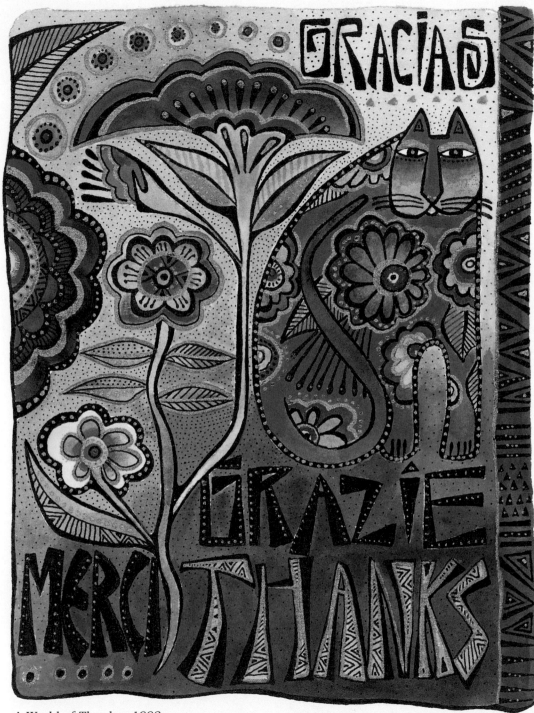

A World of Thanks, *1992.*

this is not the end... its just the beginning!